Releasing the Spirit

Releasing the Spirit

A Collection of Literary Works from Gallery 37
Volume 3

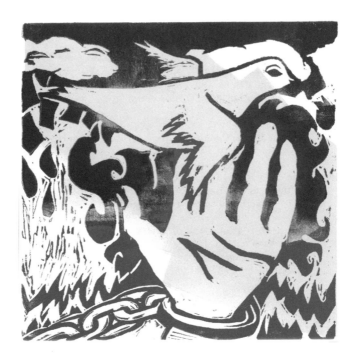

Edited by Haki R. Madhubuti and Gwendolyn Mitchell

THIRD WORLD PRESS
CHICAGO

Third World Press
Publishers since 1967
P.O. Box 19730
Chicago, Illinois 60619

 RR DONNELLEY & SONS COMPANY

A special thanks to R.R. Donnelley & Sons Company
for their generous underwriting of the production
and printing of this anthology.

Special acknowledgment to the Chicago Community Trust
and the Prince Charitable Trust for their support
of the Gallery 37 1997 literary programs.

"Dreams," from *The Collected Poems of Langston Hughes.* copyright ©1994
by the Estate of Langston Hughes. Reprinted by
permission of Alfred A. Knopf, Inc.

Releasing the Spirit is a collection of poetry, prose and playwriting
created by apprentice artists in literary programs conducted in the Gallery
37 Schools Program in the Spring and Fall of 1997
as well as the 1997 Summer Downtown Program.

Gallery 37 is a program of the Chicago Department of Cultural Affairs
with private funding made possible through The Arts Matter Foundation, a
501(c)3 organization.

Library of Congress Card Catalog Number 98-61343

ISBN 0-88378-218-9

Printed in the United States of America.

Book Design: Greg King

Cover Art: Leonides Polanco, age 18

About Gallery 37

Gallery 37 is an award-winning jobs program that provides Chicago youth on-the-job training in the visual, literary, media and performing arts. It has become an international model that has been replicated throughout the United States, and in Australia and England. Initiated in 1991, the program is designed to provide meaningful employment and arts education to Chicago youth, and to increase public awareness of the arts as a tool for learning, critical thinking, building self-esteem and molding career choices. Gallery 37 has brilliantly captured the imagination of young people throughout the city, while transforming the Loop, neighborhoods, parks, youth centers and schools into workshops of artistic discovery. In its seven years, Gallery 37 has employed nearly 8,000 apprentice artists in the Downtown, Neighborhood and Schools Programs, and has employed over 850 professional artists.

City of Chicago
Richard M. Daley, Mayor

Department of Cultural Affairs
Lois Weisberg, Commissioner

Gallery 37 Committee
Maggie Daley, Chair

Gallery 37
Cheryl Hughes, Director

The following organizations are literary participants in Gallery 37 activities:

Pegasus Players

Guild Complex

Boulevard Arts Center

Beacon Street Gallery at O'Rourke Center

CONTENTS

Hold fast to dreams
For if dreams die
Life is a broken winged bird
That cannot fly

Hold fast to dreams
For when dreams go
Life is a barren field
Frozen with snow

 – Langston Hughes

Dear Friend,

Gallery 37 is pleased to present, *Releasing the Spirit*, the third annual anthology of literary works by our apprentice artists. This collection of prose, poetry and plays showcases the work of the 1997 Downtown, Schools and Neighborhood literary programs.

Through this anthology and other artistic endeavors, Gallery 37 offers Chicago's youth an opportunity to explore their creativity, while they also learn and apply life-long work skills. The program's success in combining youth employment with art education can be measured in the experiences of its over 8,000 apprentice artists. The works in this collection represent a few of their accomplishments.

As this anthology so powerfully illustrates, the voices of our city's future have found a safe space in Gallery 37. Their words articulate the challenges and joys of young adulthood, urban life and living. They present a perspective that is candid, unique and powerful.

We thank the teaching artists of Beacon Street Gallery, Boulevard Arts Center, Guild Complex, and Pegasus Players. They have devoted valuable time to our apprentice artists, helping them articulate their thoughts and feelings in written word. We are also grateful to Third World Press for linking these works in a way that connects the young authors' ideas.

Since its inception in 1991, Gallery 37 has contributed much to Chicago and its citizens. Its performing arts and literary programs have enlivened the city, with the production of prize-winning plays and lively musical performances. Hundreds of works of public art adorn our city, from murals that brighten our city streets to benches that welcome international travelers to our airports. More significantly, Gallery 37 has unleashed the artistic talents of thousands of Chicago youth.

We invite you to participate in this exciting and rewarding program. Share our anthology with your friends and family. Commission a work of art or purchase original artworks in the Gallery 37 store. Your personal involvement contributes to the success of Gallery 37.

Sincerely,
Maggie Daley
Chair, Gallery 37

FROM THE EDITORS

Third World Press is delighted to present *Releasing the Spirit: A Collection of Literary Works from Gallery 37*, writings from participants in the 1997 Literary Program. The apprentice writers and artists completed job training programs that allowed them to create, study, explore various literary genres, and understand more about the craft of writing. The selections in this anthology show that many of these apprentice artists took their work seriously and made a genuine effort to cultivate his or her writing voice. We invite you to read, reflect, and enjoy.

When Third World Press was asked to serve as this year's publisher, we welcomed the opportunity to present some of Chicago's newest talent to the world. We also welcomed the opportunity to help cultivate and shape these new voices, and, of course, to develop a new audience of readers and writers. Many of the apprentice writers and artists have had their work presented in one or both of the previous volumes of Gallery 37 literary works. This third volume of poetry, prose, art, and playwriting further charts their growth. We want to continue to nurture and encourage all of these authors as they share their gifts of creativity with you.

Our work as editors began when the participant's work ended. The apprentice artists submitted their completed portfolios to the lead artists as proof they fulfilled their requirements for the program. We acknowledge and thank the lead artists who worked one on one with these apprentice artists to help shape each selection. They witnessed the ease or the struggles with which these pieces came to be. Our job then was to pull from among the submissions the selections and excerpts that best represented the participants. We tried to include enough of the original pieces in the original voice for audiences to understand what was happening in each selection. Offered in the anthology's five sections are fresh visions on what it means to be part of this world. Listen carefully to what these young artists tell you about dreams and fantasy, about love or living with abuse, about death and the realities of everyday life.

Third World Press adds this anthology *Releasing the Spirit*, our latest offering, to the long list of titles that we have published during the

past thirty-one years. We place these young voices along side our other Chicago authors like Pulitzer prize-winning poet Gwendolyn Brooks; poets, Sterling Plumpp, Cranston Knight, and Keorapetse Kgositsile; playwright Useni Perkins; educators, Frances Cress Welsing, B.J. Bolden, Jacob Carruthers and many others. We hope you will receive this anthology with the same enthusiasm given our other titles.

We see the good work that Gallery 37, one of Chicago's most exciting and innovative programs, offers for the youth of our communities. This anthology allows us to share some of that good work with you. We thank Pat Matsumoto, Assistant Commissioner with the Department of Cultural Affairs, who first planted the seed for this collaboration. We thank Elaine Rackos, Executive Director for Special Projects at the Chicago Cultural Center and Liz Kramer, Special Projects Coordinator for Gallery 37 for facilitating meetings around the project's production. We thank graphic artist Greg King for his innovative thinking, and design for this year's anthology. We thank and acknowledge the Gallery 37 staff, lead artists, and teaching assistants for commitment to these young artists. Finally, we thank these apprentice writers and artists for creating works now found in *Releasing the Spirit*.

rain and books & sun and books,
we are each other's words & winds
we are each other's breath & smiles,
we are each other's memories & mores,
we build our stories page by page
chapter by chapter, poem by poem, & play by play
to create a life, family, culture, & a civilization
where it will take more than sixty seconds
to tell strangers who you really are,
to tell enemies and lovers your name.
 – Haki R. Madhubuti

Plant seeds,
cultivate, have patience,
touch tenderly, water with care.
Take time,
teach, read a good book,
wait, release the spirits and
watch them grow.
 – Gwendolyn Mitchell

FOREWORD

I promised myself that when I had the opportunity, I would write a novel. Not just a novel, though. It would be a novel for all times, the best novel ever. It would be a bestseller. I would be rich for the rest of my life. It would be about a woman. Definitely. Maybe me. Yeah, I could write an autobiography. But my life isn't that interesting. Hmmm, what else? I could write a drama, maybe, or a comedy. Hey, I'm pretty funny! Naw, there are enough of those out there already. Plus, I probably couldn't get into something like that anyway. I'd probably do better to take all those little short pieces I'm always scrawling out and compile them into an anthology. I could start by writing a collection of short stories and poems as my project for Gallery 37. The ones I have written now are pretty good, I think. I could also make some of them, what was the word Michael McColly used, you know, writing that's loosely based upon bits of my life, "creative narrative." But what exciting things could I write about? As I think about this for a while, Tsehaye's CD starts playing "You Gotta Be" by Des'Ree, then I get a burst of inspiration. I look out of the tinted window at the skyscrapers across the street. It makes me think about just how remarkable I am, and about what I plan to do with my life. I feel good. Especially because it allows me to think about everything I've been through and all the things I go through that someone my age shouldn't have to. I'm amazed that I have managed to maintain and hold my own and still be an achiever, and haven't developed a nasty attitude, bitter disposition, or lost my smile. So I'll write a collection of short stories. Yeah, that's what I'll do. That way, I haven't really let myself down (as I am prone to do), and I've done my job for Gallery 37 (so I get paid), all in one fell swoop. So here it is. Enjoy.

–Sheryl Lynn Bacon
Apprentice Artist

EARTH MOVEMENTS AND SHADOWS

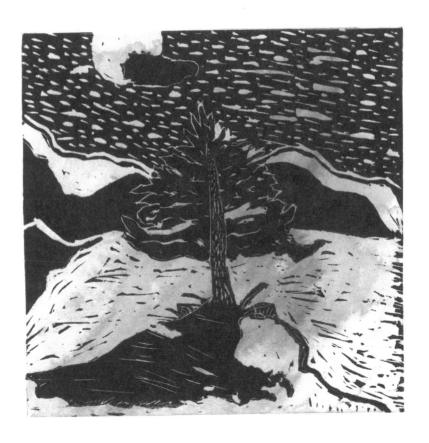

We are Not a Shadow

A loss of brotherhood
Black men withstood
We have slaved for hundreds of years
And all we have to show for it is our
scars and tears

Freedom is spurned.
All of the amendments have been
burned.
This is how I feel,
The feeling that life isn't real.

Martin Luther King Jr. did all he could
do to help us
So we wouldn't seem like a shadow.
He wanted us to stand in the lights
So we can transfigure in the nights.

He had so many dreams,
So very many soothing dreams.
His soul was a nocturne
He wanted us to get what we had
earned.

Marcella R. Knox

I'M WAITING

I'm waiting for when you will come to me
I'm waiting impatiently for your call
I'm waiting for when you can say you love me
I'm waiting impatiently by the phone that's next
to the wall

I'm waiting for you so that we could walk down
the street hand and hand
I'm waiting for you to look me in my eyes and
tell me you care for me without looking or
thinking about another girl
I'm waiting for you so we can talk about love
I'm waiting for you to tell me that you want me
to be in your world.

I'm waiting for you to be with me
I'm waiting for you to tell me you'll never leave
I'm waiting impatiently for you to tell me you want
me in your life
I'm waiting impatiently for you to propose to me and
make me your wife. So we could be together always
and forever.

I'm waiting for when you'll come to me
I'm waiting impatiently for your call
I'm waiting for when you can say you'll love me cause
I can't sleep, think, live or eat without you in my life
I'm waiting impatiently by the phone next to the wall.

I'm waiting

Tamika Little

ROSE

ROSE
IS IN MY THROAT
DEEP LIKE SAND
THAT IS DEEP
IN THE WATER

MY ROSE
IN MY THROAT
IS AN ANGER
JUST LIKE SAND
IN THE WATER THAT
FLOWS

ROSE
ROUGH, ROUND
OH! OH! BEAUTIFUL
SMELL
STRANGE, STRAIGHT
SOFT, SMOOTH
ANGRY
NICE, NEAT
DARK, DANGEROUS

Sandad Som

EARTH

Earth is a wife getting beat
Earth is a piece of gum being stepped on
People only care because they can't get rid of it
Earth is trash
Nobody cares what happens to it.
Earth is a hooker
It's always being screwed
Earth is a mother
We take, take, take
All we give back is disrespect
What have we done to the earth
What have we done to our fair mother

Kathy Jacobson

THE SONG OF THE EARTH
(my interpretation)

The fool speaks.
The wise man listens.
 –Ethiopian Proverb

Who really speaks and listens
in this world of right and wrong?
I try to even out both
as I sing along
With the songs of the earth
since birth,
I've been perfecting my tune
like a wolf howls, I sing
at the moon
this tune that I'm trying to perfect
to gain respect
In this many-sided world.

Maurice Johnson

I Don't Run

All people should try to learn before they die
what they are running from and to and why.
 —James Thurber

I DON'T RUN
I DON'T RUN
from past or future, faith or
questions, love or hate. I don't run
from my drunken relation holding
bottle in doorway to dark room
(light pouring in around him) waving
fist, hitting wall, hating daughter.
screaming blame, drunken grief
pouring from someplace deep in his
hard gut of guinness it pours from
where youthful muscles used to be

his daughter pretends not to care
she holds my feet and I hold
hers and we try not to notice

I don't run from any memories—
the ones that make me shake in
liquored highs. shake and scratch my
face and scream for someone to
get him off me

I don't run from the ones that
make me hate me or debase
my faith in humanity

I don't run from my most
troubled friend
 I realized today during lunch that suicide
 is her only option and I will weep for
 her tonight in my room when no one's
 looking until sleep ends every thing but
 the pain
I do not run because
I am a responsible human with the
weight of the world on my shoulders
and strength in my heart.

Molly Dunn

DJALI EYES

Imagine a man with eyes
Deeper than a tunnel from here to China.

Eyes that cry without shedding tears
Eyes that laugh without sound
Eyes that tell stories without words

Stories of past and present
Stories of triumph and defeat
Stories of dreams come true and lost

Dreams of long life
Dreams of success
Dreams of finding a queen

A queen to read his eyes
A queen to listen to his stories
A queen to share his dreams.

Raushanah Azim

MISTREATED LAND

Woman, so mistreated, unappreciated and
demeaned.

Do we know what she is,
or what she can give?

She is producer of all children
and life, like oxygen,
water,
and food.

She gives us the means to live
and be free.
Why can't anyone see that?

Why do people contaminate her precious temple?
Can't they see that she is deteriorating?

She needs medical attention
Wounded in blazes, gunfire, mental strain.
Mother cannot live any longer.

Civilization is killing her.
She made us, sacrificed herself
so we could live better.

She grows green grass,
and provides beautiful scenery
for our viewing pleasure.

Respect her.

Her fresh fragrance flowers the earth
with the intention to spread love.
So, why do we mistreat her?

She is motherland.

Donald Andrews

SHADOWS

Sitting in the dark
Hiding in the corner
A boy is there
A boy rearranging his "man" face
Tugging and patting
So it fits just right
Applying his man make-up
Painting on the smile
Patting away the creases
The creases that came
From suddenly having to grow up
Too fast
The boy is walking
Nodding his head and talking
Trying to ignore the tightness
That he feels from his man face
Pressing against his skin
Suffocating
Strangling
He has to be strong
He mustn't let anyone know
Of his feelings
Must shadow
His feelings
And just be strong
For all the others
So he holds his heavy head up
And walks in the sun
Only when his man Face starts to melt
Can he once again
Slip into the shadows
And let his boy face cry

Alia Rajput

Ritual

warm water covers her to her
shoulders
emmersing her on baptism
cleansing her soul and physical
and
soaking out all the shit
from the day
Red and black candles stand in
tall
silver
holders
smelling of mango
oil
Soft light illuminating
everything misunderstood
Sudsy cocoa water dancing
with her
electrically sliding with every
moment of her hands
her legs
her hips
and singing
to her
until her eyes close
and
close
drifting away to dreams
fantasies of
abandoned
once forgotten
and now reclaimed
by her twice loved
soul

Charlotte King

FEAR

Little Black Child,
have no fear,
for big sister is here.

Though mama is not very near,
still have no fear
cause big sister is here.

Food may be low
and times, they may be hard,
but still Little Black Child please, have
no fear,
cause big sister is here.

We may not have had the best of times,
we may have only had times to cry.

But still, Little Black Child, have no
fear,
I can feel the good times near.

In a state, a city, a country unknown,
but to me it's call "THE LAND UNDER
A THRONE"
only for the people unknown.

In my room, in our shelter we sit
alone,
you in your crib and I on a stone.

So Little Black Child, please stop
shedding tears,
cause food is near, so have no fear.

Wakeesha Jackson

GENTRIFICATION

I found beauty
in the crumbling buildings

There was a charm
in the wild flowers
and the tall green weeds
growing in the lots
where children played
and dogs ran free

The stairs on the huge, crowded, stone buildings
were inhabited by their tenants'
laughter and casual conversation
as the adults sat
cool drinks in hand
watching the children play
in the middle of the street
and ride bikes
on the cracked side walks
while the soft Spanish music
played from third story curtained windows

It was our home
My home

And on the fourth of July,
these non-English Speaking residents
sat on the concrete steps
lighters in hand
watching the erupting glowing flowers
in the dark city sky

Those concrete stairs were swept clean the next day
by our hard working mothers
my mother

The streets are empty now
The lots carved
by the uncaring sharp teeth of bulldozers
and weighed down
by tall, mass produced,
architectural monstrosities
The gutters are clean
never again to be littered with
thin, colorful fireworks wrappers

And the concrete steps
stand silent sentinels
having lost their laughter
the music gone
they are empty.

Restoration of deteriorated urban property especially
in working class neighborhoods by the middle and
upper classes.

Olga Chavez

Found Poem

Imagine
you are calm, peaceful
floating on a River
you float slowly.
leisurely
notice
beautiful scenery
see it once
it's gone forever
one way ticket
a moment
enjoy
then it's gone forever
suddenly
without you realizing it
the River current
becomes brisk
you're hitting Rocks
you're floating in a circle
things turn around
you see it now
the circle fills with water
river turns
into a lake of time
past present and future are all
here
your problems are put
into a boat
watch them drift away.

Taken from the Chicago Tribune (7/31/97 "Road to
Tranquility")

Jessica Carrillo

SACRED MOMENT TO MYSELF

emptiness,
has its patterns
twisting in the lifeless veins
of my heart
the invisible marks
well shown
over this sacred
and envious time

a faint light
breaks through this infinite path of
loneliness
and constant heartache
bleeding on this desperate
sheet of paper

am I
expanding these tattered emotions
I am guilty of

maybe I've changed my mind
towards what's eternally true

I am torn between
my life,
and my destiny

Scenecia Curtis

Is It Too Late?

We're all running.
Running each and every day.
Take a shower, throw on your clothes,
 Eat breakfast, get on the train, hurry up!
But what's the point?
 What are we looking for?
What are we running to?
 We all end up somewhere.
Do we know where we're headed?
Are we just running blindly
 Through chaos and random events?
Pack your suitcase, don't forget your razor,
 Tape your CD for the long drive.
Where does it all end up?
 Does anything we do matter in the end?
Kill everyone on this planet
 And would it even fucking matter?!
Get on the boat, don't rock it,
 Rudder right, back up on the left.
But when it all comes down
 To your very last weak, painful
 Whisper of a breath,
Ask yourself if it was all worthwhile.
 Ask yourself, ask her, no, don't walk away.
 No, stupid, no!
 Is it too late
 To start over?

Alan Lawrence

The Stars As Their Guide

GIFT

Life is nothing more than the pursuit of
something worth dying for.

—unknown

Life is a very precious gift
You should not try to grow up fast
Because if you do something will go wrong
I think you should take one day at a time
NOT FAST BUT SLOW.

Some people don't want to live anymore
Like me, I used to say I wish I was not living anymore
I hated the way God made me, I always asked myself
Why me WHY DID I HAVE TO BE IN A WHEELCHAIR
Some people think I HAVE IT EASY IT IS VERY HARD
mostly every time I think about it I cry
I hate when people walk past me and just look,

look at me

Trina Mack

KNOWING

There is no one to love me anymore
But maybe I don't deserve anyone
My body so unoccupied
As I sit all alone in this dark room

But maybe I don't deserve anyone
To be loved as a man
As I sit all alone in this dark room
My soul flies away from me forever

To be loved as a man
You'd be thought of as someone special
My soul flies away from me forever
Never looking back

You'd be thought of as someone special
If your heart never endured pain
Never looking back
Life would never be the same

If your heart never endured pain
My body so unoccupied
Life would never be the same
There is no one to love me anymore

Jamal C. Webster

What We Pursue

Who is not either the pursuer or the pursued? All persecute or are persecuted, and fate persecutes all.

—Anonymous

What we pursue is not our own goal but that which we hold inside to eliminate truth and persecution. Are we to follow our goal with the pursuit of our fate ready to eliminate all including ourselves? Our fate is only what we make of it, not what is to become our destiny. Destiny and fate are two entirely different things, both of which are inevitable. The inevitable is neither of our fate nor our destiny, but is both our fate and our destiny. We determine our own fate, but what we determine is what we were always destined to determine, therefore our destiny determines our fate by the transitive property. However, our destiny stems from the fates of those in the past, and destiny is determined by the fate of human history. Now, again by the transitive property, fate is determined by fate, or destiny by destiny. This creates a very confusing paradox, which I will choose to leave at that. As for pursuit, we all pursue our goals, but our goals pursue us. I would have to say that our pursuits, our goals, are what we make of them, and therefore are our fate, so by saying that fate persecutes all, we are saying that our pursuit of our own goals persecutes ourselves.

Jeff Daitsman

32

HOMELESSNESS

When our beds break
and we throw them away
there is a homeless person rejoicing
because their castle is coming their way
When we don't like something
and throw it in the trash
The unfortunate goes shopping
and won't need any cash.
So when you have something
and don't want anymore
give it
right
to
them.

A Collective Poem by the Boulevard Arts Center
Neighborhood Program 1997

DOUBLE STANDARDS

These are some weird days
Now is the time for me to be myself
Girls wear what they want
Boys are constricted

Blacks can be comedically racist
White's can't, unless they like to play with fire.
We live in a country where freedom of speech is uniquely
ours
Yet, children can't open their mouths to speak

If someone does something that
For some reason does not sit
Well with others. "No's" are passed across the board
Just because something is not the way they want it

Damn those double standards!
I'm not going to live my life trying to make others happy
No how, no way
Because, when I go to my grave
I shall go happy and unashamed

Jesse Daniels

Souls Untied

these language skills and human relations
fail me today
and I know that somewhere our souls are tied.
a worn out warrior in the classic style,
a lover, protector, jester and prince
sleeps off several lifetimes in a green glade.

but his lady has not been born yet
he is in the past,
and she will be the future
their love is locked out of time.

a princess born an orphan and loved only by cats
may someday outgrow her castle walls
may someday fight the battle
and win honor among wolves
but prefers her feline thieves
someday, I will go into the forest and find you,
weary warrior,
but youth has so much to give inside limitlessness

this unfortunate lack of opposable thumbs
and recognized meeting places for both
make it hard for me to find
(something to say to) you
when you keep speaking of truth, and Truth,
and bonds,
amidst a swirl of lies and tears.
I keep trying to break through, to break you,
but nothing works.
I could say so much to you, next time around,
if I believed you could understand me.

Amber Wilson

They Ran From Nighttime's Wild

Escaping the chains
of captivity,
striking terror enclosed their soul
trying to get to freedom,
they ran from Nighttime's wilds
The wind in their face,
and the dirt at their feet,
the stars as their guide,
they ran from nighttime's wild.
Only GOD as their preservation.
Only hope for autonomy,
they ran from nighttime's wilds.

Shannon Dellahousaye

ILLUMINATUS

He chants to me all I need to know. Grandfather-infant.
Still I the ghost.
I see myself as two lamps inside his lingering eyelids
and yet he says it is the sun he loves
Pure in honesty the pledges and prayers to sing his psalms

I see myself as two lamps inside his lingering eyelids
Knowing that I drew the drapes across his light-fed sight
Pure in honesty the pledges and prayers to sing his psalms
I yield my glass to his truth I wish

Knowing that I drew the drapes across his light-fed sight
Hearing then that the tranquil is not lazy and in that
difference his stare's not drunk
I yield my glass to his truth I wish
For more years and more words

Because I dread to be like an eclipse, a nimbused nothing,
a void holy crowned
and yet he says it is the sun he loves
the shroud slips as the shrine sinks and the lamp glows
and the lamps grow brighter
He chants to me all I need to know. Grandfather-infant
and still I the ghost.

Robertha Medina

6007 S. Carpenter

Drugs are sold around my neighborhood
I say, drugs are sold around my neighborhood
The handwriting on the wall does not look good

The funeral homes are full
Yes, the funeral homes are full
Cemeteries are ready and the graves are pulled

Families are grieving and don't know why
Families are grieving and don't know why
They end up askin' why my baby died?

Mark Hodges

A Conspiracy

We are the citizens;
They are the foreigners;
They are paid money;
While our bodies lay in the corner...
"I see a conspiracy"
We were shipped here
In bondage, and remained chained for years...
On the day of their arrival
They moved in the mansion on the hills...
"I see a conspiracy"
Brainwashed to think we
can only sing or play basketball.
While the others learn all
the intellect, and believe they are better than all...
"I see a conspiracy"

Lasonia Reed

MY SPIRIT SHALL BE RELEASED

These pigs want me to renege
and it may hurt to do dirt,
but I would rather not wrestle in the
mud.
So, so, happy to have ink and lead,
If I didn't,
I'd be writing down my thoughts
with my blood.

Round and round, that is how the
world goes.
Blocking the negativity with ease
when my eyes close.
Flying in the air,
bare without clothes,
my body might be exposed.
but my soul is enclosed
because it is hidden in the night;

In the dark it hides so right;
So right it hides in the night,
even the grim reaper doesn't know
where to look when it's my time to go.
My time, he will never know
cause I've already released my spirit
and it will go
where no man has gone before.

Jacob Lyons

Garden Haikus

1.
Two story building
Hard soil, grassy plain, empty
Historical land.

2.
Bumpy path, uncut
grass. Abandoned vacant lot.
Restore the beauty.

3.
Chopping down tall weeds
History in the making
Replaced with art and culture.

4.
Return beauty my
Englewood community
It takes unity.

Sheilina Stingley

DONE GOT OVER AT LAST

Tone the bell
Done got over
Tone the bell
Done got over
Tone the bell
Done got over at last

Plucked my soul from the gates of hell
Done got over
From the gates of hell
Done got over
From the gates of hell
Done got over
Done got over at last

My Jesus glad, old Satan mad
Done got over
Old Satan mad
Done got over
Old Satan mad
Done got over
Done got over at last

Kevin French

FOLLOW YOUR DREAMS...

Follow your dream
wherever it leads–
Don't be distracted
by less worthy needs...

Shelter it, nourish it
help it to grow
Let your heart hold it
down deep
where dreams go.

Follow you dream
pursue it with haste:
Life is too precious,
too fleeting to waste...

Be faithful, be loyal
then all your life through
the dream that you follow
will keep coming true.

Antonio Baskin

WAS IT YOU?

Was it you?
Staring in through my window pane?

Was it you?
Whistling with the wind in the cold rain?

Was it you?
Thriving off my good looks?

Was it you?
A call of my name would have been all it took.

Well, I don't know
because I got up
and closed my shade.

Antoinette Wiley

Idle Man's Hands: A Lament

Oftentimes
I get so bored
that I watch my nails grow
and grow.
I become fascinated
by the calluses
on my knuckles
which I received
from the punches I've thrown
in backrooms
of seedy bars
and intersections
of city streets.
I stare at the wound
on the palm of my left hand
It reminds me
of men who have pushed me
onto glass-laden ground.
As I lick the scar,
I gaze at my disproportionately long thumb
I gaze at my long, fat middle finger
I gaze a the old, tin ring on my ring finger
with a (rusted) heart on it
I gaze at the fingerprints on my pinky
I gaze at the stump where my index finger used to be
a single adolescent firecracker wrecked my hopes
of playing guitar and writing songs
I savor the salty taste of my open flesh as I move my hand
away from my face
remembering

when I once picked up a gun
and shot a man
to death.
So here I sit
in this jail cell
staring at my hands
watching my nails grow.

Onome Djere

THE BURGHERS OF CALAIS
(A poem inspired by a statue)

Alas, I think of things, I cannot reach. The peace
and tranquility of the rock. To see the mighty ocean
whirl and twirl with rhythm. One the rock of hope, the
rock of faith lies our destination. We pass the ocean
day by day wanderers of the unknown, trying to feel
the moment of the rock to be one with my still brother,
to feel its agony and its pain to go where the unknown
solstice of the cold winter moons. The cold winds blow
with the cry of a thousand souls to where they go no
one knows the pain and the sorrow on the plains of the
rock of the sea, the peace of the rock. Alas, the time
of the rock has come its time to be the only one, to its
worth we understand we will never find the common
land. Alas, I think.

Naya Smith

You Carried My Burdens
or
Ode to a Blankie

you were mine
from a very early age
soft and silky
checkered blue and white

you brought me sweet dreams
and took away my nightmares
comforting my sleep

you carried my burdens

as I grew
I slept less with you
instead, I put my clothes
my books and favorite toys, and
wrapped them up in you

till it seemed you were
bursting at the seams
I did this whenever

I threatened to run away
which was often

you carried my burdens

Later, you grew used to the comforts
of my closet
till I needed you again

you became a soft bed

to our new kitten
who is now a year old
and would rather tear
you to pieces
then lay down to sleep

you carried my burdens

One day, I will have a child
of my own,
and you will comfort her sleep
and take away her nightmares

and carry her burdens

Marijke Stoll

THE WEIGHT OF YOUR INDIFFERENCE

He who neither knows
Nor lays to heart
Another's wisdom
Is a useless weight.
 –Hesiod

I spoke to you in honesty
Spoke out of care
And you said nothing
As though silence were light.
So I didn't really feel mad
At the time,
But now I understand
The weight of your memories
The weight of your smile
And your words.
I feel as though
I've swallowed something
Much too heavy
And it has lodged itself
In my heart.
Not to say that
I deserve no blame–
Because I do,
But one does not wish
To incriminate themselves
And why take the time
To be angry at myself?

I know full well
What I said to you
Believing you could value my words
Perhaps they would inspire wisdom in you.
I said I did not expect to hear a reply.
I did not expect.
That is different from did not wish.
I have spent many days now

Trying to counsel you away from
That which brings you no pleasure
But your delays-
Your silences speak
Louder than your words.

The idea of you
 or
of us
Is too heavy a burden to carry.
You do not hear.
You do not feel–
Find no peace in my confessions
Though I'm sure it feels good to you.
Good to know that
No matter what you do
I will always care
Have concern
Worry.
But don't trouble yourself with the weight,
The burden it puts on my shoulders.

Understand
That these are not angry words,
Merely words of pain.
A distress that you put inside me.

I spoke to you in honesty.
Told you what I thought, felt,
What I knew to be true,
And you said nothing
As though silence were light
I understand the weight of your hands now.
I understand
The weight of your indifference.

Jennifer Clary

MUSIC LOVER

I need music. Poetry of sound.
I feel music, taste it in my mouth.
I love music and all that it is capable of saying–portraying,
in the quietest of comments issued through sobbing violins
or the loud blare of the silver tipped trumpet, piercing like
an arrow the space of time and substance with their ghost
like presence.
Audible phantoms haunting air-waves and brain-waves,
each note alive but for a second, killed softly by the next,
they form a chain of bodies that wrap around my body,
manipulating my muscles to contract and bend at their
mysterious whim.

Tap tap. Tap tap. These are my fingers striking against the
table in rhythm to the floating phantoms
Tap tap. Tap tap. Strange beings, never leave me. Never.

Michael Hamburg

Rainy Dayz

The acid filled drops may cause pain
the water washes away frustrations stress and a stew of
mess
though it may be in vain
because it always returns not the same
but changed
coming in a new form
a totally different storm
it seems to call
as it falls
filling up struggle gates
overflowing
drowning
showing
you can't swim
betta learn
cause your turn
is fast approaching
coasting
along as the sea of life swells behind you
and you find out it's not enough time to
reminisce and miss
all these points of bliss
you dismissed
through shear fear of being deemed an outcast
but alas,
how can you be cast out if you were never in
to begin?
With
a twist of fate

you became what they hate
much more successful than what they debate
about
at the beginning of the road you took a wrong route
to a land that was in drought
hoping and praying for the rain to
come again.
But while you wait all you do is complain
begging for some man with an unseen hand
to bring the showers
that make the flowers

grow
on this desolate plane
returning everything back sane
And when it comes
you succumb
to its rhythmic patterning
and splattering
of its drops on ground
it sounds in parts
like a heart
but, it is yours who will be broken every time
until you find
happiness when the sun shines.

Shon P. Harris

Everyday Images

PANTOUM

My momma be beating me
It be hurting
I be crying
Cause she be beating me

It be hurting
Don't want her to do it no more
Cause she be beating me
I be crying so bad

Don't want her to do it no more
If she do I going run away
I be crying so bad
She be making me mad

If she do I going run away
I be crying
She be making me mad
My momma be beating me

Rufus Jackson

FRIEND RITUAL

1. Begin by choosing a close friend
 and a meadow or empty field
 nearby your homes.

2. On a nice day walk to the area together.
 Sit in it and talk for a long while.

3. Now go take a 10-20 mile walk to an unknown
 or unimportant destination.

4. Don't stop if it rains.

5. Imagine the traveling is more important
 than the destination.

6. If enjoyment occurs your friend is truly close.

Kirkland Mack

DYING OF THE LIGHT
(Dedicated to Trystann L.E. Wright)

Six months ago you were healthy.
Six months ago you could see.

Then this thing. This disease came and
stole all the things that made you special.

Gone is your will, your strength and your vision.
We grieved for you. Cried tears that would
not bring back your sight. They could not make you
whole.

Now you sit in a corner closed off from the rest
of the world staring out the window, looking at what
I do not know.

Are you remembering your glory days?
Are you using your minds eyes to remember
the black clouds on a rainy day.

Or are you trying to picture mama's face —
remembering every detail,
The brown of her eyes, her silk hair?

Do you even remember what she looked like?

Like a flame on a candle you shone.
You lived.
But now that flame has been extinguished and
the light that you were is gone.

Dear little sister I can't give you back
what you've lost.

Your essence has been murdered.
Your light is gone.
And with it are gone your spirit and passion
your innocent curiosity. The light is gone.

Now you sit in a corner closed off from the
rest of the world closed off from me.
Staring out the window at what I
do not know.

Are you thinking about what once was there.

Onzsalique Ete' Ranil Wright

ETHNOGRAPHY
INTERVIEWING A FEMALE FRIEND, 17 YEARS OLD

near death experience... ok, it was October 4, 1993, when I got hit by a car I was 13 years old, it'll be 4 years this October my friends was across the street and I just needed to tell her about something....I waited for a car to pass going one direction, and I thought the other lane was clear, but the other car must have blocked my view....I remember just running, or starting to run and the next thing I remember was sitting in the middle of the street confused. It's like... taking a hard fall, your head is aching, and you really don't know what's going on. But my leg hurt, there was this strong throbbing, but I didn't realize what had happened. Luckily I was wearing jeans.... that way I couldn't see the bone sticking out from my skin.

I was so upset, they cut my clothes off of me. I remember it was fall and I had bought all these new clothes for school, and I was wearing an outfit I really liked. They just took scissors and cut everything off... I guess it was alright though, my jeans were ruined with blood anyway.... and my socks and shoes, well, shoe–how's that? when I was hit one shoe went flying off and landed on the sidewalk.

one thing I remember from this experience is you have to surrender your care to everyone else... all privacy of your body is surrendered. the nurse had to bathe me. Oh, and when you're on anesthesia you don't even feel like yourself.

I had to wait, like, 2 or 3 hours for the catscan, and they didn't give me any drugs, it was really bad. the pain was... excruciating, unbearable, my body had to deal with it and I kept blacking out from the pain. ...it felt like nothing else mattered, school work didn't matter, nothing.... it was just whether I would live or die, it's all that mattered right then.

my mother had been there when it happened, she only heard the noise and then turned to see... later she said to me "I bet you didn't hear me scream." we both cried.

I was on morphine for the first 24 hours after surgery. I would get a shot every 10 minutes but after 6 I could press this button and get an additional shot, but, man, after one minute I was pushing the button again for more even though I knew it wasn't coming. I'd just lie there pushing the button with my eyes closed slipping in and out of consciousness, waiting for the pain to go away.

I had a reaction to the drugs I was on, I was anemic with the flu and diarrhea for 3 weeks.... 3 weeks, I was so sick. I didn't eat anything, I was just alone in my living room, my stomach always hurt, I would lie there and just rub my stomach unable to focus on anything else. Sometimes it felt like I would never get better, even though I knew the worst was gone.... I was so sick. It was the only time in my life when I really thought that I'd rather die.

Eric Komosa

My Grandfather

A man I didn't even know
Until three years ago
He seemed like a nice man though
But was it just a show?
He cooked for us sometimes
He even gave me money
But was it just a bribe?
To make up for the time
He wasn't there
Like he didn't give a care.

It was last year that he got ill
Not getting better only worse until
He was gone...I love him still
Despite his flaws
Because
I'm sure that his actions had just cause
Nobody is perfect
And he was my grandfather
The father of my mother
Without him I wouldn't be here
At least I knew him for a few years
And my memories are good, not bad
Not in the least way sad
That is the way it should be
Why waste time on a bad memory?

Jennifer Weber

What I Heard

The bamming, shouting, and screaming
is what you try to ignore,
but the consistent fact of knowing
leads you to the door.
As you step out, you see a bottle on the floor.

As you go further on, you see more and more.
I opened the door and to my surprise.
I see a man's figure rise and rise.
I feel as if I will cry.
Breaking inside as if I'll die.

Noticing my mother and the pain she's in.
Looking to my father, thinking of doing a
great sin.
Running to the kitchen to get the weapon
you need.
But he beats the child back down, the child is
me.

My mother knew, if it was all she knew.
My mother knew, what I was going to do.
As he left my mother quoted "Go ahead we
have no lack,"
from that day on he never came back.

Davonna Smith

Dirme Mama
Tell me Mama

Tell me Mama
Tell me where I was born
With whom I was conceived
Did you love him?
My Father?
Did he look like me?
High cheekbones?
Blue eyes?
Rosey cheeks– some which you do not
have?
Did he babble on and on about us?
Me and him?
The 4 months that he was my Father
Tell me Mama
Dirme Mama
She replies "your reflection tells all baby"
Did he
know me like I want to know him?
My Father?
"He was unable," She says– "Perhaps
unwilling."
–I am left with this distraught feeling
of not knowing my roots.

Eliza Browne

OVERCONFIDENCE

I am the student who is no longer a student
I have beaten all the cliffs that I have come across
I know everything
I can do everything
Without God
Without learning
I come to the first cliff I overcame
and smile bravely
I knew this cliff
I could climb this cliff
I know it's too easy for me
But just because I am so knowledgeable,
I will give my mind a rest
and climb an easy cliff.

I walked back a few feet,
turned around,
and ran towards the edge of the cliff.
I jumped into the abyss
and started to fall downward.
I saw the branch I was supposed to grab onto
but I missed it.
And I fell towards the ground,
I hit the ground,
I died
Ignorant.

Heather Banas

A GOOD SIGN

Si pudera verte ahora.
(If I could only see you now)
What would I say?
What could I say?
Sometimes I forget
we speak two different
languages.
What if I could speak Spanish?
I know you love me in Spanish.
Have you passed or failed that test?
You wanting to meet my sister
Must be a good sign.
So you really must love me.
TU QUE SABES DE AMOR

Muneevah Askia

COURAGE

A 400 lb. man with no legs and terribly
scaly skin has no teeth or money.
He asks a woman for a date?
That's courage!
The woman is kind of normal and
has a beautiful smile. She tells the
man she will go out with him.
That's courage!
They go out. People taunt them and
stare coldly. They whisper things like
"How did he get her!?" or "Why would she
go out with a beast like that !?"
The couple still holds their heads high, and
they stay close together, throughout the date.
That's courage!
The man and woman stay together and
get married. They have sex.
That's courage!
They have a child. The child goes to school.
He is a normal child. His father takes him
to school for his first day. He offers
to let him go in by himself. The child
says "No! I want everyone to meet my
daddy!"
The child doesn't need courage.

Ayanna Maia Saulsberry

section four

The Stories Wrap
Themselves Around Me

HETEROSENSITIVITY
Paul Fitzgerald

Kathy and Mike met through mutual friends in the spring when school was old and life was mind-numbingly slow. She wanted love. He was looking for someone to share his boredom with. Mike had grown tired of watching his friend, Nick, smash old furniture in a dingy garage that reeked of cigarette smoke, dust, and gasoline fumes. After going out for a month, Mike and Kathy began whispering honest "I love you"s in each other's teenage ears. For Mike and Kathy, being in love meant having consistent concentration catastrophes due to day-long daydreams about each other. Mike had even stopped hanging around with Nick, just because Kathy didn't like him. Unfortunately, Mike was a typical teenage boy, with typical boy boredoms, fears, and concerns. Kathy was beautiful and great to him, but for some reason his love for her began to grow cold. Perhaps he was just selfish, but he had taken a liking to his friend Mari, who openly held the same feelings for him.

It was three months after their first date when Mike decided to break up with Kathy. She came to his house at eleven-thirty in the morning. She wore wrinkled woven trousers that were grey with assorted, unwashed stains on them and a brown UPS polo shirt. Her stringy brown hair was parted down the middle and pushed behind her thrice pierced ears. Mike opened the door to his small one floor house and smiled uneasily.

"Hello beautiful," Kathy said. She was excited to see him, but she was putting on a bit of an act. Her parents had just gotten through a messy divorce. They couldn't decide who would take Kathy, so she ended up living with her Grandma. Kathy's Grandma was a vital old woman with strong religious beliefs. She seemed to view Kathy as the annoying mistake of her irresponsible son. Kathy continued her act of ignoring her sadness and enthusiastically kissed Mike. He pulled away.

"Oh...hi." Mike whispered. Kathy picked up on his transparent emotions immediately.

"What's wrong?" She asked as Mike's eyes darted around his small, plain, living room. They looked everywhere, except at her.

"Oh...nothing really." Mike replied uneasily. He still wasn't totally sure of how he would do this. He wanted to say that he wasn't comfortable with their relationship anymore and that they

should just be friends. Now that Kathy was with him, he wasn't sure if he could say that. He didn't want to see her hurt.

"What's wrong?" Kathy repeated as she took both his hands. Lines began forming on her freckled forehead. Suddenly, Mike wasn't sure if he really wanted to go through with this, but for some reason he felt he had to. It was as though something was driving him to end this relationship.

"Well..." Mike gulped "I...I don't think we should see each other anymore." Kathy dropped his hands quickly as though she had just realized that they were infected. Her eyes widened in disbelief. "It's not that I don't like you. I mean, you're great. It's just..."

"Why? Why don't you love me? Why am I not good enough for you?" Kathy asked breathlessly. Her eyes began filling with tears. Mike shuddered when he saw that Kathy was about to cry.

"It's just..." Mike panicked as he struggled for an idea, a phrase, anything that would make her feel okay and not cry. " I'm gay... I can't I can't go out with you anymore." He said it just as fast as he could think of it. Kathy looked up and wiped her eyes with her slim hands. They just stared at each other for a while.

"Wow." Kathy said quietly. "I had no idea. When did you realize this?"

"I don't know. I guess it just kinda happened."

"We can still be friends, right?"

"Uh...yeah sure we can still be friends." Mike already knew he had made a big mistake. He considered telling Kathy the truth, but he just couldn't stand to see her cry because of his own selfishness.

"Well...I guess I should be going. I... have a dentist's appointment... I'm sorry things won't be the same, but...just call if you need anything...Thanks...for being so honest with me." Kathy said as she tried to offer a slight smile. Mike just looked away out of guilt. She gave him a weak hug and walked out of the door yelling "Call me!" as the door slammed.

"Shit." Mike thought. "Why did I get myself into this?" He remembered when he first met Kathy how he had really enjoyed being with her. He remembered when she first said "I love you" to him and how he had thought he felt the same, but eventually he realized how totally incapable he was of loving her the same way she loved him. It was as though nothing affected him. He was a robot. He didn't want to feel this way and he didn't know why he did. Mike wanted to love Kathy every bit as much as she loved him, but for some reason he never felt comfortable with the idea of love. As he

sorted through his absent emotions he started hanging out with Mari.

Mari was a light-skinned Mexican girl who Mike had met at a party. She had short black hair, and big brown eyes. Mari was funny, pretty, and above all honest, but unfortunately she was always getting screwed over by her boyfriends. The more Mike started hanging out with Mari, the more confused he was about his relationship with Kathy. Mike and Mari's relationship changed dramatically after walking home from a friends house one night in June....

As Mike and Mari walked down the street together, Mari talked about how her boyfriend had given her the old "Let's just be friends" line and the next day asked her best friend out in front of her.

"Right in front of me! Can you believe that fucker!" Mari yelled. Mike consoled her, telling her she was too good for him anyway, and how she just has to move on with her life (all the usual cliches). Then she said it. She stopped and looked right into Mike's hollow eyes. "Mike, I think we would be perfect together. I don't mean to ruin your relationship with Kathy or anything, but I really care about you." Mike felt like he should talk her out of it, but he knew he couldn't, mostly because he felt the same way. He didn't want to break up with Kathy, though, so he figured that he would wait until that relationship was over before he did anything with Mari. Waiting was okay for Mike, but after about a month, he got impatient.

Mike considered his options. He could tell Kathy the truth, hurt her feelings, and see what happened. His second choice was to call up Mari, tell her what happened and see what developed. If Kathy found out, he could say that he is still unsure of himself, but by then she would probably be over him anyway. Mike decided to go with his second option. He picked up the receiver and dialed Mari's number.

"Hello?"

"Hi, is Mari home?"

"Yeah one second." Mike waited as whoever picked up the phone screamed for Mari to get it.

"Got it. Hello."

After a pause, Mike whispered his own "Hello." It was starting to dawn on him that this just might be a bad idea, but he blocked it out of his mind and cleared his throat.

"Hi Mari...How's everything going?"

"Alright...Is something wrong?"

"Not really."

"Bullshit. I know something's wrong." It was like Mari could read his mind sometimes. Mike finally answered the question honestly. He told Mari everything that happened. How he always felt uneasy about the whole love thing, how he lied, everything. He ended his account of what happened by confidently saying. "So you see. Everything is alright now, we can go out." There was not more than a second of uneasy silence.

"YOU PRICK!!!! HOW COULD YOU DO SOMETHING LIKE THAT!?!?" Mari calmed down a little. "Kathy loves you and you treat her like that. Oh and what am I your LITTLE NON-COMMITTAL SLUT WHO WILL TAKE YOU NO MATTER WHAT A PIECE OF DIS-HONEST SHIT YOU ARE?! GO TO HELL!! I DON'T WANNA SEE YOU AGAIN!"

"But–"

CLICK! Mari slammed the receiver down so hard the sound of it made Mike's ears ring.

"Dammit." Mike said to himself. He couldn't help, but feel a sense of loss. He had ruined two relationships with a lie he made in an attempt to save them both.

Bleeee...... Mike's electric phone rang. Maybe Mari had reconsidered. Mike answered the phone with an uneasy "Hello."

"Hi Mike, it's Kathy." She sounded surprisingly happy.

"Ummm...Hi." Mike decided that it was time to tell the truth and bring whatever pain he deserved. "I-" Kathy interrupted him.

"Mike, come over right away. I have a surprise for you."

"but–"

"Just come over." Kathy hung up.

"Oh well...Maybe this would be better to do in person any-way." Mike thought. He really would have rather done this over the phone, but he was trying to convince himself that he still had some dignity.

As Mike walked to Kathy's house he wondered what could be so important. He hoped she hadn't told anybody about what hap-pened, but he wasn't very worried about it. Kathy was trustworthy. Mike arrived at Kathy's house twenty minutes later. He walked up the steps to her porch and rang the bell. Kathy opened the door.

"Mike, I was afraid you wouldn't show up." Kathy said as she hugged him. She was trying to act like she was happy again, but this time she was trying way too hard and it was obvious that she was actually quite sad. Mike slipped out of her hug.

"You...wanted to see me?" Mike said. He was so nervous his leg was shaking.

"Yeah. Come in." She led Mike in by the hand. "I just wanted to introduce you to my cousin Jay." She said as she led Mike into her bedroom. Kathy's bedroom was plain, but relatively large and well lit. The walls were all bare due to Grandma's rules. Inside was a tall, skinny boy who looked about seventeen. Jay had light brown hair that tumbled naturally over his eyes. He wore long jean shorts that seemed to be covered in a layer of dirt. Jay was laying across Kathy's bed reading a magazine. He looked up for a moment and nodded a "Hello." Mike also nodded and looked at Kathy with a confused expression on his face. Kathy grabbed Mike by the arm and pulled him out of the room.

"So...what do you think?" Kathy asked.

"About what, him?" Mike asked.

Kathy nodded. "I don't know. Why were you so excited for me to meet him?"

"Well...I thought about what you told me earlier.... Jay came out about a year ago and I thought that maybe he could help you out. Maybe you two would have some things in common."

"Wait a second, are you trying to set me up with your cousin?!? We just broke up!!"

"Oh, I'm sorry." Kathy said sincerely. "I understand if you're not ready for a relationship or whatever. I'm really sorry...I didn't even tell him. I just wanted to help."

Mike decided that it was finally time to be honest. "Well...actually...you see...I think we need to talk about what happened earlier."

The phone broke Mike's sentence off.

"Hold on a second, Mike. I think that's my Mom." Kathy quickly said as she ran to get the phone. Mike thought about how he would tell Kathy the truth. He knew that he couldn't lie anymore because everything would just get more screwed up and confusing. He also couldn't sugar coat it. This was too big a lie to make it sound like it was a minor misunderstanding. Mike had just resolved what he would say when Kathy walked in the room and sat down on the floor.

"That was Mari, who just called." Kathy said quietly, staring at the floor.

"I...I'm sorry. I just didn't want to hurt you." Mike said in the most sincere, apologetic voice he could muster.

"Sorry." Kathy said, still looking at the floor. "You

don't really give a shit about me. If you did, you wouldn't have lied."
Kathy began crying. "In fact" she sobbed "you never really cared. I
loved you! Why wasn't that enough for you. It's even alright that
you DIDN'T love me, but why didn't you just tell me?"

Jay walked in the room, curiously looking at the couple.
"How stupid do you think I am?" Kathy continued. "Of course you
don't love me, you don't even RESPECT ME. YOU ASSHOLE! HOW
SELFISH CAN YOU BE !?! GET THE HELL OUT OF MY HOUSE!"
Kathy began crying hysterically. Mike turned around quickly and
walked out. As he walked down her porch steps he heard the door
slam. She yelled something that he couldn't quite understand. He
looked back and saw her through the front room window. She was
hugging Jay and crying. It didn't matter, though he couldn't walk
back there and try leaving on a good note. Mike had permanently
ruined his relationship with Kathy. He knew she had to be alone
and probably wouldn't want to talk to him for at least a couple of
weeks. Even after that, it probably wouldn't be friendly conversa-
tion. With nothing left to do, Mike walked to his old friend Nick's
house. He once tried to escape from Nick and do something more
interesting than sit around and watch Nick smash things in his
dingy garage, but now Mike was left with nothing else to do.

An excerpt from

TRANSVERSUS
Gina Holechko

"Wise, Rune. Be careful, I want you both back in one piece," the boys' father commanded, his red molecules beginning to take faint humanoid form. "We love you!" their mother said, as her bright meringue molecules started to take humanoid form as well. Wise's and Rune's parents began to descend toward the nearby orange planet, while the two brother's molecules folded faster toward the distant solar system.

Then, as if someone was answering his very thoughts, the tumultuous winds slowly subsided. The volcanic dust waved gently like a calm sea with feminine curves past him. Up and down and up and down and up and down until there was stillness.
"Well, that helped," he said. Wise still couldn't focus through the dense ash. The flowing heat was the most discernable object.
Wise looked down at his boots, they were sizzling with every other step. This area wasn't going to be stable much longer. Suddenly, the ground gave way under his left foot. His foot was almost submerged in the orange heat. Wise was bemused for a moment, and then was curious to see the substance more up close. Wise's conscience pulled him back for a moment. No, he thought, I might be affecting the environment, but not even realize it.
The orange heat gurgled and bubbled, enticing Wise to touch the heat. It was so pleasing to the eye. There was hardly any heat on Quaza. Most of the planet's surface was cold. Except for a small tropical region, the planet's crust was based on large frozen glaciers, which had consolidated over millions of years. The Southern most parts of Quaza received the majority of their water from the melting glaciers in the north. The Quaza suns were unusual. One was much larger and closer to the planet's surface, while the other was smaller, and more distant.
After Quaza civilizations had begun to develop, other materials masked the true nature of Quaza's crust, but not the climate. It snowed often in the upper hemisphere, and rained heavily in the warm season, which was short. Wise lived in this hemisphere.
Now, as Wise bent over to study the heat closer, he wondered how much heat it would take to melt his planet into nothing. He

power of Transversus, which realistically would save everyone any-way.

Wise dangled his silver fingers above the orange heat. A gust of heat flowed to Wise fingers as he jerked them away. Wise couldn't touch the heat. He realized then that the only way to master the smallest things on the planet was to use Transversus.

The word "forbidden" seemed to pass across his lips. The search was now just futile. The storm was coming back. Wise saw the ash surrounding him start to wind toward one point near the origin of the great orange heat. The wind rose fast against his back, battling him around, and pushing him forward. Wise squinted his eyes. His long hair shielded his vision. As the ash was continuing to be sucked toward the point, it formed a conical of some sort, almost like a vertical tunnel. It rotated faster, yet it looked as if it was shrinking.

Then a curtain was dropped. Wise's brother, Rune appeared next to the rotating form, indicating it with triumph. Smugly smil-ing with his short cropped frenzied hair, Rune, undisturbed by the winds, floated just as gracefully as the form.

Rune chuckled at Wise's fate, but Wise could hear nothing over the din of the rushing winds. Now, the ash surrounding him was almost gone, and the tunnel like form became smaller, smaller, and smaller until the rotating of the form was just barely visible and its miniature containment seemed to want to break open. Wise looked in amazement as his brother disappeared, and the form exploded hurling him backwards toward the ground.

REPORTS OF HER DEATH . . .
Matthew Dunn

Jean threatened to kill herself on Monday. Shannon, her best friend, my sister, wrote about it on Tuesday, for a writing apprenticeship program we're both involved in. She wrote "I think she died today/ and I cried, for my best friend/ who's only option is suicide." Will, Jean's boyfriend, my best friend, spent Tuesday night crying. On Wednesday my sister and I went to work.

The elevator trip to the fifth floor of the Chicago Cultural Center is notoriously long and the offices there are notoriously cold. Especially during July. The monolith marble pillars and walls of windows seem bent on a permanent chill. That July was cold enough outside. Shannon turned to join the poetry group she was enrolled in. I wrapped myself in a sweatshirt I'd gotten for my birthday and crawled into a corner to work on a story that had been giving me trouble.

I put the pen to paper, took a deep breath, shifted positions a little, moved the pen to a corner, started a doodle. Damn, I thought, still nothing. Then I started writing. I scribbled line after line across the oversized pages our teachers had given us for journals. I wrote about Jean, about her long, brown hair. It was smooth and straight, like a peaceful ocean the day after a difficult break-up. She had a drug habit; shrooms, and acid and all the soft stuff she could get her hands on. Her parents were abusive, negligent pricks. She was drawn out; running down from head to toe a little longer and a little thinner than expected. Her head and limbs dangled from her shoulders like an exhausted marionette's, or washed-out ink. She smoked Camel Straights, or at least Wides. She held them with three fingers like a robot.

I found myself writing in the past tense and I thrust the journal away. There had to be something else to write about.

A few hours later I was called into the hall to talk to Lou, one of my "Teaching Assistants." He was my only superior who I felt at all close to. That was obviously why he was picked to talk to me. It was like I've seen in all the movies, where someone has to "break the news." The hallway was more like the top of a vast stairwell or a

trailed badly into the new-age too-white drywall. Every surface seemed too far away. I was frightened more by this than ever before.

"There's some bad news . . . your friend Jean committed suicide." It was not a surprise. It seemed to me like those words had been on every tongue around me for the last two days. It was bound to happen and when it did, anyone at all, a stranger on the street, one of my parents, could turn around, or stop in the middle of a conversation and say "Oh, Bob, um, Jean's dead."

"Do Shannon and Will know?" I asked.

"Shannon's talking to one of her teacher's right now. They're in the stairway. Who's Will? is that your friend who was here? I don't know about him."

"Okay."

"You wanna go for a walk? We're gonna go to the park and talk a little, okay?"

"Yeah, sure. You're going to have to tell a few other people in the program. There's a lot of kids from Whitney Young here."

As we went to find Shannon I could feel everything in me sink to my feet. My legs became heavy and numb. My breathing seemed odd, but there were no emotions, as if my reaction to Jean's death was purely physical.

On the way to the park we ran into Chris, a colleague, on cigarette break. Chris was tall, strong and aggressive but as amiable a teddy bear-punk as I'll ever meet. He was a friend from school and knew Jean better than I did. It didn't take long for him to notice the three forlorn faces (Shannon, Lou, and myself) that ambled by the steps of the Cultural Center.

"Hey, where you guys going?" he said quietly. We all turned slowly to look at him. I could see him shrink away, afraid of the news he didn't want to hear. The news we didn't want to tell.

"We're gonna go sit in the park for a little while. Shannon and Bob have a friend who, um, killed herself, earlier. So, ah . . . hrmph" said Lou.

"Wh-wait a minute. What? Who?"

"Jean's dead, Chris." I muttered.

"WHAT?!" He was loud. He was angry. He was hurt, and the pain would hit him hard later, but for now he was angry.

"Jean's dead!" I couldn't say anything else. I couldn't think anything else. I tried to figure out the implications, the repercussions, the emotions that were rolling through my nervous system like a bulldozer on speed; but all that came to me was "Jean's dead."

Finally I managed to force out the words "You can come to

the park with us if you want." I knew that Lou and the teaching staff didn't want to interrupt classes or end up with all of Jean's friends out of work and in the park, but I also knew that they couldn't be angry with me, so I invited Chris.

"When did this happen? How do we know? Where is she now?" he questioned.

"I don't know." I said, blinking at the red light across the street. "I haven't asked. You're as informed as I am." We turned to Lou.

"I was just asked to tell Bob and maybe come talk to you guys, y'know. I don't have any details." he said. His brooding eyebrows hung lower than ever and his lips stretched in protruding consternation. He had a chipped tooth and slightly outlandish sunglasses to match his funk/hip-hop outfit. It may have been intimidating at first, but the candor he held and the meditative comfort that surrounded him were reassuring. I thought about how fortunate I was to have people like him and Chris at times like this; how fortunate I had been before to have Jean.

The light changed and we made it half-way across the street, when we noticed the southbound traffic that seemed intent on hitting us.

"Last I remember Michigan Ave. went that-a-way," said Lou comically. The surprise of the traffic and Lou's delivery were almost worth smiling about. He was trying to cheer us up and it was almost working for me, but I don't think that Shannon even heard him.

We finally made it to the park and found a bench overlooking the fountain and the Metra rails.

We talked for a while about whatever we could, it didn't feel good, but somehow we knew that things could be worse. A man walked by in full sequin sport-coat and we complimented him on it. He smiled like we'd made his day.

"Well," Lou said, "We have to go in. Shannon, do you feel like maybe going home or something? You could hang around here, wait for your friends outside, until they get out. That's about two hours. What do you feel like."

"I'm still not sure she's dead." said Shannon. At first I thought that she was just holding on irrationally, that she wouldn't accept Jean's death until she saw her body or something. Then I figured that maybe she knew something about the way we got our information that could give me a piece of hope.

"God, if she's still alive I will feel really stupid, but I hope to god that I end up feeling really stupid." Chris toyed with a Swiss

Army knife.

Lou said, "Why don't you hang around here, make some calls, get something to eat, and we can talk when everybody gets out, okay?"

"I'll give you Jenny's number. She might know something." said Chris.

"Okay."

"Alright. We'll see you in a little bit then. Take care of yourself, alright? Feel free to come talk to me or any of the teachers if you need to."

"Okay, thanks."

Chris and I went back to work. I didn't tell anyone about Jean. I thought that the teacher/bosses could probably handle it better and I didn't want to start any kind of scene. I sat down and started writing:

'I know that the white streak I saw rising into the sky was not Jean's soul, but I stared at it until it disappeared, and I smiled to it, and I said my goodbyes, and when it did vanish something inside of me had changed.'

It came time to punch out and I stood anxiously in line behind Chris. I put an arm around him and hoped against hope that Shannon's disbelief was justified. "I hope that I feel really, really stupid in a couple of minutes." I said.

"Yeah . . . me too."

The trip down to the first floor of the Chicago Cultural Center is notoriously long. It is considerably longer than the trip up to the fifth floor. The ride to the first floor that Wednesday in July was about as long as anything else has ever been. The ancient elevator lumbered down floor by excruciating floor. The aged brass plating cast distorted reflections of the next five minutes in the backs of my eyes. I saw Jean, waiting out front with a smile. I saw Shannon bent over the curb in a pool of tears. The little light that was shaped like a "5" went out and then the "4" went on. I fiddled with something in my pocket. Three. I tried to squelch my hopes for Jean's return. Two. Hearing that she was not safe and sound would be just as bad as the first time. One. Oh please, God, let her be there. The doors opened.

I was one of the first people outside that day, only a few others from the program dotted the sidewalk outside of the old library. I looked for Shannon. A few others came out of the building. I looked some more. I was about to check around the southeast corner when

Shannon popped out from the southwest one. I paused and looked at her pleadingly. There was a low buzzing sound in my ears. Michigan Avenue jackhammers pounded out the seconds as Shannon came closer. I looked but her expression revealed nothing. It was as much the strain of the situation as my fears about Jean that made my eyes become moist at the edges.

"Jean's ok. She's around the corner."

As it turned out Shannon's poem about Jean's supposed suicide was misinterpreted by one of her teachers. Thinking that Shannon's best friend was dead and that the staff should offer whatever help they could to her and hers she informed the other teachers, apparently in a rather vague way. The other teachers thought they had received new information that Shannon and I were not aware of and decided that one of them should tell us that our friend was dead. Thankfully, to adopt a popular quote, reports of her death were greatly exaggerated.

FACING DADDY

Sheryl Lynn Bacon

My father had a heart attack. Now my mother makes me stand here and look at him lying pitifully in that stark white hospital bed. She's blubbering like an idiot. She still loves him. I, on the other hand, have no feelings for this man. I know that sounds cold, but the last 13 years of my life have been filled with verbal and emotional abuse, and it's been a little hard to deal with. Twelve, I could've handled, but that last year was just too much.

I wanted to tell him that it served him right, but I just couldn't bring myself to be that cruel. I also wanted to ask my mother how she could stand there crying over a man who left her with three kids and a huge stack of bills so that he could be with another woman. But I couldn't.

She leaves the room to get coffee, and I am left alone with him. There's so much to be said, but he can't hear me. Or can he? "You know I'm giving up my fourth of July morning to come see you," is all I muster. The beeping and clicking of the monitor is the only response I get. I look at his hands, hands that used to carry me, hold my bike steady, and reassure me when I was scared. Then I looked at his lips, lips that used to kiss me goodnight, call me "Smunch," and tell me I was his baby. They were lips and hands that soon turned cold and hateful, and made me feel very ashamed. This man lying here was my father, but I missed my Daddy.

I should've been like my brother and just blatantly refused to come, because now I'm getting sad. But I won't cry. I refuse to cry. Mommy comes back. She says, "Skip the coffee, let's just leave." I think that's a good idea, since that damn "Butterfly Kisses" song is starting to play in my head.

I want to tell him "I hate you," and walk away forever, but instead I lean down and kiss his forehead. "See you later, Daddy," comes from within me somewhere, but I don't know where. As I go to leave, I brush my hand inside of his. He squeezes it gently, but doesn't open his eyes. I snatch my hand away quickly, and go watch the fireworks.

AN EXCERPT FROM

ABEN

Bryson Clark

Driving my red hatchback, I came to a "T" intersection. Turning left, I pulled onto the road headed for Mystic, Connecticut. Driving down the black asphalt, I saw a small donkey. I had never seen a donkey before, it could have been a mule, but it looked like a donkey. Strapped across its back was a florescent green bag. It was walking on the slightly raised walkway to my right. I was so intrigued by the sight of a lone donkey, ambling along the side of the road, that I decided to pull off the way and follow it.

I walked next to the donkey who took no notice of me. It had a scraggly gray snout, and nostrils that flared large and black as it breathed. The donkey began to stray off the walkway, towards a narrow path, cutting up a steep hill. I followed it. A short while later, the donkey and I came upon a blue house. The donkey turned towards the porch of this house. A dog was skulking around the perimeter. Black and rusty coated, it had the girth of a Rottweiler and the thin head of a Doberman, with shaggy fur. The effect was comical as it meandered towards me at a dangerous, cocky pace. I climbed onto the back of the donkey, which kept on striding calmly along. When it had reached the porch, it climbed up three worn steps and then turned sideways. There it stood, as I sat on its back, keeping an eye on the Dober-Weiler, which had sprawled out on a patch of weeds in front of the porch.

Several minutes passed before the screen door swung open, and an old man walked out. He was skinny, except for a round belly, which made him walk back on his heels. He was deeply tanned, and his wrinkled face feature a stark, white beard, jutting arrogantly off his chin. His nose was pointy and down-turned. He wore a green hat, with netting on the back of it, and a totally flat brim.

"Hey Gorman" he managed, his restrained voice carrying down to the dog, which went around to a ramp on the side of the house. The old man set down a bowl. Gorman set to it, fortifying his already impressive girth. I got down from the donkey and began to apologize to the old man, who shook his head. " s'alright son. I know how it is. Why don't you come in for a meal."

Aben gave his guest a tour of his home.

I'm quite fond of it." Here he offered me some baked beans which were on the stove. "Thanks, that'd be nice." Except for the exchanging of names, we ate in silence. The old man went by Aben. He used to be Matthew, but he didn't think that sounded old enough now, so he changed his name. After the meal, Aben showed me around outside. In the back was a large meadow, with several holes scattered around the perimeter. Around the side of the house was an old, rusted donkey trailer. The donkey was named Horace. It seemed that Aben had a taste for atomic fireballs, so he trained Horace to walk down to the seaport, to a little store. The proprietor then loaded the green pack with the cinnamon candy, and Horace came back.

We walked around to the other side of the house, Aben smiled and pointed out 40 cages. Lining the fence were rabbit cages, made of wood and chicken wire. "These are my family." As I looked at the rabbits, one caught my eye. This rabbit was vermilion, bright orange with some red in it. I couldn't believe the color. "That there is Ruben." I wanted to pick him up, but Aben vetoed that. "Wouldn't let you, he's too proud."

As we went back inside, Aben began to tell me about his past. He had worked on the family farm in Iowa as a boy. They had always had rabbits, some to sell, and some to eat. As Aben grew older, he noticed that the rabbits were wary of him whenever he wore red. They watched him carefully, whenever he came near. As he took over the farm from his father, he began attempting to breed reddish rabbits. He started with one slightly roan male. After many years, Aben moved out to Connecticut with his rabbits. Finally, the 42nd generation produced a bright orange rabbit who he named Ruben, which is Latin for red. Ruben became the dominant male among the other rabbits, because of his size and color. Rabbits aren't known for a hierarchal society, but Ruben was bred for aggressiveness and size. He became a leader of sorts.

The animals were Aben's only friends. He had no family left, except for relatives in Canada, and he wanted the rabbits to be able to survive on their own after his death.

After gaining this much information from the old man, he offered me a job in exchange for room and board. Being a wandering young man, I accepted. The old man and his animals intrigued me.

My duties were thus. I was to feed Horace, Gorman and the rabbits. Also I tended a vegetable garden at the back of the rabbit land. This was dominated by cabbage and cherry tomatoes, which came up every year.

My first week, I slept in the guest room and read at night. I was reading about Mendel and his genetic experiments. During the day I cared for the rabbits, and worked mostly in the garden. It was a plot about 100 by 100 feet big. Aben was too old to do much work on it, and it was tough going. The rabbits had begun stockpiling vegetables in the tunnels, but the back of the garden was, for the most part, untouched. I tried to pick some of these vegetables and pile them by the tunnels, but the rabbits smelled human, and wouldn't touch them. The old man ended up making a vegetable broth from them, and I had to force that down for a week.

After two weeks, the weather started to turn. It was September and a chill blew in from the lake, which was about a half a mile west. The leaves started to fall in dry bunches. I took Horace on walks some days, and stopped to talk to an aging man who lived down the road. He was outside, working on a green MG. It was a nice car, small and fast. I drove into Mystic once in the hatchback, to pick up tools, and some things for Horace.

One day, Aben told me to let out the rabbits. I opened the cages, but most sat inside, leaning against the heating coils for warmth. Then I opened up Ruben's cage. He came out and started towards the tunnels. Eventually the other rabbits followed. They all went down below.

That night, Aben and I stayed up late into the night, thinking. We hadn't seen Ruben with the other male rabbits. Aben thought they were mating. Only Ruben was allowed to mate. When it had gotten too cold, they came back up. I listened to the old man, but I wasn't so sure. I told him about the camera. He agreed to try it out tomorrow.

I strapped the camera onto one of the female rabbits. Aben stayed in the house and watched the monitor. As the rabbits went in, I heard a yell from the house. "You idiot!" he screamed. "What about light?! It's too dark down there!" His voice was impossibly loud. Once he stopped restraining his voice, it boomed. Half-deaf, I apologized and went inside. Later that day, when my hearing had returned, I went back out. Aben was in his beach chair, watching the rabbits. They now had started going to the trailer to get hay. Some of the females had come out; it seemed that Ruben was done with them. I showed Aben a light I had made for the camera, but he didn't talk. At dusk, I let the rabbits back into the cages.

By now, it was very cold outside. The wind snapped the trees around, and the lights in the house wavered, as electricity was

funneled out to the trailer and the rabbit cages. Aben had me clean
out the flue to the fireplace. In the evenings we watched the fire,
and Aben read from Homer. He had studied Homeric Greek in his
youth, and he read from his half-done translation of the Odyssey. It
was a bit confusing, but the old man was proud to read it. At night,
his voice came out stronger, and it had a startling effect. I was
always wide awake when he read.

It was now October. Dull leaves rested on the cages, and
clung to everything. The sky was very high up, and gray.

One morning it was warmer, and we decided to let the rab-
bits out. We put the camera on one of the females, and watched
them lope into the tunnels. This time we both watched on the mon-
itor, inside. The rabbits had expanded the tunnels, and hay was
packed along the sides of the entrances, and some of the hollows or
rooms inside. A large quantity of vegetables filled one of the hollows.

That evening, the rabbits did not come out at night. Aben
was ecstatic, and he told me that he had finished translating the
Odyssey. We read by the fire that night, Aben in a green wool
sweater, the dog sleeping on his ratty blue bed pillow. I listened
intently as Odysseus made the trek home. The old man's translation
was getting better, and he had even begun to experiment with new
words.

The next day, I awoke to find Aben watching the rabbits.
They were all harvesting vegetables hurriedly from the garden. Aben
had been awake early, and he had seen the communal sleeping area
on the monitor. He wanted the camera removed from the rabbit,
who was beginning to get ostracized by the others for smelling so
strongly of man. Horace had been sent into town again, this time
for fresh lobster, as well as atomic fireball candy. It was Aben's
birthday, and I spent the day baking a carrot cake for the occasion.
We ate the lobster, and Aben was thrilled with the fishing rod I had
gotten him. The cake was a little dry, but we ate it anyway.

The next day, I awoke to find that Gorman had killed one of
the rabbits. He had left it on the steps, and Aben found it when he
got the paper in the morning. We made stew from it, with a few left
over vegetables scoured from the garden. A storm was coming down
off the coast, and Aben was a little worried. The rabbits stayed in the
tunnels all day, frightened by the storm, and perhaps mourning for
their fallen member. Aben had me set out rabbit pellets by one of
the tunnel entrances, worried that the vegetables wouldn't be
enough.

The storm came during the night. I slept through it, but

Aben did not. We surveyed the damage in the morning. The garden had been ravaged. Many of the tomato plants had been completely torn away. A tree had fallen in the yard, partly collapsing one of the rabbit tunnels. The rabbits had already filled the opening with hay.

Next, we went down to the neighbors' place. The power lines were down, but the neighbors were in Florida, so this was not a big problem. In the back of their house, many of the older trees had fallen in the storm. The result was a child's paradise. Long trunks criss-crossed to form an enormous jungle gym of branches, leaves and splintered wood. The old man and I spent two days cutting up the wood. We stored most of it under the deck of the neighbors house. The rest we took back to Aben's, for firewood.

The rabbits had taken the pellets. The camera had been gnawed off, and the monitor screen soon went blank. We used candles at night until the power came back on. Aben had a small generator to power the heater in Horace's trailer. The rabbits no longer needed heated cages, being tucked away in the tunnels.

I told Aben I was leaving in mid-October. I was going to Chicago to try and find work. I was going to attend grad school for journalism, hopefully at Northwestern. Aben said he was starting on a translation of the Iliad. I promised to come back in the spring, to work on the garden.

An excerpt from

PEACE - No More!

Jonathan Farr

No one trusted the peace, so on March 19, 2025 the three remaining world powers, The North American Alliance, a remnant of the United States, Canada and Mexico, the New Russian Republic and the Chinese Republic joined forces to form the WNSA, the World National Security Agency. The WNSA decreed that all remaining nuclear weapons be destroyed.

For twenty years the WNSA kept peace, real peace, not even a tribal scrimmage, the longest period of total world peace ever recorded. They kept the peace with PASS, Peaceful Alliance Satellite System, a satellite system, capable of destroying an entire city. PASS, project name MCS 75, could be used against any group who tried to destroy the peace.

In section 237, formerly Bay St. Louis, Mississippi, a group of terrorists prepared the final stages of PASS' takeover. Housed in the old NASA National Space Technology Laboratory, a facility that had long been abandoned. Unlike the better-known Johnson Space Center and the Kennedy Space Center, Bay Lab was not obliterated, but suffered comparably minimal damage except for the radiation. Everyone thought it was uninhabitable and foolhardy to go near the place, but somehow the terrorists managed to neutralize the radiation and quietly took over the center.

A more unlikely alliance could not have been conceived because each of the terrorists would willingly slit each other's throat if it had not been for their common hatred–peace.

There was Franklin Horrowicz, a computer hacker since he was seven who knew computers better than he knew people and preferred their company anyway. Part of a bi-product of Pass' peace was the mutual sharing by all nations of all computer technology. The millions of dollars once available could no longer be made by hackers of Horrowicz' caliber. War would make him a highly demanded commodity.

The weapons specialist was Turk. No one knew if he had a last name, and since he never offered one, no one cared enough to bother to ask. He knew every killing machine known to man and was a connoisseur of the ancient knives and guns capable of giving its wielder intimate pleasure as he took his victim's life. He also knew the most lethal modern weaponry and in his warehouses

strategically located around the globe were an impressive inventory of weapons, enough for several nations to annihilate one another. It was obvious why he wanted war, purely monetary.

And then there was Kamal Abdul, a communications expert. He was needed for his expertise in communications, but he was a part of the group because he was willing, ready to die and would stop at nothing to destroy peace. His volatile nature made everyone edgy because they half expected him to come with sticks of dynamite strapped to his chest at anytime.

And finally, there was Jimmy Johnson, the leader of the group. Unlike the others who stood to gain financially from a war, Jimmy's motives for wanting war was less obvious. He was dangerous because he was in the inner circle of PASS' design and implementation, he knew what the satellite could do and its' vulnerabilities. These four coordinated the small army of men who also wanted war for myriad means.

Their plan was simple, so simple WNSA experts would never even consider it to be a possibility. Using NASA's own satellite dishes focused on PASS' orbit, Franklin planned to redirect PASS' orbit while Kamal Abdul would jam the communication signal breaking all the WNSA's control of the satellite. Johnson in the meantime planned to reprogram PASS so that he would have total control over whatever country he decided would no longer exist.

Jimmy coolly walked over to where Franklin and Kamal were sitting and asked, "How long until we can get PASS under our control?"

Tuesday, March 14, 2045, 11:35 a.m. At the WNSA control room two tired men watched their screens monitoring PASS' distance and its speed. One of the controllers, Richard Broom, was a tired fifty-ish man with sparse blond hair mixed in with a few patches of grey. He wore thick bifocal glasses that made him look a lot older than he was. The other controller was Richard's assistant, Zacchery Morrison. He was a computer expert and engineer. In five years the two had become good friends.

They sat behind their computer screen dozing when suddenly the computer screens all went blank.

"Zacchery, what just happened?" Dr. Richard asked.

"Must be a power surge or power failure that did it," Zacchery told him.

"Man this ain't no home computer with a surge protector! Something is terribly wrong! Well don't just stand there, get the screen back on!" Richard said.

Zacchery bent down to the floor and opened up a panel that activated the backup generator. He called out to Dr. Richard. "Sir, I can see nothing wrong with the system; everything seems to be just fine." he said.

"Zacchery, it must be something wrong with the system, otherwise our software would not have blinked out on us. Go call engineering and tell them that we have a computer problem and also get Chief Lucas pronto." Richard said.

Zacchery pressed his silver communicator button on his white jacket and said, "We need engineering to come down to the control room, and we also need Chief Lucas. Chief Lucas, you are wanted in the control room, please come to the control room."

Minutes later a team of engineers flooded into the control room from all directions. It was pure pandemonium, in a scientific style. Each offered his explanation while the other contradicted the likelihood of his hypothesis. A younger engineer said that he knew what the actual problem was, that someone or something was jamming the signal to PASS. There was total shock on the faces of the men who were supposed to know the answers.

Chief Lucas walked into the room to see bewilderment.

Lucas was lean like taut steel cording stretched to its limit. He wasn't thin or puny because his muscle testified that three times each week he challenged his taekwondo master's limits to the point that the man was uneasily beginning to wonder who was the true master.

The antithesis of his muscle was his superior mind. He was brilliant with an I.Q. of 230. But what separated him from the bewildered scientists around him was his ability to take charge of a situation, solve it without the need for approval. In fact in his entire life he didn't need approval or companionship. He just needed his computer, his science, his cold unemotional rationality; people in his mind were an X factor–unpredictable.

"Richard this had better be important or you're out of a job!" Lucas said.

"Lucas I'm serous this is no joke so listen very closely. Somebody just took over PASS, or there is one serious technical problem up there!" Richard said slowly.

Lucas looked at his face for some indication of what he hoped was levity. When he didn't see any smirking on anyone else's face he turned to a person standing behind him.

Lucas went directly to his office to contemplate how he could end this situation as quickly as possible. He walked over to his desk. "How can I find out where the signal is," he thought. Then it came

to him. All they had to do was trace the origin of the foreign signal. What could the WNSA do without me! He grinned as he picked up his phone, "Richard, trace the origin of the foreign signal!"

"But sir, we have already tried that. The signal has been scrambled all over the globe and it will take days for us to find the origin. By that time only one quarter of the world might be left." Richard said.

"Get on it! We have only a little bit of time before PASS is able to unleash its full power." Lucas answered.

Lucas sat back down at his desk. He called in his secretary over the phone. "Get me Robert Long's number!"

A few minutes later his secretary appeared on the video phone, "Sir I just pulled up Robert Long's file and it says here that he retired five years ago and if I skip down two pages there it shows on a copy of his discharge papers that he never has to do any work for the WNSA from now on."

"Look, I hired you to do what I asked, not for you to get into my business. All I asked you to do was to give me his number!" He yelled.

"Sir I'm coming with them now." she said calmly.

Franklin, the terrorist hacker, knew he was on center stage once more. This is what he's been waiting for. One press of a button and Casablanca, Morocco would no longer be. PASS would take it out in a matter of seconds. It was interesting how they chose the city. It was third world, but with its half a million people, large enough to let the WNSA know they were serious. Jimmy also had some sick connection with the Humphrey Bogart movie.

"Do it," Jimmy said. Franklin grinned with satisfaction, pushed the button and Casablanca was no more.

Disbelief can only describe what the WNSA scientists felt as they listened to the news reports. They should have believed because they saw PASS head directly toward the small city, but they were powerless to do anything. They pushed the button for PASS' self destruction, but there was no response. They could only watch as the powerful satellite which was created to preserve the peace became a weapon of destruction.

In the town of Quincy, with the total population of about one thousand people, where everybody knew each other, Robert Long watched the news broadcast in horror. He knew the peace he had enjoyed for twelve years with his wife Janice and his twelve-year-old

daughter Ebony was over. WNSA would call him and he knew he would go even though he had vowed his days as a special agent were over. He had seen all types of terrorists. He knew their crazed ravings and demands. When Janice had Ebony he knew he had to quit. He could never let his family become the targets of those maniacs. When the phone rang he knew who it was.

"Robert, this is Lucas. We need you here."

"I am on the next plane there," he looked at Janice with an apologetic face but she cut him off.

"Ebony and I will be fine. You better go."

"I'll set up the arrangement," Lucas said.

At the WNSA Lucas said "We pulled up all the files of terrorist organizations who may have the capabilities of taking over PASS. So far we've come up empty handed. They all have motives, but none of them has the brains to pull it off. This was an inside job, someone who knew the codes and weaknesses of the satellite." Robert and Lucas looked at each other and simultaneously said, "Jimmy!"

Lucas shouted to one of his underlings "Pull up the file on Jimmy Johnson now!" Robert turned to Lucas and said "You know he won't find anything on him. If Jimmy wants to be hidden you won't find him."

Turned out that they did not even have to find him because when they looked up to their telescreen there was Jimmy larger than life. He told them this message was being broadcast to every telescreen in the world.

"By now you know Casablanca has been totally deleted from the map. Only the satellite system of PASS' destructive power is capable of destroying whole cities. And who operates PASS? The WNSA. And who controls the WNSA? The North American Alliance.

This so called peace treaty of twenty years only lulled you into a false sense of security. You have destroyed your nuclear armaments, you are totally defenseless against the alliance that is well armed. You have just witnessed what it can do. You don't have to be defenseless. Arm yourselves. My organization is ready to arm you with whatever weaponry you need, and within 48 hours your nation could be fully nuclear armed against any nation that comes against you. We have stockpiles of armaments strategically placed around the globe. You will be contacted."

Robert turned to Lucas. "Do you think they will buy from him?"

"Would you?" Lucas responded. "We got less than forty-eight hours before all hell breaks loose and we will be in the midst of another nuclear holocaust."

"The only good thing to come out of this is Jimmy is like most

dumb terrorists," said Lucas, "he's got a lot of mouth. As long as he was talking, we were able to get a fix on where he was broadcasting from."

A young agent replied that they had gotten a fax on his position. "It's coming from a place in the old United States, a sector once called Jackson, Mississippi," he said.

"The United States area, whew. Nobody has lived in that sector for decades since the war. It's so radioactive, nobody can survive it," said Robert.

"Well obviously Jimmy has found a way because he didn't look like he was suffering from radiation sickness to me," Lucas quipped.

"But he couldn't be controlling PASS from that location. He needs some pretty powerful equipment to jam our signal and redirect PASS. There must be something around here," he continued.

Lucas consulted his computer-like files of his memory and looked up when he had retrieved the answer. "Wasn't that Jackson place located near that old NASA space center in Bay St. Louis, Mississippi?" he queried.

"But I thought all of those space centers were destroyed by the Russians during the war," Robert said.

Lucas responded, "They were concentrating so on the Kennedy Space Center in Houston, Texas and Cape Canaveral in Florida, they must have overlooked the Mississippi site."

Unsatisfied with Lucas' answer Robert wondered how anyone could even get to the site because the United States was so contaminated by radiation after the war that anyone who survived left the entire country, what was left of it, a long time ago.

Lucas, almost as if he'd read Robert's mind, broke in, "I understand your thinking; the place was a radiation nightmare, but Jimmy somehow found a way to get into and activate the center despite the radiation and we've got to go there too. Get your gear. And you'd better bring a radiation suit with you, too."

Robert seemed hesitant. Lucas answered, "Look, man, I promise after this situation is under control, we will never bother your family again, and this time I mean it!" Lucas swore.

"Sure, fine, whatever. I'll do it only because I want my family together again," Robert answered.

"Good enough reason for me. Follow me; you all are going to need some ammunition to protect yourselves, and I know just the place."

As they grabbed enough ammo to destroy a small army Robert said, "Look Lucas, I have to tell you something. I'll do the job only if I fight this mission alone. You know I hate working with someone

especially if they don't know what they are doing!"

"Don't you remember when you assigned me to a rookie to show him the ropes, the man got sick when we had the high speed chase and before we got out of the hover car, he looked like he had a heart attack!"

"Robert, look I know this already, but you have to have someone going with you even for backup. The whole world's safety depends on us. That's why I'm coming with you."

SCENES OF A DEATH
Brenda Maldonado

I am walking down a virtually deserted sidewalk. It is late, probably midnight, I don't know. The only other person on this street is a young man, who is walking a few feet ahead of me. He is hunched over holding his stomach. His clothes are worn and filthy. He starts to moan loudly and then he suddenly stops. He falls to his knees and vomits on the sidewalk, but mostly on himself. He cannot retain his balance and falls on to his back.

He lies on the sidewalk next to the mess he just made. He looks up to the sky. Now I see why he was clutching his stomach. His guts are are falling out of his body from what looks like a knife wound. I want to help him, but something holds me back from even nearing him. It is as if the man's death can bring my own. He gives one more long moan before rolling his eyes upward and then closing them.

Surprisingly I feel no shock or disgust for what I have just witnessed. I only feel pity, because he looked so very young. I know this is cruel, but I have seen far worse, so I am not about to cry over this stranger.

As I walk on I can hear gunfire not far away. I try to remember a time when that sound would have been unfamiliar and frightening to me. I can't. The street is littered with abandoned houses and vehicles. It smells dirty and the sky shows signs of rain.

I am relieved that I felt nothing when the young man died. I soon understand the reason. I am becoming numb to the violence and chaos around me. The sight of death is no longer something that can make me feel anything bad, because I have become used to it.

I rationalize that this is a good thing. Besides there is no sense in crying or losing my lunch for someone I don't know.

6 JEFFERY
Lenora Warren

I'm sitting on the bus nodding off to sleep due to heat and lack of sleep. The woman with thinning hair and glasses next to me is also sleeping. The bus is crowding up but I hardly notice. All at once I wake up and see a ragged man standing next to the seat in front of me. The first thing I notice are his feet. They are bare with blackened over-long toenails. His unbuttoned navy blue shirt is covered in lint balls. The filthy white shirt he wears underneath has a picture of a globe on it. His dark blue jeans sag. I tentatively look up at his face, not wishing to stare but unable to stop my observation short. He wears a dusty baseball cap with USA printed on the front. His grizzled beard has flecks of white like bits of cotton. His arms are outstretched across the aisle as he grips the handrails creating a discomforting parody of the crucifix. He is singing softly to himself. Crazy? Drunk? Crack head? I wonder. Anyway, THIS should be interesting.

The passengers directly surrounding him are pointedly looking away as I am trying to do while at the same time taking mental notes. Everyone is thinking the same thing. "Please don't come any closer." I am glad that I can't smell him and feel sorry for the women sitting in front of me who, no doubt, can.

Suddenly he turns around facing the front of the bus, revealing the mud-spattered tears on the back of his left leg. He grasps the handles on the backs of the seat in front of me and proceeds to lower himself into a sitting position on the floor, his legs outstretched in front of him. I feel everyone around me stiffen and they look anywhere but at him. I, too, am uncomfortable but also interested in finding out what he's going to do next. Already I am thinking about how I will write this when I get to work at Gallery 37; how I will describe the matted hair under the baseball cap like steel wool, how the lady in the pink shirt in front of me sat rigidly throughout the trip downtown looking neither right nor left. I feel like this is a show for my benefit, to give me material to take with me and create an interesting story. I am tempted to take out my notebook and jot down a few notes but decide against it, feeling that it would be in bad taste given the tense atmosphere.

The man does not disappoint me. The next thing I know he has stretched out full length, lying on his back in the middle of the

103

aisle dozing. Now the people around me are beginning to stir and murmur. A woman with a Jamaican accent sitting behind me curses under her breath. "There ain't nuthin' wid you," she says. "Just tryin' to get attention."

The woman next to me is awake now and has noticed the lanky form lying on the floor next to me. She leans over and whispers, "Probably drunk."

I nod and say, "Hope he moves before someone has to get off." We both chuckle softly. The attitude on the bus has shifted from discomfort to nervous amusement at the absurdity of the situation. The Jamaican woman behind me calls out, "Bus driver, der's a man lyin' on de floor here." People are now staring openly, waiting to see if the bus driver will do something to remedy the situation. He, of course, does nothing.

The dilemma of how people are going to get around him is solved when a man in a red shirt walks up and says deliberately, "Excuse me." The barefoot man makes a startled noise and scrambles to his feet. At that exact moment the bus turns onto Michigan Avenue causing him to lurch into me. I have a moment of panic that he will lose his balance and fall on me. I am almost ashamed of myself at the power of this fear but am unable to keep from cringing away.

Thankfully, the bus rights itself and the ragged man staggers towards the back of the bus. There is an inaudible sigh of relief from my fellow passengers. The space where he was lying is left vacant but, in spite of the packed state of the bus, nobody moves to fill it, as though it is now tainted.

At the Art Institute the man gets off the bus. His steps are wobbly and I can tell he's singing loudly. A portly man with a green shirt and a camera stares at him as he passes by while others rush by him, heads bent in denial of his existence. The bus passes on and I lose sight of him. I now feel a strange sort of kindred the people on the bus, as though we've been through a tense ordeal. And I know that we will all get off this bus and tell our co-workers, friends, and families about the barefoot man who took a nap on the Jeffery.

WHO DO YOU THINK YOU ARE?
Carolina Coello

It was a cold winter night. I believe it was around February. Yes, it was. My sister was planning a surprise party for her friend. We went to the bakery to get her birthday cake.

We were already dressed for the party. You know just in jeans. Casual. There was no parking on Milwaukee Ave., so my sister had the bright idea to double park the car. She parked the car in front of a corner store. I noticed that it was jammed with all kinds of people coming in and out, buying groceries and beer. I felt really uncomfortable breaking the flow of traffic. The noise of the cars honking at one another and so many people around made me feel so uneasy.

While I was in the car waiting for my sister, a police car passed by on the opposite side of the street. There were two police officers in it. The driver was a woman and the other one was a man.

The police woman stopped and pointed at me. She told me (with her loud speakers to make me even more embarrassed) to move the car. I thought to myself "how am I going to move the car, I can't drive." When she saw that I didn't do anything, she made a U-turn and stopped right behind my sister's car. I thought to myself "oh great!"

She was a chubby woman. Not chubby, fat. She wore glasses uglier than my grandmother's and her dark hair was pulled back in a ponytail with her police cap on. The man who was with her also got out. He was a tall man with dark brown hair and dark eyes. He was kind of heavy set and had a face that was scarred from teenage acne.

They were both Caucasian. I heard a lot of stories of how white cops treat Latino people. The place where we were parked by was Logan Square. This place has a reputation of being dangerous because of all the gangs and cops are really strict in this area. I felt really uneasy.

When she tapped on the window, I rolled it down.

She said "Don't you understand English or what? I told you to move the car."

I said " I can't drive"

"Go get the driver, NOW!!" I started to tell her that I couldn't leave the car, but she cut me off and said " GO @#$@!%$ GET HER!"

I stood still and looked at her and said, " DON'T BE @#$#!#*
SCREAMING AT ME, WHO DO YOU THINK YOU ARE?"

She was surprised at first. Then mad. The police officer who
was with her told me to watch my mouth. I couldn't help myself. I
was angry. I don't remember ever being this angry before.

During all of this, all the people who were in the corner store
were staring. Two dark haired men, each with a beer in their hands,
were standing outside the store watching, enjoying this little scene
as if this was a movie being filmed.

As if she had heard my call for help, my sister came with the
cake and with an expression of amusement asked what was going on.
The police woman told her that I had cursed at her for no reason. I
told her that wasn't true, and she knew it. My sister just told me to
shut up.

Both the police officers went to their car to do a ticket. While
we were waiting in our car, I started to cry. When I get really mad I
start to cry. I really hate that but I can't help it. You know how you
feel when a big injustice is going on right in your face and you are
paralyzed with rage and can't even talk and you start crying from
frustration? That's how I felt.

When the police woman came over with the ticket, I tried to
calm down so she would not see me crying. I didn't want her to see
me cry.

As she was handing the ticket to my sister, she said "You know,
I wasn't going to give you a ticket but since your daughter opened
her mouth, I am." I thought "Your 'daughter'? What an ignorant
bitch." My sister grabbed the ticket and said "She's my sister and
you're lying because she wouldn't curse at you for no reason." She
closed the window and drove off.

While driving, my sister was screaming at me. She was telling
me that I should learn when to shut up. That because of me she had
gotten a ticket. I said "Please, first of all you were the one who dou-
ble parked the car." Then, after a moment she asked me what had
happen. I told her and she just told me to watch it. After, I asked her
"Do you really believe that they weren't going to give you a ticket?"
She didn't answer.

I don't regret what I did. In fact, I'm proud I stood up for
myself. Now when my sister doesn't find a parking space and leaves
the car double parked, she tells me to keep my mouth shut if any-
thing happens. Since now I know how to drive, I tell her " Don't
worry, I can move your car."

RAVEN'S SONG
Edith Bucio

I'm kissing strawberry lips behind closed doors while my mother feeds our raven bird. I love that bird. It's singing that song it always sings whenever someone remembers to give him something to eat; that song that Robin and I know way too well. My dad is sitting on our grandfather's couch which my grandmother gave to us when he passed away. After about fifty stains and twenty washings in two years, it still has Gramp's orange garden tobacco smell. Sitting on that couch can always make me smile, I can't help but to feel five again with two thick braids and on my grandad's lap. "Mi princessa negrita," he would whisper with a kiss. Nicole is the one who gets to be the princess in our grandad's couch now. She's laughing in my dad's arms, and I almost run out of my room to tell her never to let go. If she does, surely one day, all she'll have left of him will be his smell, mixed in with my grandfather's smell in our couch.

The raven's song is louder now. I can feel its anxious voice inside of me, making me want to fly far away with my Robin, making me forget my grandfather, Nicole's grandfather, and my mother. All I can think of, all I can feel, is that hopeful song and my Robin, penetrating through my skin and into my veins. Its voice grows stronger inside me, the raven and I believe to be free, and I smile because I feel like a princess again. We both sing, me as I taste Robin's strawberry lips, and the raven as it escapes its prison cage.

Nicole, with her crown full of grandfather kisses, knocks on my door. I open my eyes and realize I'm not entitled to be a princess anymore; I'll never be able to fly off with my Robin, its not allowed. The little girl continues to knock, wanting to come inside and shatter my world apart. Robin's kisses stop and I sadly smile as she puts on my yellow daisy skirt, my clothes always look better on her. We look at each other as we both hear Nicole giggle her cute little laugh behind the closed door. It slides beneath the edges of our crystal castle and breaks it into countless of sharp cutting diamonds, that fall all over my Robin. She holds me with slashed arms and kisses me with bleeding lips.

princess screams. Satisfied she walks back to my grandfather's couch and sits on her abuelito's lap. She's the only one who gets to live in a crystal castle made out of pink cotton dreams.

"Maldito Pajaro!" my mother screams, she's chasing the singing raven, with a broom stick, all through our living room. It's trapped, all the windows are closed. My mother pulls on to one of its ticklish feathers; the raven falls, helplessly laughing into my mother's arms. The singing stops, and I sing my room, covered in a shining gold blanket as I see my Robin fly out my bedroom window and down the street.

WORKING AS A DESK CLERK
Amey Barba

Michael looked up from his shirt-tail table and skated

fingers through his scotchy hair, coating thick glasses, framing

raisin eyes.

What did she want. Her face slipped side to side before

the answer came. A kiss. She slide her butternut fingers

together like a woven patio rug.

You're nutty, Michael. Quiet-library toned so others

wouldn't hear. She shook like popcorn and threw him paper

thin spaghetti poems on feministic fish before melting under the

door, and why? Just relax and read your book, he bit his nails,

and close the doors at six o'clock.

WATER BUFFALOS
Sarah Pickett

Water buffalos rage against the sky. I watch as they pound their way past, melting and reforming. They weigh less than a feather, yet they seem ready to drop from the sky and crush me. Words spill onto the page and create a pool, dripping from my pen. Fireflies caught in that big bluish black thing. With you everything is gas. Laughter shattering my mind like glass; shards flying everywhere, embedding themselves in my skin. I am leaking heart, flowing emotion, through eyes, down cheeks, dripping onto page, creating pool. Pool of thought? Pool of heart? Smiley faces dance sending waves of remorse. Rockets to the sun, brushing atmosphere. Sound bounces around my head, echo memories. Escape into dreams of butterflies and rainbows. Flowers spring up where I step. Everything seems to be holding it's breath. Watching. Waiting. I explore picking candy apples from cotton trees. It's raining rose petals. They fall into my hair. They cover the ground. I look around for someone to share it with. I turn in a slow circle, searching with my mind. Finding no one. Alone. Alone? I look again. This time with my thoughts. Carefully feeling. Finding no one. I let go one word. Why? The word falls from my lips and hits the ground with a gentle thud. I study it from where I stand. A spider is crawling on it. Some ants pick it up and carry it off. I am lost. Lost in memory. The sky darkens. The water buffalo are back again, raging against the sky. Invading my privacy. I jump on one of their backs and they pound their way back to reality. When we arrive they dissolve. I stoop and pick up the remainders of my shattered mind and walk into the sunset.

An excerpt from
SON OF SORROWS
Jonathan Baskin

My earliest memory is of a circus. I was small, even smaller
than I am now. It is better to say I was young. I was five years old
and fascinated by the three-ring circus that had come to my city.
Orange soda dripping out of the bottom of my cup made my hands
sticky and stained my white pants. Red and green jellybeans fought
for position in my mouth and stuck adamantly to my teeth. From
the middle ring the ringmaster bellowed out instructions in an
excited voice for what was to come next.

To the right of the ringmaster, a man rode on top of an ele-
phant. Behind the ringmaster, Hanz, the magician, was pulling
Snow White, and sometimes black rabbits out of hats.
On the other side of the ringmaster, tigers growled. Up above that
wondrous scene, girls and boys walked fearlessly on tightropes. A
mysterious purple costume enveloped the tightrope experts.
Flowing gowns of violet punctuated the girls as they tiptoed across.
Tight dark purple pants and lavender shirts clung to the male bodies
which, in considerably less graceful form, meandered across the
rope.

But really it is none of these things which I remember best.
It was a group of cheerful clowns who danced and pranced so stupid-
ly in front of us. I was not afraid or at all put off by those red-button
noses and jubilant masks. Yellow polka-dot pants distinguished one
clown from all the other suspicious characters roaming the circus
grounds. The clowns' faces appeared to be drawn on with neon
markers, which glowed and sparkled in the circus light. I felt a cer-
tain tie with those clowns, with those bright spectacles of color and
smile.

And then a small one appeared. To a small child, a small
adult is a hero. A small clown is a God. The tiny clown joked
around and frolicked with the others. The clown's yellow polka-dot
pants hung especially baggy and his shirt sleeves did not stop at his
wrists. He looked as I believed a clown should look.

From my second row seat on a long metal bench, I took in
the overt smells, the sacred noise, and finally the deafening roar that
was, as the ringmaster informed us, the greatest show on earth. As
the ringmaster thanked the crowd for coming, the tiny clown with a

large forehead walked my way. He hopped easily over the first row and stood, between my parents, right in front of me. He leaned over, although not as far as others would have to, and whispered in my ear with cracker-jack breath.

"Did you enjoy the show?"

I nodded furiously. The little clown hopped off as nimbly as he had arrived. My parents eagerly asked me what the clown had said. But I would not tell them. Some things are too magical to be shared with parents.

That little clown must have known I would grow up to be small.

I didn't choose to be born a dwarf. Many act as if I made the choice, as if it were my fault. I would like to ask them why they chose to be tall. I would like to ask why one might choose to have long ugly arms, unsteady thin legs. I would ask why one would choose to spend life so far from the ground, on a wobbly frame. But giants do not choose to hit their heads on ceilings and I did not choose to look into people's waists when I talk.

My parents, Mr. and Mrs. Sorrow, certainly did not choose that I be a dwarf. I suppose my parents knew when I was born that I was a dwarf. The doctors must have known. I am an achondroplastic dwarf, the product of a rare genetic event, some sort of spontaneous mutation. An achondroplastic dwarf can be born of normal parents and its children have about a fifty percent chance of also being dwarfs. No doctor has ever discovered a genetic marker for the characteristic and very few have bothered to search for one. I was born with a head disproportionate to the rest of my body and stubby hands and feet. However, a parent's imagination for a child is boundless and my parents were able to successfully imagine I was a regular child until I completely stopped growing when I was nine and it was clear I would grow to be just over three feet.

I was always a frightened baby. At an age which is surely too far back for me to remember, I do remember searching for the beasts. My father generally put me to bed while my mother talked on the phone at night. I put on my pajamas, which were lime green with little pictures of children doing different things like riding a carousel and sliding down a slippery yellow slide. I brushed my teeth and went into my room.

My room was a strange looking place. My parents had covered the light bulb with an orange and blue lantern. The light was connected to a white ceiling fan which turned, it seemed to me,

extremely fast. The effect on the white walls was this: If the light with the lantern was turned on and the fan was set on the right speed so it turned very slowly, the walls would become streaks of slowly churning blue and orange. This made me feel frequently like I was moving around briskly in a circle with the colors. If I put some festive music on in my room, it was like a cheap merry-go-round with no horses. My father was waiting for me with a story.

He read, often, to my delight, imitating the voices in the story. As the lights swirled around him he might deepen his voice to imitate a giant or make his voice high and squeaky when reading the dialogue of some tortured Princess. But although I loved them, it was during these stories that I learned about the beasts. There were giants. There were eight-legged sea creatures. In my story world there were man-eating whales, scheming madmen, and schoolyard bullies.

Like many young children I would search under my bed and in my closet to make sure my room was free of beasts when I went to sleep. My father, after he learned it was futile to tell me there were no beasts at night, brought me warm white milk to relax me and often assured me that the beasts had gone to sleep.

But I would always be fearful of the beasts. They took various forms in my life, and I was never sure when one would awaken and try to snatch me.

As a small child I have few other memories. There are certain things I remember. I remember a mother, often squeezing my head in her hands when in public so my differences were not so obvious. I remember countless relatives smiling their two-faced smiles and remarking that I looked just like a regular child.

I remember a father trying to stretch out my limbs, gently. Pulling hopefully on a leg, grabbing onto an arm. Perhaps even stretching a foot as he changed a diaper. Then, I would let out a cry, and the pulling would stop.

I remember Susan and little Timmy and Mark from preschool who remarked with sunlit faces that I was "cute" and "adorable." I remember the teachers' stunned faces who were sure they'd been dealt an unfair hand when they learned I was in their class.

But my early childhood was dull compared to the rest of it. I was not, in any cruel way, treated so terribly. Slight insensitivity by others was not enough to make my childhood a bad one. There are certainly good memories.

An excerpt from
THE VOICE IN THE EARS OF MADMEN
LaToya French

Damoniel sat up and groped about on the beige pillows until his hand wandered across the bottle. He flung it roughly across the room where it shattered noisily against the wall. Damoniel winced as the sound cruelly pierced his throbbing skull. He swung his long legs over the side of the couch and pushed himself to his feet. A sharp pain stabbed through his stuffy head and had him sinking back into the cushions in an instant, a tortured groan escaping his lips. He hung his head between his bare thighs and his eyes fell on yet another empty bottle. Damoniel grasped it by the neck and turned the label towards him. Vodka. His favorite mode of escaping reality. He groaned again and dropped the bottle back on the plush gray carpeting.

He remembered now, only too well. He'd downed about four bottles of the stuff and had proceeded to heave his guts out not long after polishing off the last one. Now the rest of his body was protesting the indulgence with a vengeance. Besides the pain in his head, his limbs felt like lead weights and he was more exhausted than he'd been in a long time.

Damoniel put his fingertips to his temples and, pressing slightly, commanded the pain to leave him, commanded his body to be well. It resisted stubbornly, the pain and exhaustion ebbing away at first then rushing upon him again strong as ever like the waves of an ocean caressing the beach. But slowly, he forced them to recede until there was only the minutest pain and a tinge of fatigue, mere echoes of his previous agony.

Sighing tiredly, Damoniel pushed himself to his feet again and peered around the loft. It was completely trashed from the previous night's debauchery. There was paper trash and half-eaten food strewn everywhere, not to mention the empty liquor bottles and the pile of shiny glass from the one he had broken. Damoniel raised a curious eyebrow when he spotted three empty condom wrappers among the litter and smiled slightly. "What have I been up to?" he wondered. Perhaps later, when he was back home, he would remember; but for now... He stretched stiffly and picked his way through the garbage to the bathroom. He would have Drac muck the place out later.

He paused suddenly and looked about the loft again. Where is his little goon this evening? "He'd better be close," Damoniel thought darkly. "Or it won't be well for him." That bastard and all

his like were almost useless except as menial laborers. But then, that was essentially what they were: servants and thugs. Some liked to use them as secondaries, making their own jobs easier and getting in a little extra work that they could take credit for.

Well, Damoniel preferred to do things on his own and detested having Drac and his squad constantly at his heels. Not only was he perfectly capable of doing his job alone, he knew Drac and his henchmen for what they truly were: watchdogs, watchdogs for his superiors so they could keep tabs on Damoniel's kind. He resented that and, therefore, resented Drac. He tended to leave Drac and his fifteen subordinates at the loft whenever possible, although he was sure at least one of them always followed him. He wished he could leave them where they belonged, but it was required that he take along a few "just in case." Yeah, just in case he did something the Sultan didn't like.

Dropping the sheet carelessly onto the cold white tile of the bathroom, he turned the shower on full blast and stepped under the cascading water. He hissed appreciatively as the hot water beat relentlessly against his back, the sensation rousing his senses with a much needed shock. It was very hot. But he'd known things hotter, much hotter; agonizingly hot. Despite the heat, Damoniel shivered and applied himself to washing his body. It was better not to think of such things, especially when he did not yet have to.

As he entered the main room of the loft again, he glanced at the wall clock over the bed. It was nine-thirty. Hastily, he dressed, grabbing the first clothes his hands touched in the closet. Ironically, they were dark red—the color of dried blood. Damoniel shook his head as he gazed into the dresser mirror. Must he always be so morbid? So dark? But then, it was hard not to be, considering what he was. Even his appearance was dark. Black hair, dark brown eyes, olive skin and a tendency to clothe his tall muscular body in dark clothes only contributed to the dark aura that characterized him. Damoniel fingered his neatly trimmed goatee. Maybe if he shaved it, he'd look less menacing. He smiled slightly at his reflection. Not bloody likely. Besides, it was fitting. Damoniel ran his hands through his short black hair, attempting to tame the wild mass just a little. He shrugged into a long black wool trench coat and then, slipping the shiny gold-hued keys to the car he'd recently purchased into his pocket, he ventured out onto the terrace. The city was aglow as usual. Tiny pinpoints of amber light stretched from as far as the eye could see all the way to the street thirty-three floors below his feet. The dazzling skyline of the city superseded the weak stars with their electrically generated light, creating a show that rivaled nature's own.

Damoniel turned about and leaned part way over the railing, peering towards the edge of the roof. He could see nothing beyond that. Irritably, he glanced at the ledges around him. All empty.

"Drac, you maggot, where the hell are you?!" he called. "Get your scaly ass out here!" There was a flurry of wings and the sound of snickering on the roof. A moment later, Drac stuck his ugly head over the side of the building.

"Master?" he said gruffly. Damoniel gestured him down and he obediently glided to the terrace. The familiar flatulent stench of brimstone that always accompanied the gargoyle quickly pervaded the air and Damoniel grimaced in distaste. Even after centuries of dwelling with the constant odor of the stuff, he had not grown accustomed to it. How the smell reminded him grimly of his home.

"Have those lap dogs of yours clean the loft up", Damoniel ordered. "And when they do it, have them come as anything but gargoyles. I'll not have the reek of brimstone in my home. I've had quite enough of that." Drac ducked his head submissively.

"Yes, Master," he answered.

"I'm going out for the night. Have them done by the time I return at sunrise," Damoniel told the gargoyle as he turned to leave.

"You go to conclude affairs with the bearded one?" Drac inquired. Damoniel paused but did not turn.

"Yes." There was a sickening rasping sound as Drac rubbed his scaly hands together and he chuckled. Damoniel imagined his sharp evergreen features contorted into his parody of a smile.

"His Lordship shall be pleased," he commented. Damoniel sighed and walked on.

"Yes, I suppose he shall," he said quietly, his tone containing the merest hint of sadness, as he got onto the elevator. The elevator descended quickly from the penthouse to the ground floor. Damoniel checked his watch as he walked at a brisk pace towards his car. It was ten-fifteen now. He whistled appreciatively, his breath forming a small white cloud that quickly disappeared into the air. He'd have to push it if he wanted to make it to the concert on time. As he climbed into his glossy black automobile, he wished he'd woken earlier. He happened to like the band that was playing tonight and would have liked to have seen it. Oh, well, the concert wasn't the reason he was out.

No, it was his mentally-imbalanced puppet, Raymond, that had brought him out tonight. Raymond, with his scraggly black and gray beard and his long greasy white hair, his blue eyes wide and perpetually in motion. He was a paranoid schizophrenic who'd only needed a little push to become homicidal. Damoniel snorted as he

turned the wheel and car sharply. He really hadn't needed him for that, Raymond would have turned into a killer on his own; designing some insane hallucination to justify his actions. He was one crazy motherfucker. He realized that the moment he'd first seen him. He'd been strolling the streets that night in search of a likely prospect, when he'd heard Raymond's stuttering voice issuing from a dark alley.

"W-W-What the f-f-f-f-f-f-fuck a-are you l-lookin' at?" he'd asked. At first, Damoniel had thought the man was speaking to him. He'd ventured into the alley intending to physically reprimand the creature who'd dare speak to him in such a manner. The dirty bum he'd discovered huddling against the slimy stones of a brick wall among cardboard boxes and rusty red dumpsters had surprised him enough to hang back for a moment. Damoniel blended easily into the looming shadows, his dark clothes camouflaging him as he stealthily approached the man. He paused about fifteen feet shy of him and stared silently into the darkness, his sharp eyes trained intently on the man like those of an animal stalking its prey.

Clad in a pair of grimy gray slacks and a black-streaked holey red tee shirt, he had his knees drawn up tightly to his scrawny chest. Wild eyes glared from a haggard tight-skinned face at the cause of his agitation as he passed a hand under his pointy nose like a four-year-old, leaving a shiny slime trail across it. Damoniel followed the path of his gaze and grinned as he saw a mangy white cat that had paused in grooming its dirty fur to stare with round green eyes at the heap across from it. Damoniel leaned casually against the wall, sensing some drama about to play itself out. This ought to be diverting.

"I said, w-w-what the f-f-f-f-f-funk a-are you l-l-lookin' at?" The cat blinked and set the paw it had been licking on the ground. "S-Stop lookin' at me," the man stuttered. The cat blinked dumbly and mewed a query. "Wh-Wh-Who a-are y-you?! Wh-Wh-Who s-s-sent you?! You-You-You-You're one of th-them, aren't you?! You-You-You-You're after me!" The cat blinked again and swiveled one pink furry ear back and then pricked it up again in alertness. Suddenly, the man had lunged across the alley, sliding through a puddle of dirty water which his clothes quickly soaked up. His hands were outstretched towards the cat, his dull blue eyes wilder than ever. The cat was on its feet in an instant—claws unsheathed, fur bristling, back arched, teeth bared—hissing a challenge. Damoniel could see that it was missing its left hind leg as the man grasped it by its scrawny neck. The cat became a ball of fighting fury, limbs flailing in an attempt to injure its attacker. The man

squeezed and squeezed, his knuckles turning white with the strength he was expending. Long after the cat had stopped struggling and its skinny body hung limply in the man's big hands, he kept on choking. Damoniel had chuckled, genuinely amused by the spectacle of a vagrant choking a three-legged cat he'd thought was out to get him. It was then he'd decided this man would be his newest venture. That was how he had met Raymond.

He was remarkably easy to manipulate which made him the perfect pawn for one of Damoniel's jaunts. It hadn't been too tough. Taking advantage of their shape shifting abilities, he'd drafted the gargoyles into his plan. With them playing the parts of "typical" humans, he'd convinced Raymond that everyone was out to get him. A carefully planned episode here and there with the gargoyles effectively abusing his little pigeon had done the trick quite well. He had to hand it to them, they tended to be bothersome creatures, but the gargoyles did have their uses. For months, he'd molded Raymond; all the time readying him for the ultimate purpose he'd had in mind all along. And tonight, he would see the culmination of all his hard work.

As the engine roared and he turned onto the expressway, Damoniel felt an uncharacteristic twinge of guilt. Slowly but surely, he'd driven Raymond even further over the edge so he could use the man to wreak havoc. On a whim to know what kind of life his most recent subject had led, Damoniel had picked from his brain the fact that he'd been much neglected as a child and when he had been noticed, more often than not, he was savagely attacked—physically and emotionally—by his drunken mother until he complied with whatever was required of him. He'd learned quickly it was better not to be noticed and better to take anything anyone ever said to him to heart. And it was on that principle that he lived his life. Hiding in alleys, providing for himself as best he could without being noticed and moving on the instant anybody told him as much. Too used to obeying and being treated like an animal, he had taken to Damoniel like a puppy to a child. But Damoniel had taken a different approach to the man, first befriending him and giving him the respect he'd never experienced while implanting more wild notions in his head to whirl around with the ones already there.

"What do you want, Raymond?" he'd asked him once. Raymond had his long body curled up into a ball again with his head on his knees. A lock of his thin hair was hanging across his face and he brushed it away as he spoke.

"To be left alone," he'd answered. "Peace."

"Then I'll help you get it," Damoniel had returned.

An excerpt from

TWILIGHT MOON
M.C. Gluck

The lives we discover in the dreams we desire to live.

I found this diary up in the attic. Apparently it had been
shipped to my aunt, my mother's older sister, when my mother had
died three years earlier.

The diary was blue with a gold sun in the front upper right-
hand corner, and a moon on the back on the lower lefthand corner.
There were many golden stars sprinkled randomly throughout the
cover. Each had faces, the sun and the moon and each of the stars, a
different face and a different expression. I had mentioned the book
to my aunt, and the strangest look had come over her face. It was
the same book she had when her first husband had been hit by a
truck. I asked her what was wrong, but she merely shook her head
and sat down. When she had recovered her breath and color, she
asked me where I had found it. I didn't tell her, just repeated that I
had found it somewhere. She muttered something under her breath
about it being "too late to turn back now, maybe she'll forget it" and
she smiled weakly at me. I pasted a smile of my own on my face and
took the book back upstairs with me. I hid it under a loose floor-
board under my bed and went back downstairs to answer my aunt's
summons.

I was sitting on the floor and I pulled out my mother's
diary. I looked at her tiny and neat handwriting. God, I missed her.
My throat tightened but the tears did not come.

I closed my eyes and leaned my head back against the bed.
She was so beautiful, so very beautiful. She had long black hair and
thick black eyelashes framing emerald green eyes. She was breath-
taking, exotic, tiny. She looked like a gypsy. Nothing at all like her
sister Norma Jean, who was downright ugly. I suppose that was why
Norma Jean hated my mother so much. I wonder if I look like her.
Maybe that's why Norma Jean enjoys making me work and making
my life a living hell. She must be getting revenge on her dead sister
through me.

My mother used to sing to me, strange crooning haunting
songs. I did not understand the words, yet I knew them all. She had

died when I was only six years old. I don't know where we had lived. I can't remember, no matter how hard I try.

After she had died, I had been transferred from foster home to orphanage, the streets to juvenile hall, and finally when I was fourteen the state had located my long lost aunt and I had been dumped into the hell-hole she called home. My aunt had not been happy to have me living in her house, a living reminder of the sister who had always been better than she. At least, until she put me to work. Once she realized that she could use me as her slave, she decided to keep me. How fortunate I was. But now, after three years of living in this house, I had found my mother's diary. I felt alive again, young. I retrieved it from under the floorboards and carried it up to the attic. I had found it in a large chest. The diary had been on top of clothing and other oddities.

I sat down on the floor with my back against the wall, opened the diary and began to read.

> *Jarod is so beautiful that sometimes I forget. I forget to eat, to sleep, sometimes even to breathe. He is not only beautiful on the outside, but on the inside as well. He has shown me the beauty of his land, of his world.*
>
> *He has been so kind to me, so understanding in light of my situation. I feel so terrible, not knowing who I am or where I come from. The only clue to my identity is the amulet I wear around my neck at all times. The amulet is the only reason why they have not killed me. It is an ancient symbol from their clan. Shanon has told me to never take it off, but she won't tell me why.*
>
> *I heard the wolves cry early this morning. Serena, Jarod's cousin, was amused by my surprise. She asked me, was I not a child of the motherland? I replied, "no," surprising the both of us. Serena realized this was true, for although I spoke flawless Ceylonese, I dream-spoke in another language.*

I did not understand. Was this my Mother? It was her handwriting. I was almost positive, but what was this place where they spoke Ceylonese? Had my mother ever been there? It was possible, I realized. She had died when I was so young, that I must have never known about it.

> *Jarod had asked me to handfast with him, and I agreed. It*

was so beautiful. I love him so very much. As is the custom of our people, we are handfasted for a year after which we will have a proper ceremony before Shanon, and he will be mine forever.

I skipped through the diary, wondering. I skimmed over descriptions of people and Ceylon. Then something caught my eye.

I am pregnant. I am most certain that the child will be female...

Child? I had a sister? In Ceylon? Wherever that is. I thumbed over the next few pages, reading furiously. The change in my mother's neat scrawl alerted me immediately.

I remember. I remember everything. Oh, dear G-d, how could I have done this? I am not from Ceylon, I am from America! My America, a place they have never even heard of before! I left! From reality into this make believe world! Oh, how I wish I had never come here! Oh, Jarod, I am so sorry but I cannot stay here! I just can't! It's not where I belong! It's not where I belong! It's not my home! It's not my world! Jarod, Serena, everyone, please understand, I love you both, but I can't stay here and live a life that's not my own!

She had only one journal entry after that, when she was home from where ever it was she had been. Suddenly, I realized that while this last journal entry was in English, the others had not been. And yet, I had been able to read and understand what had been written!

There is no way I can survive the trip back home, back to my world. I will give the amulet to Seradt and I will hold her. When I emerge once again into the real world, I will no longer be living. Jarod tells me that it's not fair to take our child away from her home, to take her to a place where she will be raised by strangers. But I will not leave her in this primitive, barbaric world. Someone will find her, and they will raise her right. Some stranger, some kind stranger, who will love my baby as if she was their own...

Her last entry was written three days before her death. Before she had died? But I had already been six years old when she had died. Surely, I had lived in America all my life, not some strange place that I had never heard of!

An excerpt from
THE DAY OF SALVATION
Keinika Alina Cooper

Cindi

It's 8:27 a.m. I have three minutes to sleep. Oh well, what's the use. This baby is kicking the mess out of me. I can't take this anymore. I wish this baby would just pop out of me. Let me roll over and see if Jon's up. I can't believe it. He actually got up early this morning. It's only 8:29 a.m. and he's up. I wonder what he's doing. I know he's not making breakfast because I don't smell anything. He is not playing with the kids because no one has come running to me talking about they are bleeding. What is he doing? It's just too quiet. Wait, here comes the maid, let me ask her.

"Good morning, Madam Gracey."

"Good morning, Traci. Where's Jon?"

"Mr. Gracey is asleep on the floor in the downstairs den."

"I knew it was too good to be true. Why is he down there?"

"Well, he came in drunk from the company party last night and he was only able to scoot to the downstairs den."

"Who brought him home? I know he didn't drive home drunk. Did he?"

"No, madam. Mr. Roundtree escorted him home in Mr. Gracey's car, so I told Jeff to drive him to his car in the limo."

"Thanks, Traci."

That idiot. He couldn't control himself at the company party with his little so-called conservative friends. That pompous imbecile. Let me call Shelle and tell her. She'll get a kick out of this. Oh, I have to tell her to tell Mark , "Thank You for dropping Jon the hopeless drunk off at home." I hope she's awake. Shelle is probably laid up with some man she met two days ago. Let me call her anyway and wake her nymphomaniac butt up.

"Hey Shelle, you up?"

"Yeah, Cindi, I'm up, but this man sure isn't. I've been trying to wake him up for twenty minutes so he can go home."

"Is that Troy? The one that is fifteen percent away from being fine, never has a dime to his name and you wonder why yours are always missing. The one whom you met three days ago on Wednesday. The one that is the most popular guy on the block and focuses on everyone, but you?"

"Yeah and on top of that he's not all that good of a lover."

"Well, what did you expect. He puts all his time and energy into being well known."

"Anyway, what's up?"

"Aw, yeah, I called because I want you to tell your brother 'Thank You' for bringing Jon home last night."

"Sure, what happened?"

"Well, he went to his company party last night and got a little tipsy. Traci said that Mark saw him waddling to his car and he was trying to put the key in the keyhole, but he was aiming for the tire."

"Man, I wonder, how does he pee?"

"Shut up. So Mark put him in his car and drove him home. When he got here he brought him in and Jeff drove him home in the limo."

"Girl, that husband of yours is a trip."

"Well, at least he brings in a good check."

"Oh, speaking of checks, I have to go deposit my measly little check. Look, I'll talk to you later. As a matter of fact I was going to come by there at about 7:00 p.m. Is that okay with you?"

"Yeah, that's cool."

"Alright, see ya."

Shelle

What am I going to wear today? I always have to look good. Hey, what am I talking about? I always look good. Duh! It's so hot today! Well, in Atlanta, Georgia it would be. You know what, I'm going to wear my blue DKNY skirt and top, the short one, with my blue and silver skechers. I feel like showing my figure and catching a man because I sho' need a man. A good one, who actually has his own money in his pockets, not mine. I think I'll wear the blue frost lipstick and matching nail polish. I'll wear my skechers hat because I need my hair rebraided. Let me call Lynette and see if she can fit me in for today. I, also, need to call Ken to see if he can give me a fill-in because I need one bad. A little eyeliner to finish off my look and there. Still fine! Now to find my DKNY purse and my car keys and I'm off to the bank. It's a nice day to drive the Mustang Convertible. Man, it's hot! Nice day for the beach, but I gotta get my hair done, my nails done, got to go to the bank, clothes and grocery shopping, and shopping for Cindi's kids. Always got to think

about my godchildren. Even the one on the way. Let me put the top down and turn on some sounds and I'm all set to go.

Oooo, Cooloo! Perfect summertime music. Hey!! Ooo, good. No traffic. Straight shot to the bank. Aw, man. No parking spaces. Looks like I'm going to have to park in KFC and walk over. Good thing I got on my skechers. Just my luck, a long line. Well, while I'm waiting I can make my nail and hair appointments with Lynette and Ken.

"Good morning and how may I help you today?"

"Let's see. I want to deposit this check in my checking account."

"Please scan your ATM card at the right, then punch in your pin number, please. Okay, your current balance is $5,376.59."

"Only $5,000.00!!...wait, let me think, aw, okay. I see."

"May I please have the check?... now your balance is $8,804.87."

"Shelle Langden, your back! Okay, now I want to withdraw $350.00."

"Okay and how would you like that?"

"Two hundreds, two fifties, and five tens."

"Okay and here's your receipt. Your balance is $8,454.87."

"Now, those are the figures I like to see in my account. Thank you. Now I can go to Lynette's place so I can get my hair rebraided and then on to Pretty Nails' to....hey, what the?"

"Oh, I'm so sorry Miss. I didn't mean to bump into you. Wow, do you know you have beautiful eyes? What color are they?"

"Who wants to know?"

"Feisty little thang, aren't cha? My name is Darrell Franklin."

"I'm Shelle Langden and they are greenish-gray. I get the gray from my mom and the green from my dad."

"And where do you get those fine looks from?"

"Oh, those just come naturally."

"You know, I'd like to take you to lunch. Can you arrange that? I love a woman who takes charge."

"I love a man who can appreciate that in a woman and yes, we can, as a matter of fact now."

"Well, that's cool. Where should we go?"

"Giordano's. They have the best stuffed pizza in town."

"Okay. Can we meet in 30 minutes."

"No problem because I have a few calls to make before I proceed with our plans."

"Okay, I'll see ya in a little while."

"Bye."

Ooooo, I have to call Cindi and tell her about Darrell. Man, she's not home. I'll tell her when I get over there. Wait a minute. I'm going to get there late because of our lunch date. That's alright she'll understand. I'll probably get there at 7:30, 8:00, tops. Looks like my luck is changing. I met this fine man at the bank!! He does look pretty wealthy. Well, as I always say. Share your wealth. Not mine. He was probably there to deposit a large amount of money. He looks like he has a good profession. I bet this man can buy me diamonds, furs, and luxury cars. What if he is not all he seems to be? I hope his looks aren't deceiving. He sho' is fine. Man, look at this traffic. I'm going to be late. Oooo, I still gotta call Lynette and Ken and reschedule. Let me see what's on the radio. Nothing but whiny ol' Keith Sweat. Oh well, I hope he withdrew a good handful of change because I love Giordano's and I sho' love to eat pizza. Especially stuffed. Man, if I have to flip for the bill I'm going to just walk on up out of there. Leaving him there. On the real. Well, looks like I'm finally here. I wonder which car is his. I bet it's that black Benz with gold detail over there. I hope so. Let me check my ensemble. Perfect as always. Never tamper with perfection .

"Shelle, over here!"

"There you are. I was beginning to think you didn't show up."

"Now, I wouldn't do that to a woman as beautiful as you. Come to think of it, I wouldn't do that to any woman at all."

"Well that's good. Sounds like mama brought her boy up right."

"Yeah, mama didn't raise no fools. Hey, I came out perfect."

"Whoa, bring your ego down a tad wit' your conceited self."

"Never that, sweetheart... So, what do you do for a living?"

"I work at Thompson Brothers Insurance Company"

"Wow, great job! I hear they are the biggest in Atlanta. Not to mention, great rates, too."

"Thank you. What do you do?"

"Well, I, um, sorta...."

"Are you two ready to order?"

"Sure, um, what do you want?"

"Stuffed sausage and cheese with a medium sprite."

"What size?"

"What's good for you Darrell?"

"Medium's fine and I'll have a sprite, too."

"Okay and your drinks we'll be coming soon right along with your bread sticks."

"Thank you.... Now what was I saying? Oh, yeah, about my job. Right now I'm in between applications for law firms. It's so hard to decide."

Really, that sounds interesting. You know this fall my company is looking to promote me to..."

"Well that's nice. You know my resume was so great. I had listed all my great achievements and you know they are thinking of picking me as their, blah, blah, blah, blah, blah, blah, blah."

Listen to this arrogant fool. All he does is talk about himself. He's worse than me. Man, I hope they bring out the food soon. Maybe then he'll shut up. I am really starting to think he's a Virgo like me. We, Virgo's, love ourselves to death. Let me ask him. Yup, I was right. An August one at that. Just missed Leo. Man! I love Leo men. Oh, well. I knew he couldn't be all that perfect. Aw, yes! The food is here. Wow! He shut up. Hard to believe. Now, it's my turn to brag about myself. Giordano's food is soooo good. Good and hot. Just like me. Uh! Oh! The bill. Oh, he's paying and tipping. Why is there a bus token mixed in his change. Maybe it got there by accident because I know the bus wasn't his ride here. I don't think so. Anyway, time to go.

"Well, that was nice. Unfortunately I have to leave. I have some things to do and then I have to go by a girlfriend's house and help her with her kids. She's 6 months pregnant."

"I understand. Can I see you again?"

"Sure. Here's my number. Why don't you call me sometimes."

"Okay. I'll do that and here's my number."

"Ooooo, cards. Smooth. Okay, but now I really have to go, it's 12:49 p.m."

"Alright, well, I'll call you tomorrow then."

"Okay, bye."

Man, I didn't even get to see which car was his.

Cindi

Where is Shelle? She was supposed to be here an hour ago to cook dinner. These kids are driving me nuts because they are hungry and Jon won't be home until 9:30 p.m. I hope she gets here

soon, unless I'm going to have to cook dinner myself. Let me check my voice mail. Maybe she left a message. Well, she left a message, but not about being late. Just about some man she met. That's the doorbell now. Maybe it's her.

"Hey big mama! How are my little godchildren?"

"Active and hungry."

"Aw, speaking of the kids, I brought them some gifts from F.A.O. Schwarz."

"Oh, isn't that nice. Oooo, I see you got your hair rebraided. I love your nails, too. Oh, about the toys take them out back to the kids."

That's why I let her be my kids godmother. She may make bad decisions when it comes to men, but not the kids. She's always thinking about my kids. She is the only person, besides my mother, I can trust my kids with. She would make a great mother, if she would just meet the right man. I pray everyday that she finds a man worth the while. Here she comes. Now, she's telling me about this new man she met today. I can tell right now that it's not going to work. They are too alike. They are both arrogant, conceited, and live in their own little nutshell of a world. Opposites attract I say. Oo, it's 8:30. It's time for her to start dinner. Wait a minute. Who is this coming in the house?

"Jon, what are you doing home thirty minutes early?"

"We finished the session early. The husband decided he wanted to settle. Is dinner ready yet?"

"No. Shelle and I were about to go and start, but if your that hungry there's some leftover sweet potato pie to tide you over till dinner."

"Okay. What's up Shelle?"

"Hey Jon. My life is just great. I met the most wonderful man, today."

"Again, that's nice." Ring!! "I'll get it."

"What's up Big Jon?!"

"Hey Darrell. What's going on?"

"Aw, man. I met this fine little honey today. Her name is Shelle and she's about five-seven or five-eight with greenish-gray eyes and..."

"Wait. Did you say Shelle? Shelle Langden? Hold on a minute. Shelle!! Could you come here a minute?"

ETHNOLOGY PROJECT
by Ann Janikowski

For this project I interviewed a very close friend of mine. There was only one question: How would you define your family?

"Oh come on. You met my family. We're a bunch of nuts! I mean, you already know I have two brothers and two sisters. My brothers are in their late thirties, my oldest sister is probably forty. My other sister is twenty. Man, time flies you know? I hate being so old. Its like the world is moving along without me and its just so depressing. Anyway, I always felt closer to Mark because our personalities are so much alike. Remember when you met him the weekend of the party? He called you Betty. I still don't remember why he did that. We were so close and when I was little I looked up to him. He was an alcoholic. He probably still is. Withdrawal from alcohol is like heroin. The pain was so bad for him that he was in the ICU for three days. I caught him drinking again when I went to visit him in California. I was so angry but there was nothing I could do. If I told my mom she would freak out. Um...my other brother is the GQ success story of the family. He's used to be in the army and now he is the family businessman. My oldest sister is a biologist. Another success story. As for me and my sister we're just sort of there. We're not really getting ahead in anything just living life and doing what we can to make it from day to day. My family is really into unity. My sister in law is Korean. It kind of brings together two different worlds. We used to be close but then I just grew up I guess and everything changed including me. It's hard you know? I'm expected to be the next one moving ahead and I just can't do it. Maybe...maybe... I don't know. Maybe it's just that I don't want to move ahead. I'm afraid to grow up and ween myself away from my parents and make it on my own. I want to stay this age forever and keep everything the way it is. I don't deal with change so easily. But back to my family. Everyone hates my dad. Yeah, he's a mean guy that doesn't know how to keep his mouth shut when he needs to. One time when I was little, we were in Wisconsin at my uncle's cottage and me and my dad went for a walk. On the way I put down a pile of sticks and lit them with a match just to see if they would burn out by the time we got back. Well, they did burn out but the fire began to spread in all directions. Since my dad's a fireman he took it upon himself to put it out while I watched crying my eyes

out. I burned down an acre and a half and he never yelled at me. Not a word. But the way he'd look at me just killed me. He wouldn't talk to me, wouldn't touch me, wouldn't even acknowledge me. It hurt. Since then that was his way of dealing with things. Either ignore me or blow up in a rage and yell, throw shit around until he doesn't have anymore energy to release. Then ten minutes later he acts as if everything's okay. I hate it. I resent him for it. But I'm kinda the same way, huh? I mean, I don't snap at you or people close to me, but sometimes I can't help but snap at someone for nothing. Just like that. And my big mouth has gotten me into trouble too many times you know that. But I'm really a passive person. My mom is there for me all the time. I wish you'd talk to her more. She really wants to know you. I mean, I can't really define my family in one word. We're just normal. At least by the national dysfunction standard. Every family has problems. Some more than others.

Stages, Voices
and Dreams

An excerpt from

IS THIS WHAT I BARGAINED FOR?
by MARY KUSHINER

As Helen gets ready for her big day, the family prepares for festivities. The invitations are sent, the church is ready, the party has been planned. Helen is going to be a nun. Now all Helen needs to do is say goodbye to her best friend. But God may have different plans for her life.

This is a memory play. The frame is HELEN praying to God and it ends at a certain point in the play, when it becomes the here and now.

Scene One

(The stage is dark. HELEN lights a match and then lights the votive candle. Then she walks downstage and looks up. She is holding a prayer book. A light shines down on her. Everything else is dark. HELEN opens prayer book and begins to read from it. She crosses herself.)

HELEN: In the name of the Father and of the Son and of the Holy Spirit. Amen. Come, let us worship. (She chants slowly) Give ear to my words, O Lord; give heed to my groaning. Hearken to the sound of my voice, my King and my God, for to you do I pray. O Lord, in the morning... (PAUSE, she brings the book down to her side and sighs) Dear Lord.... people say that married life is hard and I ... I'm not sure that I'm ready for it. I guess I'm feeling a little anxious about everything that's been happening. What I want to know is..... is this the kind of marriage you planned for me?

(Lights go off, then lights go on in kitchen. HELEN is seated at the table, eating a bowl of cereal. There is a box of cereal, a gallon of milk, and cup on the table. MOM stands at the counter licking envelopes. There is a stack of them in front of her and keys lie on the counter also.)

MOM: Well, that's the last of them. (She puts envelope on stack and fixes stack.) After I send out these invitations, I'm gonna call your father. I told him this morning to put the announcement in the church bulletin, but I have a feeling that he forgot. He never remembers anything I tell him.

HELEN: Why do you have to put it in so early? The party's in a month and anyway, everyone at church already knows about it.

MOM: Fr. Paisus said we should put it in there in case someone doesn't know about it.

HELEN: Well, I'd be surprised if someone didn't. Oh, did I tell you what Fr.Paisus told me after church last week?

MOM: No.

HELEN: He said that he hadn't expected me to be having that kind of marriage.

MOM: That's strange.

HELEN: Yeah. And I know he knows I'm not dating anyone.

MOM: And what other kind of marriage is there?

HELEN: I guess being a nun is the same as being married to Christ.

MOM: That makes sense. (MOM smiles) But, wow, talk about the perfect husband, huh?

HELEN: Yeah, I guess so.

Helen and her Mom continue talking.

HELEN: You're a great Mom and I'm glad that I'm making you happy by becoming a nun.

MOM: As long as you serve God, that's the best way to make me happy.

(HELEN smiles at Mom. A knock is heard from the back door. HELEN gets up and looks through the peephole.)

HELEN: It's Peter. (HELEN opens the door and PETER enters.)

PETER: Hi, Helen.

HELEN: Hey.

(PETER watches HELEN as she sits back down and continues to eat.)

MOM: Hi, Peter.

PETER: Hi. (PETER goes to icon, crosses himself, and kisses it. Then he goes to the fridge and takes out a can of pop. He sits down next to HELEN, opens pop and drinks it. As he does this, talk goes on.)

MOM: (to PETER) Did you tell your Mom I can't make it to the women's group meeting?

PETER: Yeah, she said thanks for telling her. I guess no one's gonna be there next week.

MOM: Really?

HELEN: I'm not surprised. (HELEN looks at MOM, PETER looks at HELEN)

MOM: (to PETER) Isn't your family going to Michigan this year?

PETER: No, my Dad hasn't been able to get time off.

MOM: That's too bad. But, at least you'll get to spend more time with Helen before she leaves. (PETER looks at HELEN, MOM turns back)

PETER (to HELEN): What are you doin' today?

HELEN: Nothing much. (She looks at MOM) But, I think Mom wants me to clean the living room before I go anywhere.

PETER: I need to get a birthday present for my mom, so I thought you could help me find something for her.

HELEN: Okay. (Eats a spoonful of cereal.) Oh, you'll never guess who I ran into yesterday.

PETER: Who?

HELEN: Jenny Sellers!...(PETER looks away, HELEN lightly hits him on the arm.) You remember, your old girlfriend.

(PETER looks back)

PETER: (sarcastically) Thanks for reminding me.

HELEN: Kristen told me you still like her.

PETER: Where'd she get that from? You're the only one who would know who I like. I never liked Jenny to begin with.

HELEN: Really? If you never liked her then why'd you go out with her?

PETER: She forced me into it. Besides, I didn't want to hurt her feelings.

HELEN: Well, you didn't seem to care about mine. You ignored me for a whole month because of her.

PETER: I didn't mean to.... Jenny has a way of taking over people's lives.

HELEN: (knowingly) Sure she does. You were probably glad to get away from me for a while. Best friends have been known to do that.

PETER: No, I—-

MOM: (to PETER) Sorry to interrupt, (to HELEN) but I've got to go to the post office to mail the invitations. I'll be back by lunch time.

HELEN and PETER: Bye.

(MOM walks over to icon corner, crosses herself and kisses the icon of Christ. Grabs keys on counter and stack of envelopes and leaves through back door. MOM changes clothes for the next scene. HELEN begins clearing off her place. PETER gets up and helps her.)

HELEN: Hey, do you want to help me clean so we can leave earlier?

PETER: Sure.

Scene Two.
Later that day.

GRANDMA (to HELEN): So, how is my precious granddaughter doing? You wouldn't believe how happy I was when I heard you're going to be a novice. You know, my favorite aunt went into the convent when she was your age. I used to visit her on the weekends to be away from home for a little while. She was such an angel.

GRANDPA: The nuns I knew were definitely not angels. They made my life a living hell.

HELEN: I'm not going to be a Catholic school nun, Grandpa. My calling is to publish spiritual books.

GRANDPA: Spiritual books, huh? I thought the invitation we got from you was going to be a wedding. (to MOM) Did you put her up to this?

MOM: No. This is all her doing, but I won't say I'm not proud of her. I've always wanted to have a daughter who's a nun.

GRANDMA (to HELEN): It's nice to have at least one holy person in our family.

GRANDPA: Well, I don't know about that. (to HELEN) Are you sure you want to go through with it? You know it means that you'll never get to have (short coughs) you know. (MOM and GRANDMA act shocked. DAD gives a short laugh and HELEN laughs.)

HELEN: I think I can manage to live without it, Grandpa.

GRANDMA: (to GRANDPA) Of all the things to talk to her about, you choose sex.

GRANDPA: (defensively) I was just making sure that she was serious about becoming a nun. We wouldn't want her to change her mind when she gets there.

GRANDMA: Of course Helen's not going to change her mind. She wouldn't have made us come all the way up here if she was, (to HELEN) right, dear? (HELEN smiles. PETER enters through dining room door. EVERYONE looks at him.)

PETER: No one answered my knock.

GRANDMA: Hi sweetie, how are you?

PETER: I'm doin' fine.

MOM: Come and sit down.

(PETER sits next to HELEN.)

PETER: (to HELEN) Hi, Helen.

HELEN: Hi.

GRANDPA: (to PETER) Have you been working out? The last time I

saw you, you were skin and bones. (HELEN snickers. PETER looks at HELEN.)

PETER: A little bit.

GRANDPA: So, Grandma was just talking about how proud she is of our Helen. What do you think of all this?

PETER: (shrugs his shoulders) I guess it's okay.

GRANDPA: Well, five years ago, you would've cried. (to HELEN) Whenever we'd visit he'd always catch me when I wasn't doing anything just to tell me how much he loved you. I swear, whenever you went out of the room, he'd quick go up to me and say, "Is my hair sticking up?"

HELEN: How come I never knew about this?

GRANDPA: Oh, he made me swear to secrecy.

PETER: (to GRANDPA) Yeah, I thought we were still good for that.

GRANDPA: I didn't think you would care. I mean, it's not like you're still in love with her because if that were the case she wouldn't be going to California.

MOM: All right Dad, that's enough joking around. You know, sometimes you don't know when to stop.

GRANDPA: Okay, okay, I'll stop.

(Uncomfortable silence.)

The adults depart and Helen and Peter are left alone.

PETER: Have you been avoiding me because of—

HELEN: No, of course not. It's not like we haven't fought before.

PETER: We haven't.

HELEN: Yes, we... No, maybe you're right. Yeah, I guess we never have.

PETER: What's going on with you?

HELEN: What do you mean?

PETER: You know what I mean.

HELEN: No, I don't. If you mean why am I acting different, I think leaving home is a big enough reason.

PETER: Then you are scared.

HELEN: No, I'm not. (The phone rings. HELEN gets up, but PETER grabs her hand and looks at her imploringly.)

HELEN: What? What is it?

PETER: Don't leave. (Phone rings)

HELEN: I need to answer the phone.

PETER: (frustrated) No, don't leave. (PAUSE. HELEN sits down and PETER lets go of her hand.)

HELEN: What do you want from me?

PETER: I want you to listen to me. There's something I have to tell you. (phone rings)

HELEN: Can't it wait? I was expecting a call from the monastery.

PETER: No, I've waited long enough. Helen, I want you to stay here with me. Don't go to California. (phone rings)

HELEN: I don't understand. I have to go to California.

PETER: Helen... I I love you. (Phone rings. It's cut short by the answering machine.)

MOM'S VOICE: Hi, we're not in. Leave your name and number after the beep and we'll get back to you.

NUN'S VOICE: (cheerful) Greetings in Christ. This is Mother Xenia from the monastery. I'm just calling to say that we received Helen's message. We'll be picking her up from the airport next Tuesday. So, until then, I will be praying that Helen will be brought here safe to us. God bless you. (Answering machine shuts off.)

An excerpt from
A Rose From Rose
by Tiffany McDonald

Scene One

(Lights up on RACHEL in her mid 40's sitting on a bench with a book
in her hands. She is wearing jeans and a white t-shirt with a pearl
sweater over the t-shirt. She also has on glasses. She opens the book
to a chapter.)

RACHEL: (in a soft voice) Chapter eight, "My Sister." In the spring of
1996 most of my friends were hanging out, going to dances, cheering
at our basketball games, preparing for summer fun, basically living a
"normal" teenage life. But that wasn't my case. I was at home taking
care of my sick sister. My sister, Rose, was diagnosed with pancreatic
cancer that previous winter. The doctors said she had less than a year
to live since her type of cancer was incurable. I didn't believe them but
my mother went hysterical. She made me come home straight from
school everyday and watch Rose and attend to her every need while
mom went to work. I didn't mind at all , at first. If I didn't do it who
would ? My mother couldn't afford a live-in nurse since she has to pay
hospital bills and doctor bills. So my mother and I split the responsibili-
ty of taking care of Rose.

(Lights down on bench lights up on a bedroom. ROSE is lying down in
the bed. RACHEL enters the scene wearing a white t-shirt and blue
jeans.)

RACHEL: Hey Rose. How are you feeling?

ROSE: (sits up a little) I'm straight I guess. But it's kind of chilly. Can
you close that window?

RACHEL: (sighs) Sure. (RACHEL closes the window then fixes ROSE'S
pillows.) Are you comfortable?

ROSE: Nope! I ain't gone never be comfortable. (RACHEL goes and sits
in a chair and bites her fingernails) As long as I'm in this here bed,
(Rose points to the bed.) I ain't gone ever be comfortable. (Pause)
Some days I feel fine other days my side just be achin'! (RACHEL goes
and sits on the bed.)

RACHEL: Babe it's going to be alright just hang in there. (RACHEL

rubs her back.) You want some more juice? (ROSE shakes her head yes.) Okay. (RACHEL walks to the table and pours some juice in a cup. ROSE struggles to sit up but finally succeeds.)

ROSE : So did you talk to Mike today? (RACHEL hands her the drink.)

RACHEL: Yeah. Our one year anniversary is coming up. I can`t wait! (RACHEL sits on the bed next to ROSE.)

ROSE: (smiles) I`m happy for you. So what he got planned?

RACHEL: (looks disappointed) He won't tell me. But it`s probably nothing too special. I know his dad is going out of town tonight. So you know what that means...

ROSE: (yells) Rachel! Ewww..... I can`t believe you said that.

RACHEL: (laughs) Calm down it`s not what you think. Besides mom would kill me.

ROSE: (points to herself) I would kill you. Cancer or no cancer you`d be hurt girl.

RACHEL: (looks at ROSE hard) I`m 16. I`m ready.

ROSE: When I was 16 I wasn`t ready so you ain't either!

RACHEL: (giggles) Okay! You know I was just kidding with you. I`m not going to have time for all that once my writing career takes off. I`m going to spend most of my time writing.

ROSE: Yeah. And you better dedicate one of your books to me.

RACHEL: (smiles) I will. So did Mr. deadbeat call?

ROSE: Yeah, he told me to tell you hi. (ROSE picks up a magazine and begins to flip through the pages) Call him.

RACHEL: (with attitude) Why? I don`t know how he can say hi to us when he couldn`t say bye to us when he left us 14 years ago. Now he wanna be somebodies` daddy. Sure!

ROSE: Yeah, whatever. I don`t care. That's old news. He`s here now so that`s all that matters. So would you just call him. Talk to him and maybe you can grow to like him.

Scene Two

(MOM walks in with a white nursing suit on looking tired.)

MOM: Hey girls.

RACHEL: Hi Ma.

MOM: Rose baby, how was your day? (MOM looks at them both.)

ROSE: It was okay. You know. The same as usual. (ROSE stops looking at that magazine.)

MOM: Well we all know you tough so you can take it.

ROSE: Yeah whatever.

(MOM looks at RACHEL)

MOM: (sternly) Rachel! (Rachel looks at her quickly.) Did you do everything you were suppose to? (Nags) Did you mop the floor, clean the kitchen?

RACHEL: (whines) Yeah ma! (RACHEL walks and leans on the dresser.)

MOM: Did you give Rose her pills, feed her, give her a bath....

ROSE: (yells) Yeah! She did everything ma! God. She only one person. You make it seem like I'm a puppy.

MOM: (Sternly and points her finger) Don`t raise your voice at me! I work too hard to come home and listen to this. (MOM turns to RACHEL.) And before I forget that party tonight is out of the question. I have to fill in a shift at the nursing home, so I can`t stay home with Rose. (RACHEL looks at MOM then at ROSE.)

RACHEL: (whispers) Yes m'am. (MOM exits. Lights down on bedroom lights up on bench.)

RACHEL: My mother was always rearranging my life. If I had plans to go somewhere she would change it at the last minute. Because she got some unnecessary overtime or filled in for someone who did home nursing for that day. I know it wasn't her fault. She worked so hard to provide for Rose and me. But Rose had so many special needs. I don't

think my mother could handle it. At that time it was frustrating for me. Don't misunderstand me. I loved my sister with all my heart but I was getting sick of taking care of her. It sounds selfish but that is how I felt. My mother put so much pressure and responsibility on me. I felt like I was doing her job. I wanted to be taken care of too. I had bigger dreams than living my life for other people. I wanted to be a writer. My mother always told me I had the potential of being a good one. But Rose needed me. I know sometimes she felt guilty about that so I tried to be upbeat any time I was with her to hide my frustration. I never saw my friends or got to do things I wanted to do. All I wanted to do was lead my own life.

Scene Three

ROSE: I wanna get out of bed.

RACHEL: What. Do you want me to help you to the bathroom?

ROSE: I want to get up and go outside! Rachel please take me!

RACHEL: Now you know I can't do that. You know mom would have five heart attacks.

ROSE: (whines) Please! For me Rachel!

RACHEL: (looks at her deeply) Well O.K. but if you even sneeze or shiver you coming inside.

ROSE: (smiles) O.K.

(RACHEL precedes to help her out of the bed and into the wheelchair. ROSE makes faces of pain but tries to hold it in so RACHEL won't see. RACHEL gets her into the wheel chair. ROSE face relaxes.)

RACHEL: There you go. Do you feel O.K.

ROSE: (unsurely) Yeah. Wait hold on! (ROSE starts to hold her side) Ouch! Ouch! I can't do it!

RACHEL: O.K. O.K. calm down. Come on let's get you back in bed. (RACHEL gets her back in bed.)

ROSE: Rachel. God it hurts. (RACHEL gets her pills and some water off of the table and hands it to ROSE.)

RACHEL: Don't worry. Here take your pills. Feel better?

ROSE: (yawns) Yeah a little. Thanks so much.

RACHEL: Look don't worry about it. (RACHEL notices a dozen roses in a vase on the table.) Cool roses. Who got them for you?

ROSE: Dad.

RACHEL: (cuts her eyes) Oh. Well I'll let you get some sleep. (RACHEL walks toward the door. ROSE tries to get up but doesn't.)

ROSE: Rachel wait! (RACHEL turns around quickly.) Well since you like the roses. Here have one. (ROSE slides over enough to pick one of the roses out of the vase.) Take it with you when you go to Mike's house fo' y'all anniversary. For good luck. (RACHEL walks and takes the rose out of ROSE'S hand. She looks at the rose then smells it and smiles.)

RACHEL: Thank you. I'm sure it'll bring some. Enjoy your nap.

Their mother had to work again that night. She told Rachel that she could not go on the anniversary date that she had been planning for weeks. Rose convinced Rachel to go anyway.

Scene Three
*Rachel enjoys her evening and returns home
and is surprised by the presence of both her parents.*

MOM: Rachel, sit down with us. (They all sit down.)

Rachel: Mom it really isn't this serious.

DAD: (stern but sadly) You don't know how serious. Look we have something to tell you.

RACHEL: What do you have to tell me "father dearest." (RACHEL puts her purse on the couch then looks at both of her parents. They look very upset.). (angrily) What's going on? Would one of you tell me!

MOM: (with anger) Look! Rose died two hours ago. Because you weren't.....

RACHEL: You're kidding right?

DAD: No she's not.

(RACHEL jumps up. Puts her hands on her head and paces back and forth. MOM gets up to comfort her but RACHEL shoves her away.)

RACHEL: (screams) OH MY GOD! OH MY GOD! OH MY GOD! I cant believe this! (RACHEL runs to the back of the room to check for ROSE but the bed is empty. She falls on her knees at the bed.) I'm sorry Rose. (Lights down on bedroom, lights up on bench.) Life just wasn't the same after Rose died. So much regret filled my heart I didn't know what to do. I thought I killed my sister for one night with a man I grew to hate. I remember Rose telling me I would not regret going to Mike's house that night but who'd ever guess she'd be wrong. I think of her day and night, night and day wishing I could go back in time to at least hold her hand through her time of pain. Also to let her know that I always cared. (RACHEL closes the book and walks up to a grave, kneels in front of and places the book gently on the ground.)

An excerpt from

WHAT GOOD IS A POEM
IF IT DOESN'T HAVE A RHYME?
ALBERT DOWNING

Characters :

DANA: 18-year-old black female. She's in love with DAVID, who is Jewish. She's scared to tell her parents that she's been dating a Jewish guy.

DAVID: 18-year-old Jewish guy. He's in love with DANA, who is black. He wants to finally meet DANA's parents.

MOM: (DANA'S mom) She's about 44 years old. She's very understanding of DANA's situation. She dosen't mind that DAVID is Jewish.

DAD: (DANA'S dad) He's about 46 years old . He's not a racist, but he has many ill defined feelings about DANA dating a guy that isn't Black.

Scene One
The Plan

(Curtains open, revealing DANA and DAVID in their separate bedrooms, speaking on the telephone to each other.)

DANA: So David are you sure that you still want to come over to dinner tonight?

DAVID: Uh, yeah I'm still gonna come over tonight. I'm just tired of keeping this from your parents. I feel that it's time for them to know.

DANA: Yeah, you're right, but I just don't know what they're gonna do when I tell them that you're Jewish.

DAVID: (surprised voice) So you still haven't told them yet?

DANA: No, not yet. I was...

DAVID: Why not? I thought that you were supposed to tell them everything a couple of days ago!

DANA: I was going to tell them, but they were in such a good mood, that I didn't want to spoil it and make them upset. But, I'm gonna tell

them everything before you get here tonight. Don't worry about it!

DAVID: O.K. It really doesn't matter anyway.

DANA: What doesn't matter?

DAVID: You know. I mean, when I come over there, they're gonna see that I'm Jewish anyway. So it really doesn't matter. But, then again they might have a heart attack or something when they open the door.

DANA: Yeah, they probably will. But, I'm just gonna tell them everything before you get here. It's not like interracial dating is one of the biggest sins or crimes or anything like that. But I'm still not very sure of how they're going to feel about this whole thing. I mean, they're not racist or anything like that, but... well... I mean... you know, its just assumed and expected that I would marry a black man. I bet that your parents expected you to marry a Jewish woman, right? You see, its not really racism, you know, its just the way that things usually happen.

DAVID: Whoa! Wait a minute, Dana. Did you just say marriage? I mean, I do love you and everything, but marriage is... just a real big jump for us I mean, that's...

DANA: No, no. I was just using marriage as an example. You know what I mean? I'm not even thinking about marriage.

DAVID: (sarcastically) But, what about us? Dana, I love you.

DANA: Yeah I love you too. But you're the one who said that marriage is a big step for us. Remember?

DAVID: (sarcastically) Uh... Oh yeah. I forgot!

DANA: (laughing) You're so crazy! (laughter leads to silence) Let's talk about something else.

Scene Two
The Announcement

MOM: So, who are you inviting?

DANA: I invited one of my friends from school.

MOM: What's your friends name?

DANA: (slowly) Um... my friends name is... David Green.

MOM: (surprised) Oh! It's a boy! Is David your boyfriend?

DANA: Um, well... I guess so. That's sort of why I came out here to talk to you...about me and David.

(DAD reaches for the remote control on the table next to him, then turns off the television.)

MOM: (worried) Is everything alright? Are you ... You're not... I mean... Did you two have sss...

DANA: No, no. It's nothing like that. I just..

DAD: Is there anything that we should know about this David before he comes over?

DANA: Well...yeah. But it isn't anything bad. I just wanted you two to know.

DAD: You wanted us to know what?

DANA: We've been seeing each other for a while at school and... I just wanted you two to know what type of boy he is. I like him a lot. He's really smart. He's a musician and a poet. And he's just a really sweet guy. He even wrote me a poem! Do you wanna hear it?

MOM: (surprised) Um, sure. We'd love to hear it.

(DANA runs into her bedroom, leaving her parents a little bit surprised. She re-enters the living room once again with a sheet of paper and squeezes back into her position on the couch.)

DANA: Here's the poem that he wrote for me. It goes like this. (DANA takes a deep breath). "What good is a poem if..." Oh, yeah I forgot to tell you the title of the poem. It's called " What good is...?" It goes like this (Another deep breath) " What good is a poem if it doesn't rhyme? What good is a clock if it doesn't keep time? What good is the sun if the sun doesn't shine? And what good is the world if it can't be mine? What good is writing if there aren't any words? What good is speaking if you aren't heard? What good are high goals if they must be lowered? And what good is tomorrow if there's nothing to look toward? What good is a dream if it doesn't come true? What good is freedom if there's nothing to do? What good is the sky if the sky isn't blue? And mostly what good am I if I don't have you?" (a moment of

silence). I really like it. Did you two like it?

MOM: Oh yes, I loved it. He sounds like a really sweet boy! I can't wait to meet him.

DAD: Yes, yes. I'd like to meet the young man as well. That poem that he wrote for you was very good. He has a lot of talent. (DAD looks at MOM) It almost reminds me of a poem that I wrote for your mom back when we first started going together. It was something like, "Roses are red, and violets are blue. I was only pretending to like her so that I could get closer to you." (They all start to laugh.)

MOM: (to DAD) Oh, you're so silly!

DAD: Well, you know, I try my best! (While her parents are still laughing, a serious expression grows over DANA'S face.)

DANA: Mom, Dad... there's just one thing that I didn't tell you about David. It probably won't really even matter to you, though. I mean, it doesn't really matter to me at all. But ah...well...

DAD: Yeah, what is it?

DANA: Well, I hope that... um... You guys won't get mad, will you?

MOM: What could we possibly get upset about? He sounds like a perfect gentleman.

DAD: Yeah. He sounds alright to me. So what is it?

DANA: Well... you see... he's not... um he's.. Well, you see we both have a lot of stuff in common. We both like each other a whole lot. We both listen to the same kind of music. We both like to watch the same television shows. And... uh ... Well, you know, stuff like that. But... there's just one thing that we don't have in common.

MOM: Yeah. What's that?

DANA: (sarcastically) Um... you know that stuff they call melanin?

DAD: (unsure) Uh, what's that? (pauses)) Wait, I think...

DANA: Well...(confident voice) I'm just gonna say it right now and get it over with.

MOM: What?

DANA: David isn't Black.

DAD: Damn it. I knew it was something wrong!

Scene Three
The Meeting

(DANA walks to the door and opens it.)

DANA: Hey David! How you doing? (she hugs him)

DAVID: Hey! I'm doing good. How about you?

DANA: I'm doing good. Come meet my parents. (she brings DAVID into the house.) Mom, Dad, this is David. David, these are my parents.

DAVID: (confidently) Hello! How are you both doing?

MOM: (walks up to DAVID and shakes his hand) We're doing fine. It's nice to finally meet you.

DAVID: Its nice to finally meet you also!

DAD: (Gets up and goes to shake DAVID's hand) Yes. It's nice to finally meet you. (With a slight grin) We've heard so much about you. We've been waiting for months for you to come by. (They all start to laugh.)

MOM: Well, David I know that were probably expecting some food, but we still haven't started it yet. So Dana and I are gonna go in the kitchen to cook some chicken, and we're gonna leave you two men alone to talk for a few minutes. (MOM exits. DANA and DAVID stare at each other for a moment, then DANA exits. DAD and DAVID sit down on the couch.)

DAD: So, David... um... yeah! Where are your parents?

DAVID: Well, they're at home. I told them that I wanted to come over here by myself.

DAD: Yeah, I think I understand. (thinking) You know, that poem that you wrote for Dana was very good. I told her that I thought that you had a lot of writing talent.

DAVID: Well, thank you very much Mr. Cooper. I really love writing.

Especially poetry.

DAD: Is that so?

DAVID: Yeah!

DAD: Have you ever heard of Gwendolyn Brooks?

DAVID: Sure! She's one of my favorite writers! Her, Maya Angelou, and Langston Hughes. They're all my favorite writers... and...

DAD: (staring) Wait a minute. Are you trying to tell me that you've read Langston Hughes?... And Maya Angelou and Gwendolyn Brooks?

DAVID: Yeah. I like them a lot too. And I forgot to mention James Baldwin. I like him a lot too.

DAD: Oh my god! This is very interesting. The fact that your favorite writers are... all Black. I mean, I just didn't expect this.

DAVID: Yeah, I understand. To tell you the truth, Dana was real surprised also when we first met each other. But personally, I like to read everybody. I read everybody, I listen to everybody, and... you know, I just like all types of people. Um...do you mind if I ask you a question?

DAD: Ah, no. Go ahead.

DAVID: Well I guess you know that Dana and I have been seeing each other for a while now at school and she came by my house to meet my parents and everything... but...

DAD: (surprised) Well, I didn't know that she had come to your house to meet your parents. I didn't know that!

DAVID: Well it was only to meet my parents. They really liked her a lot. But the reason that you never about us sooner is because Dana told me that you might all get upset. So.. I just wanted to know if you have a real big problem with your daughter and I dating each other?

DAD: Well, I don't know what Dana told you exactly, but... I'm not a racist or anything like that. Alright?

DAVID: Mmm...alright.

DAD: But it's not really that I have a problem with you two seeing each other or dating, but... its just kind of hard to put into words. But

basically, I'm just worried about you and Dana, because I know that there are a lot of crazy people in this world who are racist that don't accept this idea of interracial dating.

DAVID: Yeah, I understand. My parents say the same thing.

DAD: See, I thought you would understand, and I thought that your parents would have the same concerns as well. But... to answer your question, no I do not have a problem with you and Dana dating each other... Because I know that both of you are strong and smart and... basically I feel like it's all gonna work out well.

An excerpt from

DON'T DO IT SAMANTHA
Claudia C. Alonzo

Looks aren't everything. But how far would one girl go to be thin and attractive?

(The lights reveal a bedroom, which will occupy all of the stage except for a narrow portion of the entire left side. Samantha is sitting on her bed. Heaps of clothes are on the floor. She is wearing a loose [padded] dress, since the actress will have to signify heaviness.)

SAMANTHA (thinking aloud): Summer, summer, summer. It's great! Would be even greater if I could fit into last year's summer clothes... God, what am I going to do about this? (sighing loudly)

(knock on door. Enters Vera)

(SAMANTHA sits on desk chair and VERA lays on her stomach on the bed).

SAMANTHA (trying to sound excited): So, Vera, how was Hawaii?

VERA: It was beautiful! Sam, I swear, you shoulda been there.

SAMANTHA: Wish I was. Sounds like a great place...

VERA: Absolutely gorgeous! The beaches, the food, the guys...

SAMANTHA (laughing): OK, spit it out, Vera. How many guys did you meet?

VERA (propping chin on hand): A lot. But nothing mushy or any-thing. I don't think long distance romances are good.

SAMANTHA (in soft voice): You're so lucky, Vera.

VERA (shrugging): My dad won this raffle at work and BANG! Aloha! We get to go to Hawaii. Yeah my family and I were lucky to go, but it's not like we could go whenever we want.

SAMANTHA (sadly): Still, you're pretty damn lucky.

VERA: Yeah... why do you sound so sad, Sam?

SAMANTHA: While you have a body that resembles Claudia Schaefer, I have one that resembles a very large sea creature.

VERA (sitting up):Oh, Sam, don't say that.

SAMANTHA (standing up and starting to pick up a heap of clothes on floor): I tried on these clothes this morning, and.... and they don't fit that well.

VERA (grabbing some clothes and handing them to SAMANTHA): Let me give you a hand with these clothes... what are you going to do with them?

SAMANTHA (taking clothes from VERA): I don't know ... burn them? Use them as rags? (throws clothes under bed) They should be fine under the bed.

VERA: Um... ok... Sam, don't get so upset!

SAM (sitting on floor, crossing arms): I'm not going psycho or anything, don't worry. I'm just upset.

VERA: I understand that, Sam, but—

SAMANTHA: But what? There is nothing to say except that maybe I can join Shamu the whale for a water show?

VERA. (head in hands): Samantha, would you—

SAMANTHA (jumping up and standing center stage): I can see it now! (raising arms towards ceiling and begins to speak in deep announcer's voice) Ladies and Gentlemen, here we have Samantha Chandler and Shamu performing a magnificent art show!

VERA: Sam, would you shut up?

Scene Two
A few weeks later.

(lights reveal ERICA, SAMANTHA'S mom, standing in the middle of SAMANTHA'S bedroom. She is alone, wearing glasses, dressed in jeans and a blouse, carrying a few shopping bags).

ERICA: Samantha, where are you? (SAMANTHA emerges from the door at up stage right. She is wearing the loose dress she wore at the

beginning of the play, except this time, the padding is gone. In previous scene she was wearing the robe, over the dress. Her hair is messy. She slowly sits down on desk chair).

ERICA: What's wrong, dear? (SAMANTHA remains silent) Samantha, talk to me! (drops bags on bed and stands at SAMANTHA'S side).

SAMANTHA (in throaty voice): I'm fine, Mom.

ERICA (putting a hand on SAMANTHA'S forehead): You don't have a fever, but your throat sounds hoarse, Sam.

SAMANTHA: Just allergies, Ma. I'll be fine.

ERICA: Your voice...

SAMANTHA: Ugh, Ma, I just have allergies. My throat is dry. That's it. What's in the bag?

ERICA (sitting on bed): Some clothes for you. I took a quick trip to the mall... I'm not sure about you, Samantha. You look pale. It's noon and you're not even dressed yet.

SAMANTHA (shrugging): Ma, I told you. It's allergies. Didn't sleep well. I just took some Benadryl. I'll be fine. The medicine makes me tired.

ERICA: I'll take you to the doctor in a couple days if you're feeling sick.

SAMANTHA: OK. I'm sure I'll be fine, though... (quickly) so show me what you bought.

ERICA (taking a few tank tops and skirts from bag and holding them up): But remember, doctor visit in a couple days if you're still not well... Do you like them?

SAMANTHA: Yes, but who are they for, Ma? Cindy Crawford?

ERICA: No, for you! (ruffling Samantha's hair) You have really got thinner, Samantha. This past month and a half, you've gotten quite slender.

SAMANTHA: Ma, you didn't have to buy me—

ERICA (handing clothes to SAMANTHA): See, I have always told you, if you eat what I cook, you'll be healthy. You only ate my food if I cooked something "normal." Now you are eating my healthy cooking.

I can't believe you ate tofu the other night!

SAMANTHA (shrugging): Well, I love your tofu. What can I say?

ERICA: Wow, you've changed, Samantha. I'm happy for you dear.

SAMANTHA (looking down):Thanks. (ERICA exits down stage left. SAMANTHA retrieves diary from dresser drawer. She reads her diary entry aloud.) I am happier with my body. I am, really. I won't have to do this forever. Besides, I look a lot better than I did before! I may not feel so great, but I look great. As I heard from someone, you gotta suffer to look beautiful. I've been smart about this, I haven't been caught. The trick to this is being secretive and pretending that everything is normal. I told my mother that I exercise with Vera at her house. When she asked why, I said that Vera offered to help me, and I couldn't refuse my best friend. Ma was kinda hurt, I guess, but got over it quickly. I think she's starting to like the idea. I don't enjoy what I do, but it's working. Mom won't figure me out. Vera won't figure me out. No one will. I won't let it happen. No one will ever know. It's like I'm living a secret life: the new Samantha, the one who exercises and eats salads and the secret Samantha: the one who eats and eats and gets rid of it afterwards. The secret Samantha will never surface and show her face to the real world. (closes diary and lights go out)

An excerpt from

A HARD HEAD MAKES A SOFT BEHIND
by TIFFANY HENDERSON

A mother does know best. In this play, that is a lesson one teen must learn on her own.

(Lights up on SANTRICE reading from diary, Center Stage)

SANTRICE: I wish things could be like they use to be with my family. I'm 16, she needs to let me go. I feel trapped. I want to be with MAREESE. I don't have any space, I can not do anything with out being questioned.

MOM: Santrice what are you doing in there?

SANTRICE: I'm combing my hair, you know I can't go out side all messed up.

MOM:Well hurry up because I have to use the bathroom

SANTRICE: (Pause) Here I come, give me one more minute.

MOM: (getting mad) Get out the bathroom now! If you don't come out, I'm coming in.

SANTRICE: (Mumble) I'm out, man.

MOM: What you say?

SANTRICE: Nothing, nothing at all.

(MOM in bathroom. phone rings. Lights up on MAREESE.)

SANTRICE: Hello, the Wilsons.

MAREESE: What's up?

SANTRICE: How you know it was me? It could been my mamma.

MAREESE: I know your squeaky voice.

SANTRICE: Whatever, ain't nothing up. I just got through combing my hair.

MAREESE: Is your mom at home? I see her car outside.

SANTRICE: Where you at?.

MAREESE: On the porch looking dead at your house.

SANTRICE: (Smiling) I know you are glad you live down the street. That gives you a chance to spy on me.

MAREESE: What do you mean spy on you? Just come on the porch in 10 minutes.

SANTRICE: For what?

MAREESE: So I can talk to you.

SANTRICE: (Thinking) Give me twenty minutes.

MAREESE: Yeah! just be out there. (Lights down on MAREESE. MOM comes out of the bathroom.)

MOM: Who was that?

SANTRICE: Just a friend.

MOM: (Hand on side) What friend? Don't tell me that boy Mareese. Aren't you getting tired of seeing him. (MOM and SANTRICE start to set the dinner table)

SANTRICE: Well... (MOM cuts her off)

MOM: (Loudly) Well, I am getting tired of seeing that boy.

SANTRICE: He is a nice boy mom. He has some problems that needs help other than that he's a nice boy.

MOM: (Not paying much attention) That's nice then.

SANTRICE: (Ask with suspicion) Are we still going to church Sunday?

MOM: (Happily) Yes baby, never miss a Sunday.

SANTRICE: (Dragging her words) I know never miss a Sunday.

MOM: Santrice.

SANTRICE: Yeah!

MOM: (Mad) Don't answer me yeah!

SANTRICE: Yes.

MOM: (Smiling) Ask your little friend if he would like to join us.

SANTRICE: He is not my "little friend" ma, that's my boyfriend.

MOM: (Saying nicely) Well, whatever he is ask that little baggy pants wearing boy if he would like to join us in church sometime.

A few minutes later.

MAREESE: (Happy) What's up doll? Where's yo' momma? I bet she in there reading some ole' gospel magazine.

SANTRICE: (Upset) Don't be talking about my momma's beliefs. Keep your comments to yourself.

MAREESE: So have you told your mother that I don't believe in your so called "God."

SANTRICE: No! You know if I tell her that it would break her heart to know her little girl is dating the devil.

MAREESE: (Eyes pop out) What dat mean? I ain't nobody's devil.

SANTRICE: (Tries to explain) I didn't mean it like that but my mother would think you some kind of devil, all that drugs you be slanging on the streets.

MAREESE: Com'on now you know I don't slang.

SANTRICE: (Laughing) My bad! You just be sitting in somebody's momma kitchen counting money. (They both laugh) (Said low) You know me and my mother was talking about you going to church.

MAREESE: And what did you say?

SANTRICE: I lied. I told her you had to go to your own church.

MAREESE: Good! So are we still going to the show tonight?

SANTRICE: (She gets quiet) Well I can't go today because I have to go to church for bible study.

MAREESE: Can't you tell your mother you're sick or something. I

really wanna be with you. Can't you tell her a little white lie.

SANTRICE: (Loudly) No! I can't lie, I been lying for you for the last four months, I'm tired of it. Do you know how it feels to lie to a mother who trust you.

MAREESE: (Pause) So what you trying to say? You don't want to be with me. Is that what you're trying to say?

SANTRICE: (Defensive) No baby! I just don't want to hurt my mother. You know I want to be with you.

MAREESE: (Loudly) But you love goin' to church with yo' church goin' bible head momma.

SANTRICE: (SANTRICE rolls her eyes in disgust) (Loudly) What you trying to say? My momma ain't nobody bible head momma. What about yo' daddy, your drunk daddy, always saying something stupid, just like your big head ass. (SANTRICE looks up in the air with hands together as if she was praying) (Says very fast) I'm sorry God.

MAREESE: Look at you can't even say a curse word without saying I'm sorry God. (Starts to mock SANTRICE)

MAREESE: "I'm sorry God," I really am.

SANTRICE: You know what? You can be about your way, and when you get some kind of intelligence come back and see me.

MAREESE: That's cool, when you stop listen to yo' momma then call me up.

SANTRICE: (Rolling her eyes) Bye then.

MAREESE: Bye. (still mocking SANTRICE as he's walking down the street) "I'm sorry God"!

SANTRICE: (Talks to herself) Sometimes he is just so stupid, but I still care about him.

(Lights still upon porch. Lights up on kitchen on mom.)

MOM: (Calls loudly) Santrice! It's time to come in, I need your help with the dishes, so we can eat.

SANTRICE: (Loudly) Here I come. (Get's off of crate, watching Mareese walk down the street as she is going in the house. Lights down on Mareese and on porch)

Later that evening.

(Phone rings, lights up on MAREESE. SANTRICE runs to phone.)

SANTRICE: Hello, the Wilsons.

MAREESE: What's up?

SANTRICE: (Sounding mad) Nothing, nothing at all.

MAREESE: Well look I'm sorry about not respecting you and your mother earlier.

SANTRICE: (Not believing him) Yeah! Whatever! I was just about to call you.

MAREESE: (Being smart) I thought you had to go to church.

SANTRICE: I did, but I told her I was sick.

MAREESE: (Smiling) That mean yo' mom ain't at home.

MAREESE'S DAD: (In the background) Mareese get off my phone!

MAREESE: In a minute.

SANTRICE: She's still at church, she ain't gon' be home until 10:00. That two hours from now.

MAREESE: So can I come over?

SANTRICE: (Unsure) Well, I don't know.

MAREESE: Here you go again.

SANTRICE: Well, I guess you can come over for a little while. When you coming?

MAREESE'S DAD: Get off my ghat damn phone!

MAREESE: (Says very fast) On my way now.
 (Lights down on MAREESE.)

SANTRICE: (Talks to herself) Let me fix the bed, Oh yeah! Let me spray the bathroom cause momma came out last and I know how that

is. I don't want Mareese to be talking about my house and that smell that's coming out the bathroom. (She laughs to herself gets the spray can and begins to spray.) I hope my mother don't come home all early because I want to spend time with Mareese. I hope he don't bring his big head friend with him because I don't want him to be all in our face. (Stop spraying. Goes into living room and starts to spray Lysol on the couch and in the air.) Let me brush my teeth because them onions I had was no joke. (Goes into bathroom to brush teeth, she starts to sing. Mumble singing, toothbrush in mouth) "I'm every woman, it's all in me, anything you want done baby, I'll do it naturally." (SANTRICE finishes brushing her teeth. SANTRICE walks out the bathroom. She walks through the house with the spray can. Door bell rings, she throws the spray can under the pillow on the couch. Looks out peep hole) Who is it?

MAREESE: The boogy man. He's coming to get you.

SANTRICE: In that case I can't have company.

MAREESE: (Getting loud) Girl open the door. It's me Mareese. (SANTRICE opens the door, as MAREESE walks to the couch he falls on a church mat.) Why don't you tell yo' momma to move that mat, every time I come over here I fall on that stupid ass mat. (Trying to be cool as he gets up and walks to the couch.)

SANTRICE: (Laughing) That ain't my fault you fell.

MAREESE: What you laughing at? Shut up man.

SANTRICE: You can't tell me to shut up.

MAREESE: Just tell yo' momma to move that stupid ass mat. (sits down on the couch)

SANTRICE: (Getting mad, talking loud) Listen you are in my house and when you're in my house you will respect my mat, my mother's belief and mine as well. (MAREESE gets up and moves to the other side of the couch.)

MAREESE: What the hell! What's this I'm sitting on? (Pulls can from under his behind.) Who put this can right here? I bet you did it. (Phone rings.)

SANTRICE: (Paranoid) Don't say nothing! I bet this my mom. (MAREESE looking dumb.)

MAREESE: Whatever. (Lights up on mom. SANTRICE answers phone.)

SANTRICE: (Sounding sick, dragging her words) Hello, the Wilsons resident.

MOM: Do you feel a little better?

SANTRICE: (Sounding sicker) Not really.

MOM: Well, I'll be home at 10 o'clock.

SANTRICE: OK, I have to go to the bathroom (MAREESE laughing to himself.) You know the deal. (SANTRICE fanning her hand telling MAREESE to stop.)

MOM: Respect me. I'll call you back in 30 minutes then.

SANTRICE: (Thinking hard) I'll be sleep by then.

MOM: (Suspicious) Do you have company? Because you are in such of a rush trying to get me off this phone.

SANTRICE: No! I don't have company, you just caught me at a bad time. Anyway I feel too bad to have any company. I don't want anyone to see me like this. Bye mom I really have to go to the bathroom.

MOM: Bye. (Lights down on MOM. MAREESE froze.)

SANTRICE: I lied to my mother, not feeling guilty at all. Most of all I lied to myself for a night of lies. I'm felt confused about my feeling for MAREESE. I didn't know what to say to him when he told me how he felt about me. I didn't know what to believe. I felt surprised and very confused.

An excerpt from

A TRICK OF LOVE
by Naimah S. Cyprian

*Even when sisters are the best of friends, sisters will be sisters.
In a trick of love, it takes the love and patience of a mother and
her best friend to be sure they stay sisters.*

SETTING: Two Apartments: SEMIKA'S apartment is located on the
whole down part of the main stage. SEMIKA'S apartment contains
DEBORAH and ZABRINA'S bedroom down stage right to stage center.
Also, her living room on the whole down stage left to center down
stage. DENISE'S apartment is located upstairs (platform upstage).
SEMIKA and DENISE are sitting on the couch, center stage, in SEMI-
KA'S living room. DEBORAH and ZABRINA join them to watch a
movie.

ZABRINA: (With popcorn in her mouth.) Man, I cannot wait until
school starts. I'll be a freshman.

DEBORAH: (Cheering.) I'll be the big senior. Watch on the first day
you gonna get pennies thrown at you.

ZABRINA: Let somebody throw one penny at me. I'm gonna set it
off. But when you get there everybody gonna run for cover (Lowering
her voice.) from how ugly you look.

SEMIKA: Shhh!

DEBORAH: Would you stop hogging all the popcorn? Dang!

ZABRINA: No you stop hogging the popcorn. Don't tell me what to
do.

SEMIKA: Shut up you two and watch the movie.

DEBORAH: (DEBORAH is snatching the bag away from ZABRINA.)
The rest of this is mine.

ZABRINA: Let me get some. Give me the bag back. Give me the bag
back.

DEBORAH: Nope! (ZABRINA is grabbing the bag and ripping it.)
Look at what you did.

ZABRINA: Here you can have it now. I don't want it. (ZABRINA is throwing popcorn at DEBORAH. DEBORAH is throwing popcorn back and smacking ZABRINA with the popcorn bag twice.)

SEMIKA: What in the hell are y'all doing?

DEBORAH: Don't be throwing nothing at me.

ZABRINA: Why you hit me twice? (DEBORAH and ZABRINA are pushing each other on the floor.)

SEMIKA: Break this up right now. (SEMIKA and DENISE are grabbing a hold of DEBORAH and ZABRINA by the arms standing them up and away from each other.)

DENISE: Calm down Zabrina.

ZABRINA: Let me go.

SEMIKA: Deborah, why are you fighting your sister?

DEBORAH: She's the one who started it.

ZABRINA: She took the bag from me. Let me go!

DENISE: Miss you better calm down first.

SEMIKA: Calm down! (SEMIKA and DENISE are letting the sisters go.) Deborah you know you are too big to be fighting.

ZABRINA: If she was never hogging the bag like she ain't never ate before and throwing popcorn at me. We wouldn't be fighting nor would we be discussing this right now.

SEMIKA: Two wrongs don't make a right. Remember that, from the time when you almost got expelled from school.

DENISE: Look... I'm going to catch you later. Where are my keys? I had them in my pocket, but now I can't find them.

ZABRINA: They're in the corner of the couch. (DENISE is grabbing her keys and SEMIKA is walking her to the door that is up stage right.)

DENISE: Aw! I'll get my videotape later. Y'all two need to work out y'all problems and try to get along. Cuz at some point, y'all going to really hurt each other. See ya.

SEMIKA: Bye.

DEBORAH: Mom you don't even have to bring back up that schoolent. That happened a long time ago.

SEMIKA: Don't tell me what not to bring up.

DEBORAH: It was Zabrina's fault from the beginning.

ZABRINA: No it wasn't my fault.

SEMIKA: That's the same thing you said when some girl kept bumping into your desk in school. And so instead of you telling the teacher what the girl was doing, you took matters in your own hands.

ZABRINA: She show did.

DEBORAH: Shut up. You always have something stupid to say.

SEMIKA: Deborah leave the room. right now.

DEBORAH: Huh!

SEMIKA: Don't question me. Don't come back until you can settle things with your sister and calm down that attitude of yours.

(DEBORAH is walking out the living room through up stage left.)

DEBORAH: (To herself.) I can't stand being in the same house with Zabrina. She is always getting me in trouble and don't shit ever happen to her. I wish I could live with Denise.

SEMIKA: Come back here, Deborah. What was that that you were mumbling?

DEBORAH: Nothing.

ZABRINA: She said something about hate being in the same house with me and wishing something.

SEMIKA: What did you wish? Tell me.

DEBORAH: I wish I could leave with Denise.

SEMIKA: You want to move with Denise?

DEBORAH: Sometimes.

SEMIKA: Do you think moving with her is going to make things better with you and your sister? Do you? Look at me while I'm talking to you.

DEBORAH: Yeap.

SEMIKA: Fine... go pack your bags and move. I give you the permission to call Denise right now and see if you can stay. (SEMIKA is turning. DEBORAH towards the up stage left exits and pushing her.)

DEBORAH and ZABRINA: Huh?

SEMIKA: No... I don't want to hear not one word. Go on, Deborah. Call her right now. You want to move. I'm granting your wish. Bye.

DEBORAH: All right! Fine! (Lighting up on DEBORAH picking up the phone.) (To herself) I don't know what's going on, but man.... let me gon head and call Denise. What was her number? Aw. 555-6702. Hopefully, she'll let me stay over there.(Sound effect of a telephone dialing and ringing three times until picking up sound.) I hope she is there and didn't go anywhere. (Lighting up in DENISE'S apartment. DENISE is walking towards the phone. She is taking rollers out of the left side of her long, skinny braids. She is wearing a long, white bathrobe, with white slippers and the right side of her hair is hanging down.)

DENISE:(To herself.) Who is this callin' me? I hope it ain't who I think it is. Hello.

DEBORAH: Hey, Denise. Um? I need to ask you for a really big favor.

DENISE: What is it?

DEBORAH: I need to know if I can stay up there for like... a couple weeks....months? Because I am not welcomed here anymore. I think I'm going to go seriously crazy over here.

DENISE: Hold on now. What do you mean when you say, "not welcomed"? I mean..... what happened after I left?

DEBORAH; I don't mean it like that. Anyway, right after you left, me and momma were still arguing. Then she told me to leave the room. Talkin' about some, "Don't come back until you can settle things with Zabrina and calm down your attitude." Then she told me to leave.

DENISE: Was she serious?

DEBORAH: Yeah she was. So can I move up there with you?

DENISE: Well.... I'm not too sure about this.

DEBORAH: Please? Can I?

DENISE: Are you sure that she told you to move out?

DEBORAH: Yes, I'm sure. I heard it with my own ears. All I need is to just move up there for a couple of days. Please? You know she never says anything that she doesn't mean.

DENISE: Well... I think so, but I'm still not too sure about this. Let me speak to your mom.

DEBORAH: Mom telephone.

SEMIKA: Yeah.

DENISE: Hey! Um... can you talk? I mean, is Deborah near you?

SEMIKA: Yeah.

DENISE: Well listen, Deborah is asking me if she could stay with me for a while. So, let her come over and I'll teacha lesson. You know, make her want to go home to you and Zabrina. You could do the same with Zabrina. All right?

SEMIKA: Okay. Here Deborah.

DENISE: We talked about it and you can stay.

DEBORAH: Thank you so much. You're the best godmother I could ever have. I won't even get in your way at all. Okay, I'll be up there in about twenty minutes. Bye.

DENISE: Bye.

An excerpt from

HIDE IT UNDER A BUSH, OH NO!
by Margaret Elrod

MARY, lead character, 19 years old; daughter of JEANIE and ROBERT; parishioner of PASTOR MCDONALD

GOD, ageless, needs to be a man because of Lutheran religious beliefs

JEANIE, 50s, mother of MARY, wife of ROBERT; parishioner of PASTOR MCDONALD

ROBERT, 50s, father of MARY, husband of JEANIE; parishioner of PASTOR MCDONALD

PASTOR MCDONALD, 50s, Lutheran pastor of MARY, JEANIE and ROBERT

other parishioners to fill the church, if available

(The set: a Lutheran church; center stage right needs to be the front of the church with alter, pulpit, cross, etc.; pews or rows of chairs need to extend to up stage left and center stage left with an aisle in the middle; down stage left needs a table with three chairs. Second pew, down stage right needs 3 hymnals. MARY, JEANIE, and ROBERT enter center stage left. MARY is wearing a dress, not frumpy, with a cross necklace hidden underneath. JEANIE is wearing a dress. ROBERT is wearing dress pants and a blazer or a suit. They encounter PASTOR MCDONALD who is wearing a black suit with clerical collar. Organ music is playing in the background.)

PASTOR: (very enthusiastically) Good morning, Jeanie! Isn't this a beautiful day? And, Robert, remind me to talk to you about the church council meeting. We could really use your input.

(ROBERT nods in understanding and shakes PASTOR'S hand)

ROBERT: Good morning, Pastor. I'm really interested in hearing about the council's ideas for the church's anniversary. Jeanie and I have been talking about it and we have lots of ideas.

(JEANIE nods in agreement)

PASTOR: We'd love to hear them. (PASTOR turns to MARY) Mary, it's so nice to see you again! Are you glad to be home?

MARY: Yeah, but Chicago was great. It's so big and exciting. There were always a million things going on and I always had something interesting to do. But it's nice to be home, just to get a break from all the people and the noise. (JEANIE looks at MARY) And of course to see my parents. (JEANIE puts her arm around MARY and gives her a quick hug)

PASTOR: Have you decided on a major yet, Mary?

MARY No. There are so many to choose from, I just don't wanna choose the wrong one.

JEANIE: We told her there's no rush. She's got plenty of time.

MARY: Actually, Mom just wants me to stay at home for the rest of my life. (Everyone smiles and laughs a little)

JEANIE: That way she can take care of us when we're old and grey. I can finally have the maid I always wanted. (Everyone smiles again)

PASTOR: (looking at his watch) If you'll excuse me, please. I need to go robe up. (PASTOR exits center stage left. MARY, JEANIE and ROBERT walk to center stage right where they sit in the second pew at downstage right. PASTOR enters up stage right wearing vestments. He stands facing the congregation and makes the sign of the cross) In the name of the Father and of the Son and of the Holy Spirit. Amen.

ALL: Amen.

(The organ plays a hymn and everyone sings, PASTOR with a lot of gusto)

PASTOR:(after hymn) We will kneel for silent confession. (ALL kneel with heads bowed. Scene freezes)

MARY: All right, we've been kneeling for long enough, now. How many sins can some one confess? God, I am so hungry. When is this gonna be over? Maybe I oughta confess something. Uh, sorry, God, that I haven't been going to church much. I've been really busy with school and work and my friends and stuff. I didn't always have time to go and sometimes I just needed my sleep more. Uh, sorry that I swear sometimes and that I've lied. All right, that about covers it... okay we can stop now... how long is this gonna go on?

(GOD enters through back of church speaking loudly on a cellular phone. He is wearing a white suit and looks very business like. He needs to have a stack of papers and envelopes inside of his jacket.)

GOD: (with enthusiasm) So I told him. I said, Matthew, I'm your boss. Write it the way I say otherwise people will think you just made it up... yeah.... that's what I said... uh-huh... oh, and then I had this problem with Thomas. I told him exactly how it was.... yeah, you know, and, well, Thomas, he just kept questioning me and I said, "Thomas, have a little faith,"... well you know how he is.... he just has to question everything I say. I know, I know... ah, well...

(MARY has watched this with disbelief. She now rises and walks toward GOD)

MARY: Shhh! This is a church service. People are trying to pray.

GOD: Oh, go ahead, go right ahead. Don't mind me. (GOD continues talking on phone) So yeah... I know it's going to be a problem... I understand that we're understaffed....

MARY: (frustrated) Look, I'm trying to confess here. Could you maybe go somewhere else? (GOD does not hear her and continues talking)

GOD: Oh, yeah, we're getting a couple of new guys today.... uh-huh... I think one of them's a lawyer.... I know, it's a miracle, huh?

(MARY looks at GOD and rolls her eyes as if saying, "This guy is so weird.")

MARY: (to herself) This is so boring. I hope it's over soon. I'm so hungry and so bored and so tired. I just want to go get brunch and then go home and go to bed. I wonder if Rob's here? I haven't seen Liz yet either. I wonder how their school year went? I can't wait to tell them about Chicago. They're going to be sorry that they missed out and went to school here. Okay, we can get up now. I think this has gone on long enough. Why do I have to go to church now any-way? I haven't gone for so long; this feels so weird. I wonder if God's actually listening? (to the heavens)So, uh, hey God, are you listening?

GOD: Excuse me?

MARY: Sorry, I wasn't talking to you. (to herself) I can't believe that guy is talking on a cell phone in church. That's so disrespectful... boy, I haven't been up this early on a Sunday morning in ages...

GOD: ...well, Sunday mornings are our busiest.... how's attendance?...still that low, huh?... I know, it's all those late Saturday nights... I completely agree with you, Pete... how do the enrollment graphs look?... wow, that's a big decline... times sure are different, now... just make sure the newcomers get the attention they need...

MARY: (to herself) I wonder if God actually listens?

GOD: (to MARY) Excuse me, did you ask me something?

MARY: No.

GOD: Oh. All right then. So yeah, Pete... be sure you keep up on all that paperwork...

MARY: (to GOD) Um, excuse me, but this is a church, don't you think you should do that somewhere else? This is hardly the place to do business.

GOD: Hold on there, Pete. (to MARY) I work here. Now, I know what I'm doing here but do you?

(MARY looks at him like he's crazy and then turns her back on him to continue "confessing")

MARY: So, uh, God, I know I missed church a lot of Sunday mornings but I needed sleep. Otherwise I knew I'd never make it...

GOD: (on phone)... you'll make it, Pete, have faith...

MARY: It's not as if church or you didn't matter or anything, it's just that... well...

GOD: ...I know, I know. There's always so much going on...

MARY:there's always so much going on...

GOD: ...well, Pete, I'm glad to hear you're swamped... hey, just delegate a little, why don't you?... just keep your chin up and have faith, everything works out eventually... (GOD looks at his watch) Uh, Pete, I've gotta go, I've got an appointment...uh-huh... you be good, okay?... tell J.C. I said, "Hi!"... uh-huh... okay... bye!

MARY: It's about time you got off that phone. That was so rude and disrespectful.

GOD: To whom.

MARY: To the people trying to pray, to me, especially to God.

GOD: To God, huh?

MARY: Yeah, to God.

GOD: And what does he have to do with this?

MARY: People are here to worship him and to be forgiven of their sins.

GOD: Well someone sure learned her Catechism. It's a good thing, too. You'll need it in life. People aren't just here for those good reasons, Mary some people are here because they have to be.

MARY: Yeah, so maybe some of them are, but at least they're here.

GOD: Is that good enough?

MARY: I think it is and I don't need anymore than that.

GOD: Well, gee, Mary, who died and made you God?

MARY: No one, but what difference does that make anyway? I have the right to say what I feel.

GOD: Sure you do, Mary, of course you do. But, I just gotta tell you, you're wrong.

MARY: Who are you to tell me what is right and wrong? You're just a yuppie with a cell phone and an Armani suit. I don't know who you think you are.

GOD: (matter of fact) Well, Mary, someone died and made me God.

MARY: Sure, sure. You better wake up and smell the coffee because you're dreamin'. (MARY walks back to pew where her parents are kneeling. She rejoins them and waits for PASTOR to continue. The scene remains frozen except for GOD and MARY.) Is Pastor ever gonna start talking again? Gosh, most Sundays he goes on and on. I wonder what's going on? (GOD stands looking innocent and whistling softly.) Will you please stop that whistling? (as if irritated; She is not calling him by name.) God, you are so annoying. (MARY continues kneeling)

GOD: Mary, things aren't going to change until you do.

MARY: Who are you and how do you know my name?

GOD: I already told you. You really ought to pay more attention. (GOD'S cell phone rings and he answers. MARY gets up and moves toward him.) Hello? Yes this is he. No, I'm sorry I'm not interested... I realize that this is a great deal, but I don't need a personal psychic... Not even LaToya Jackson could change my mind... Thanks for thinking of me, though... all right, bye! (to MARY) Sorry about that. Now, where were we?

MARY: You were gonna tell me who you were.

GOD: I thought I already told you that... (MARY rolls her eyes)

MARY: Hello? Are you following me? I don't know your name or anything else about you. (GOD pulls a business card out of his pocket and hands it to MARY. MARY reads card aloud.) G.O.D., head honcho and all-around ruler of the Universe. Yeah, right. Someone's got a big head. (Unbelieving) You have a FAX number? And a cell phone?

GOD: Well, I've got to be accessible all the time. Did you see my pager number? Pretty cool, huh?

MARY: I don't even have a pager. My mother said only drug dealers have them.

GOD: I have one and I'm not a drug dealer. You'll have to tell her that.

MARY: Oh, yeah, I'll just say, "Gee, Mom, guess what? This really weird guy who claimed to be God cornered me today in church and told me that it's okay to have a pager. So why don't you let me get one?" (sarcastically) Oh, yeah, she'll really let me get one then.

GOD: Mary, I'm telling you, I am God.

MARY: Sure you are. If you're God then (MARY walks up to her parents' pew talking as she goes) how come I can just come up here and join the church service, huh? (The service is till frozen. MARY looks at GOD as if she doesn't understand.

GOD: I told you. Didn't you notice that no one but you and I is doing anything? Didn't you think it was weird that no one told us to be quiet and sit down?

MARY: This isn't really happening...

(GOD begins to dance down the aisles and sings, "What if God was One of Us?" by Joan Osborne.)

GOD: Wow, Mary, look at all the people stare. I am causing quite a scene, aren't I? (No one has paid attention to him; all are still frozen.) I'm telling you, Mary, that until you're ready to talk, everyone will just sit here in silence. I have ALL the time in the world to wait for you! (GOD laughs at his joke; MARY smiles weakly but is not amused)

MARY: This is all so ridiculous. This can't really be happening. The idea of God coming down here to talk to me is stupid. You must think that I am the most idiotic person in the world if you think I'm going to believe this scam. Am I on totally hidden video or something? This has got to be a joke.

GOD: No joke, Mary. This is actually happening.

JULIET, CHANGE YOUR MIND
by Stephanie L. Hernandez

How can Monica play the part of Juliet if she can't fit into the costume that's been used in every performance of Romeo and Juliet at her school? How can she break tradition? Monica must learn to cope with a fate worse than death - a low self-image. With encouragement from her best friend Melissa, Monica learns a valuable lesson.

KNOCK! KNOCK! KNOCK!

VAN: I'll get it. Sit down.

(Van goes to the door and answers it. The same young man stands in the doorway. Mon goes to her seat and sits)

YOUNG MAN: Vanessa, Mr. Koss wants to talk to you. It's about some costume sheet? (Van looks back at Mon and rolls her eyes. She leaves and shuts the door)

MON: (soliloquy) What does she mean by it's only a dress?! It's so much more to Mr. Koss, I just know it. God, this just makes me feel out of place, like I don't belong here. I really want to be an actress, but they all seem to be perfect and skinny, and way concerned with their health. (She looks at the necklace that is wrapped tightly around her wrist. She unwraps it and puts it around her neck) Grandma, what do I do?

(Van re-enters the room holding Mon's dress. She walks to the clothes rack as if trying to avoid Mon.)

MON: It's that dress again. That's what started all of my problems. (Looking at Van suspiciously as though she is hiding something) I thought Mr. Koss wanted to see you?

VAN: Yes, he did, and he did talk to me. But on the way back here I found your dress on top of the prop box, so I figured I'd just hang it up. It's very pretty.

MON: Of course it is. That's why it's used for Juliet's big scene. It's the perfect party dress to attract Romeo's attention. It's just that this Juliet might be mistaken for the Shamu 2000!

(Van sits besides Mon and looks at the ground and slowly picks her head up as she speaks)

VAN: How many times do I have to tell you that you are not FAT! Don't you have a mind of your own? Listen, I'll just find you another dress!

MON: But that's just it! I don't think Mr. Koss will go for that idea very well. (Mon gets up and starts walking around the room as if very nervous)

VAN: Sure he would. He's the instructor, why wouldn't he go for it?

MON: Because. I heard him. It was when you were looking for me.

(Lights dim on the rest of the stage and highlight the whole downstage area. Mr. Koss enters from down stage right wing and positions himself at downstage right. Van goes to down center stage, and Mon takes off robe again puts it in same place and moves to down stage left. Mr. Koss looks as though going over scene backgrounds. Van is looking for her friend and meets Mr. Koss. Mon is looking downward with her arms holding her upper body. She is trying to get away from everyone. Freeze. Unfreeze)

MR. KOSS: This is going to need another coat of paint. Oh dear it's lose too. (Van stands in front of him with a worried look on her face.)

VAN: Mr. Koss, have you seen Monica?

MR. KOSS: Why no. I haven't. But if I see her I'll tell her you were looking for her. Oh, later I want to talk to you about a missing costume sheet, okay? (Van nods and leaves at down stage right wing and stays in wing) Now, where was I? Oh. Looks like 15- UMPH! (Mon accidentally bumps into Mr. K. A look of shock spreads over his face, then disappointment) Are...you okay?

MON: Sure. (She frantically looks for an escape route)

MR. KOSS: (sounding concerned seeing how uncomfortable Mon is) So is that the dress?

MON: Yes Mr. Koss. It doesn't quite fit, though.

MR. KOSS: Oh. Well, um...Vanessa is looking for you. And...um, don't forget to tell her the dress...doesn't...fit.

MON: (relieved having found her exit) Sure. I will. Bye Mr. Koss. (Mon walks past him and is now behind him. She stops and slowly turns as though she has something to ask or say. Before she can, Mr. Koss begins to speak to himself.)

MR. KOSS: (sounding worried about not finding her another dress) Oh, Lord! What am I to do? That dress is supposed to be worn in her scene, in Juliet's party scene. Juliet doesn't fit in her dress...What am I going to do?

(Hearing this, Mon begins to run away when she bumps into Van who has reentered from the wing. After seeing Van, she runs off stage even more furious with Van right behind her. Lights out. Mr. Koss exits down stage right, and the girls are exactly where they were previously.)

MON: See? (Mon goes to sit down feeling a bit tired and frustrated)

VAN: He said that? But Monica, he never implied that you were fat or that the dress was so important.

MON: But you know he was thinking it. You could tell by his voice. It was like he thought I was gross and I just don't know what to do...It hurts my feelings, you know, all of these people saying I'm fat today. I'd rather be dead than suffer this kind of humiliation. That's why I'm...(grows meek) I'm...thinking of quitting! (She looks up into the mirror at herself, then looks down at the magazine and begins to flip through the pages)

VAN: You're thinking of quitting? That's stupid, Monica! You're the best Juliet this school has ever seen, and you're thinking of quitting?! This isn't about the dress anymore, is it? It's about you. Monica, do you really deep down think you're fat? Don't you like yourself?

MON: (she stops flipping through pages and looks up at Van through the mirror) I don't know. I do know I like myself, but I'm not sure what I think about my weight. If actresses have to be skinny, does that mean I can't be?

VAN: Absolutely not! And here's a news flash, you are not fat. In fact, you're not fat at all. I'm telling you right now, you have to like yourself for anyone to have respect for you. This is the you that people love. Don't exclude yourself from the fun because you're worried about whether or not you are fat. You are not. (Pauses as though has brainstorm) Do you think I'm thin?

MON: (almost too enthusiastic) YES!

VAN: Well I'm a size 9! You're an 8! If anyone is fat around here, it should be me. But I don't think I'm fat, so I know I'm not fat. You have to be sure in your mind about anything that concerns yourself to have other people believe the same thing. You make it easy to tease you if you don't know what you think of yourself.... Your opinions and views on life should not be decided by others. Don't quit because you didn't fit in that stupid dress.

MON: You really think I'm good?

VAN: You're excellent. You're really good at acting, you have a gift for it. Just promise me you'll get over this fat thing, and I'll do whatever I can to fix this dilemma. Just please, please, learn to like yourself, otherwise people will begin to hate you. (Vanessa looks at her watch) Well, it's 2:25, and I have to go get the rest of the clothes and the props from the auditorium. So I'll let you get dressed while I do that, and I'll come back here and we can go home.

MON: Fine with me.

VAN: (getting up and getting her clipboard and bookbag) Well, alright then. I'll be back here in a few.

An excerpt from

CLOSE YOUR EYES, THIS WON'T HURT A BIT
by Lindsay Quinlan

(Brian and Melissa sit on steps of a large Catholic church, lights are not up yet)

MELISSA: Just close your eyes, this won't hurt a bit.

BRIAN: (Lights up) Ow! What'd you just do?!

MELISSA: (holding a fist in front of Brian's chest) I stole your soul.

BRAIN: What?

MELISSA: I stole your soul. (showing him her fist) It's in my hand.

BRIAN: What do you mean you stole my soul?

MELISSA: Exactly what I said. You had a soul, I took it, and now it's in my hand.

BRIAN: Yea, okay Melissa. How do you even know I have a soul to be taken?

MELISSA: Well of course you do dummy. Everyone has a soul, (nodding) at least all Catholics do.

BRAIN: Melissa, not everyone has souls. And who cares? What good are they anyway?

MELISSA: What good are they? Hello? We've been in the same religion class since the second grade and they've been telling us since then, that God gave us souls and it's our souls that go to heaven.

BRIAN: Well then I guess I can't go to heaven.

MELISSA: What? Why?

BRIAN: (mocking a girl's voice) Because you have my soul.

BRIAN: Melissa, even if I had a soul, it's not something you can take. I'd have to give it to you.

MELISSA: Oh really? So then how did I take it?

BRIAN: You didn't! Just stop with the soul stuff, will ya? God! You're so stupid.

MELISSA: Oh, I'm stupid? I'm not the one who failed the vocabulary test yesterday.

BRIAN: So, I'm not good with words, but I'm way better at math than you are.

MELISSA: No you're not.

> *BRIAN and MELISSA continue talking as they wait*
> *for their rides to pick them up from school.*

MELISSA: Brian, what's wrong?

BRIAN: Nothing.

MELISSA: Brian you can tell me what's wrong, I won't tell anyone I swear.

BRIAN: I'm not telling you. Nothing's wrong. Sorry, you, Kate and Colleen won't have anything juicy to talk about on the phone tonight.

MELISSA: Brian if something's wrong you can tell me and I promise I won't tell anybody. Not even Kate, and she's my double best friend. (Brian laughs) Are you gonna tell me Brian or are we gonna just sit here and swear all night.

BRIAN: I'll tell you.

MELISSA: Why do you think you're going to (whispers) hell? (looks around nervously)

BRIAN: (long pause) (begins tracing scar on his left forearm with his right index finger and stares down at this action) Because I killed my dad.

MELISSA: Brian, stop joking. I know you didn't kill your dad.

BRIAN: Yes I did.

MELISSA: Oh, okay then, I'll play the let's see how stupid Melissa is game...(monotone) How'd ya kill him Brian?

BRIAN: I made a deal with the devil.

MELISSA: What? Yea right.

BRIAN: My dad used to hit my mom and so I promised that if he made my dad stop hitting her I would give him my soul.

MELISSA: Why did you ask the devil instead of God?

BRIAN: Because God never answered. (pause) He never did a thing about it. So I decided to ask the devil. (said fairly quickly) One night I turned off all the lights in my bedroom. I laid on my bed on my stomach with my face in my pillow and my hands at my sides so God wouldn't hear me. And I begged in my head every night for two weeks for him to stop my dad from hitting my mom. And one day, I came home from school, and a bunch of relatives were over and my mom was crying the hardest I've ever seen her cry. I walked in and she hugged me so tight it hurt and when she talked it sounded like someone was choking her. And she said, "Brian, Daddy's dead." (pause) And I didn't even care, the only reason I cried was because my mom was so sad.

MELISSA: Why didn't you care about your dad?

BRIAN: Because he beat my mom up when he got mad for something stupid! He was a jerk. I didn't want him dead I just wanted him to stop hurting us. And God wouldn't help and so the devil stopped it forever. But now I can't go to heaven because I promised the devil my soul.

MELISSA: Maybe you could talk to Sister Diane or go to confession. You didn't kill him yourself and you didn't ask for him to be killed, you just wanted your mom to be okay. God will have to forgive you. (pause) You didn't actually talk to the devil did you?

BRIAN: No. It was just like with God, he never talks back, you just hope he's listening.

MELISSA: So wait, how did your dad die?

BRIAN: Well you know how he was a construction worker?

MELISSA: Yea.

BRIAN: Well he was working on a high-rise and he fell off the twenty second floor and died instantly.

MELISSA: Brian, it was just an accident. Only God can say when people are ready to die. (BRIAN listens to MELISSA and absent-mindedly traces his finger across a scar on his arm).

MELISSA: What is that?

BRIAN: What's what?

MELISSA: On your arm, what are you picking at?

BRIAN: Oh, it's a scar.

MELISSA: From what?

BRIAN: Oh, um, just this one time, my dad was fighting with my mom, and I got in the way. I got pushed into a glass door in the kitchen and my arm went through it.

MELISSA: Your dad didn't just beat your mom up, did he?

BRIAN: (pause) Not always. (Car honks)

MELISSA: Shoot, that's my mom. Do you want to just get a ride with me?

BRIAN: No, my mom will be here.

MELISSA: Okay. (she hesitates) Everything will be okay Brian, I promise. And I swear I won't tell anyone, ever.

BRIAN: Okay...bye. (Melissa runs down stairs and exists stage right. Brian sits, looks left and right for his mom. He makes the sign of the cross, folds his hands, and bows his head in prayer. A couple of seconds pass. He raises his head upward. In a voice that is pleading and sounds like he's about to cry) I'm just so sorry. (He makes the sign of the cross. Lights out, car honk.)

An excerpt from
TO WHOM IT MAY CONCERN
by Jessica Violet Rose

There was a time when Violet's only wish was to spend
time with her father. She had to learn the hard way that wishes
don't always come true. This play gives an interesting perspec-
tive on one daughter's relationship with her absentee dad.

(Lights reveal a room. VIOLET walks to desk, pulls out chair and sits
down. VIOLET sits in thought for a few seconds then begins to write.)

VIOLET'S VOICE: Dear Dad, I've...(VIOLET stops writing, crumbles
paper and starts over)... Dear Abe, I've decided to write you because I
believe you need to know the effect you have had on my life.
Although I can count on one hand the occasions I have been granted
your presence in the last 15 years, the impact those occasions have
had some would say is phenomenal. I still can remember the first time
I met you when I was four... (Lights fade on girl writing. Lights
reveal a restaurant booth and door. VIOLET makes transition to 4
years in a white shirt and blue shorts. VIOLET holds her MOM'S
hand. VIOLET lets go of MOM'S hand, skips to the booth and sits
down. MOM walks toward booth and sits down also. MOM checking
watch and looking around.)

VIOLET: Maaaaaa when am I going to get my Happy Meal?

MOM: In a minute, Okay?

VIOLET: (VIOLET shrugs nonchalantly) Okay! (VIOLET begins play-
ing with fingers as if they were people. After a minute or so VIOLET
stops. MOM looking around and checking watch.)

VIOLET: Ma do you know what I want on my Happy Meal? (MOM,
distracted from looking around by VIOLET'S voice, gives full attention
to VIOLET.)

MOM: (Smiling) Yes!

VIOLET: What? (VIOLET smiling enjoying the guessing game she
started with her MOM; MOM pretending to have a hard time, stuttering
between words.)

MOM: A hamburger.... with onions..... aaand ketsup! (MOM point-

ing finger at VIOLET as if remembering something. VIOLET continues to smile.) And a orange pop with no ice!

VIOLET: You forgot I hate onions and like ice in my pop! (VIOLET begins laughing.)

MOM: Oh, I did forget didn't I. Come on lets go get your Happy Meal!

(VIOLET bounces off booth to the register, MOM gets up and walks after; CASHIER's off-stage voice needed.)

CASHIER: Welcome to McDonald's may I help you?

MOM: Yes, can I have a hamburger Happy Meal with no pickle, onion, or mustard and an orange pop.

CASHIER: Okay, your total is $2.23, Thank You.

(MOM hands CASHIER money and CASHIER hands MOM food, MOM checking food; FATHER walks in slamming door; MOM distracted from food to door. MOM and FATHER stare for a moment then FATHER speaks.)

FATHER: Is that my...? (MOM cuts FATHER's sentence while walking toward him.)

MOM: Yes.

(VIOLET looks curiously at FATHER for a moment, VIOLET walks toward MOM and FATHER; VIOLET looks at FATHER as if searching for a clue; FATHER bends on one knee coming down to VIOLET's level, VIOLET still looking curiously.)

FATHER: Hey!

VIOLET: Hello, my name is Violet. Who are you?

FATHER: Well (hesitating) I'm your–

MOM: Violet he's your father! (MOM becomes relieved; VIOLET speaking in carefree manner.)

VIOLET: Oh! (It is silent for a moment; VIOLET breaks silence.) Ma what about my Happy Meal?

MOM: (MOM's speech broken, and voice cracked.) Yeah, let's get

your food before it gets cold. (MOM walks back to counter, VIOLET and FATHER follow. They return to the booth. VIOLET prays over food and begins to eat. Booth very quiet, occasional glances MOM and FATHER; VIOLET breaks silence.)

VIOLET: Guess what?

FATHER: What?

VIOLET: I bet you I know your name! (VIOLET begins smiling, FATHER gives blank look to MOM)

MOM: The "Guessing Game."

FATHER: Oh. (FATHER catches on and begins smiling.) I bet you don't! (VIOLET and FATHER continue to smile, MOM sitting back watching)

VIOLET: Yes I do!

FATHER: What is it then?

VIOLET: Abraham Thomas. (FATHER puts hands up pretending to be in total surprise. FATHER pretends to be suspicious.)

FATHER: What else do you know about me?

(Lights fade on booth with VIOLET talking to FATHER about pre-school; Lights come up on girl writing.)

VIOLET'S VOICE: I was so ecstatic that I met you. I couldn't stop telling people that my father had a Bachelor of Science and was going to be a big architect one day. I still can remember the 1979 maroon Cadillac that you drove. Another thing I remember is you never calling. You promised me and my mom that you would call, but you never did. Because of that I soon forgot you. I still had memories of you as being the "Man I met at McDonald's". This is the reason why I didn't know who you were the second time I met you when I was 6...

The next meeting was even more brief, but it
set a predictable pattern of lost hope and pain.

VIOLET'S VOICE: When I really thought about it, I knew who you were, but it didn't affect me. I mean why should it? I was six years old. I had no

obligation to you, unless I made one. But mom talked to me and explained that I had a obligation to you as a daughter; she said it would be best for me to pray for you. So I did (pause) Religiously. Every single night, I prayed for you. But as I got older, I stopped. I finally realized that you weren't coming and it was useless for me to continue to pray. I was tired of wasting my time. The pieces began to fall together all too well. I was finally understanding the whole picture....

(Lights fade on VIOLET. Lights come up on empty room. The phone rings three times. VIOLET walks in with bath robe on and answers phone. VIOLET makes transition to ten years old)

VIOLET: Hello, Bynum residence.

FATHER: Yes, may I speak to Victoria please?

VIOLET: She's not in right now, can I take a message?

FATHER: Well, is Violet in?

VIOLET: (getting frustrated) Speaking.

FATHER: Oh (long pause) hello Violet (long pause) (VIOLET continues to comb hair, looking at phone strange. She finally puts comb down.)

VIOLET: Excuse me, I don't know who you are. So if you don't speak now, I'm hanging up the phone!

FATHER: It's me, your dad.

VIOLET: (mumbling) You mean father.

FATHER: What was that?

VIOLET: Nothing, so what do you want?

FATHER: To check up on you, and see how you were doing.

Violet has another superficial conversation with her father.

VIOLET'S VOICE: The reality of me being your daughter is not a reality to you. Some how you have conceived if you do one of your two or four year check-ups, that don't amount to more than fifteen minutes, you have achieved your responsibility as a father. Then you expect me to be in this pretend reality with you so we can both be blinded to the truth....

An excerpt from
Buzz
by Zaneta Wrightsell

(Jackie comes in stage left. Shante looks surprised.)

JACKIE: Hey Shante.

SHANTE: (questioningly) Jackie, Is that you?

JACKIE: Yeah. This ain't no dream. So whatcha been up to?

SHANTE: (in awe) Nothin' really.

JACKIE: Oh.

SHANTE: (regular) So, why'd you come to my house?

JACKIE: (beginning to rise) Oh, do you want me to leave?

SHANTE: (angry) No. (nice, pleasant) I mean no– (Jackie slowly sits down) It was just that you're so popular. I mean I know you started talkin' ta me and stuff, but I neva would've guessed that you would've come to my house.

JACKIE: (acceptingly) Shante, your one of the coolest gals I ever met.

SHANTE: (unconfident) I am?

JACKIE: That's why Tarence–you know–likes you so much.

SHANTE: (puts up hand) Hold up. Wait a minute. You mean ta tell me that Tarence goes with me because I'm popular?

JACKIE: (laughs) No, he likes you for who you are. Your personality.

SHANTE: (insecure) My dull, boring self?

JACKIE: (JACKIE shoves SHANTE.) Girl, you cool, crazy, and considerate.

SHANTE: So, why nobody eva hang around me?

JACKIE: (jokingly manner) Shante, Shante, Shante. Everyone at school is intimidated by you because of your A's and B's. They're jealous.

SHANTE: My grades?

(JACKIE shakes her head in agreement. CHRIS enters stage right).

CHRIS: You gotta dollar?

SHANTE: (mean) Fa what?

CHRIS: (daydreaming) For some Chocolate Chip Cookie Dough Ice Cream.

SHANTE: You owe me.

(CHRIS sees JACKIE signaling "come here." JACKIE searches for two dollars in her purse.)

SHANTE: (serious) Girl, keep yo money!

JACKIE: (playfully) Come on, girl! $2 won't hurt. (CHRIS hurries and snatches the money.)

CHRIS: (gladly) Thanks.

SHANTE: Chris?

CHRIS: (yelling) She made the offer! (CHRIS exits stage left.)

JACKIE: (ghetto style) Homecoming was the BOMB!

SHANTE: (ghetto style) For real?

JACKIE: (excited) Yup, you shoulda been there.

SHANTE: (sadly) My mama wouldn't let me go. (attitude, rolls her eyes) She thinks parties ain't nothing but drugs, drinkin' n' kissing.

JACKIE: (insensitively) Yo mama be trippin!

SHANTE: (from vocal chords, mouth closed) Um hum (SHANTE gives JACKIE five)

JACKIE: (takes a huge yawn, stretches arms out wide): Shante, I gotta go (not boastful) My posse going out tonight.

SHANTE: Oh (feeling left out).

JACKIE: Maybe we could go to the mall or the movies or somethin'. (SHANTE smiles) You know you could meet my homies. Ait? (like

alright but slangish).

SHANTE: (smiling) Word. Thanks, Jackie.

(JACKIE grabs her purse and other belongings. JACKIE exits stage right. SHANTE freezes. Her brother CHRIS walks to the stage.)

CHRIS: Hmmmm, my sister? Always wanted to be accepted by the crowd. She always sought to have a good ol' friend. She had one– Tiffany. She was in the fourth grade. She was fine. I remember when Tif started changing. Everybody at school thought she was the coolest girl. Then "that day" all dem boys likes her and all dem girls talked to her 24/7. (CHRIS' speech slows down). But she ignored my sista. She stopped bein' wit my sista n' so why Tif was gettin' attention, my sista was bein' kicked to da curb. Ever since then, my sista wanted to be popula. N' she still ain't but I don't want to lose my sista. Because I loves her (ghetto style).

*Shante convinces her mother to let her go to her
friend's house to study, but her friend has other plans.*

(The phone rings).

SHANTE: Hello?

JACKIE: Hey, what's up, Shante? You still comin' to my crib, right?

SHANTE: Yeah, ta st–

JACKIE: Shante?

SHANTE: Huh?

JACKIE: (hesitation) Well, um...

SHANTE: What's up?

JACKIE: I– Shante, at my house we're havin' a party! You wanna come?

SHANTE: Great! But when will we study?

JACKIE: (insensitively) We can do that later. (sweetly and slowly) And guess what?

SHANTE: What?

JACKIE: (sweetly and teasing) Tarence, your boyfriend, is going to be there.

SHANTE: (excited) He is? (worried) But what do I wear?

JACKIE: Wear anything. Jeans and a belly shirt.

SHANTE: (unsure and confused) I don't know, Jackie. You know how my mom feels about goin' to parties.

JACKIE: (uncompassionate) Cheer up, Shante. Ain't gonna be no drugs or alcohol. What's the worst that can happen?

This Performance Is Not For Nothing

An excerpt from
SONG OF AHUVA
by Chasiah T. Haberman

The following words are listed in the order in which they appear in the script along with their explanation and pronunciation:

AHUVA: (uh-HOO-va) Jewish name, meaning "beloved".
EEMA: (EE-mah) Hebrew word for mother.
REFUA SHELAMAH: (reh-FU-ah sheh-lay-mah) a complete recovery
SIDDUR: (si-DOOR) Jewish prayer book
KADDISH: (ka-DISH) Prayer recited by Jewish mourners for eleven months after the death of a family member, and every year on the anniversary of death.
AVRAHAM (av-ra-ham) SARAH (sa-rah) YITZHAK (yitzhak) RIVKA (rivKAH) YAAKOV (yah-ah-kov) RACHEL (rah-hel) LEAH (lay-ah)
The forefathers and mothers of the Jewish people.
CHALLAH (ha-lah) Bread, usually braided, and is eaten by every member of the family in honor of the Jewish sabbath.

(Lights on AHUVA who stands center stage, downcast, she wears a sweater, CRYSTAL stands several feet behind AHUVA. AHUVA lifts her hand to the collar of her sweater and rips it until her heart is one firm motion, exposing the shirt she wears underneath. Lights down on AHUVA, CRYSTAL exits. Lights up on AHUVA who is seated on a low chair, she rises and moves to downstage center in a slow walk with her head down, then lifts her head and faces the audience)

AHUVA: (to g-d) I knew perfection. It made the losses harder. I knew what must be wished for, longed for, missed. I knew. If only I had never known. (Turns fiercely and faces the low chair) And what do you gain? Does it give you joy- to see my suffering? Does it give you fulfillment to shatter hearts? To break? To murder? To rob? Does it give you joy? (Pauses and turns to the audience) I gave me grief.

(Lights shift to MOTHER who sits in a chair near the I.V. and tubes attach it to her chest through her robe. AHUVA wears her shirt without the sweater, she walks quietly to MOTHER who holds a book in her hands, clearly unsure whether she is awake,

MOTHER flips the pages of the book absently)

AHUVA: Hi Eema, I'm home! (AHUVA walks to MOTHER, AHUVA and MOTHER hug awkwardly around the I.V.)

MOTHER: Hi Ahuva, how was it?

AHUVA: Fine, I saw Mrs. Stern on the way and she wishes you a Refua Shelamah, (AHUVA puts down her backpack) Mrs. Wiessberg also said to feel better.

MOTHER: That's nice of them, did you get your report card?

AHUVA: Yeah.

MOTHER: Good, do you want to show it to me?

AHUVA: Not really,

MOTHER: Ahuva- (AHUVA smiles) you're going to have to show me sometime, I am your mother.

AHUVA: I know but-

MOTHER: Ahuva, you're going to have to show me sometime today, it doesn't have to be now, but by the end of the day I want to see your report card.

AHUVA: Fine, just don't kill me when you see it.

MOTHER: I won't kill you. (laughs) (Pauses and looks around her smiling) I don't even have the strength to-so you're safe for now. (They both laugh)

AHUVA: Thanks, that really cheered me up.

(MOTHER puts a bookmark into her book and puts it down, then turns to AHUVA as AHUVA speaks)

MOTHER: Anyway, what happened at school today?

(NURSE walks in carrying equipment)

AHUVA: Not much (AHUVA sees NURSE but ignores her completely)

MOTHER: mmm-hmm.

(NURSE walks to MOTHER, MOTHER notices her and smiles)

NURSE: (heartily) Hello, Mrs Gutstien! Sorry I'm late, I didn't realize it was going to rain, so I didn't give myself any extra time, the roads were so slippery by the time I got near your house, I had to drive slowly.

MOTHER: Oh, don't worry about it Rose, how are you?

NURSE: Fine, and how are you doing today? (NURSE is searching for something in bag, MOTHER gives her a weak smile)

MOTHER: Thank g-d.

NURSE: (NURSE returns a sympathetic smile) Here, let me help you up.

MOTHER: Thank-you.

(NURSE helps MOTHER up, MOTHER leans weakly, half on IV and half on NURSE, who guides her, they exit. Lights down.)

(Lights up on AHUVA who is sitting in chair.)

AHUVA: I watched as people carried the body that was once my mother, as they buried it, as I helped cover it, because it was the last I could give her. And now I will sit here, as I will till the passing of a week of days. (Visitors begin coming toward AHUVA,)

(NURSE comes in, she and AHUVA hug, AHUVA sits on the low chair and NURSE sits on the dining room chair)

NURSE: How have you been doing?

AHUVA: (pauses and smiles) Thank g-d.

NURSE: (NURSE returns a sympathetic smile) You know, even after people go away, they are still with you, some of you is empty, but some of you will be just as full. (AHUVA nods her head) Your mother was a special person.

AHUVA: She was.

(Lights shift to table, MOTHER is standing, wearing a big fanny pack which holds her I.V. over a bright dress and an apron, her

197

sleeves are rolled up. The tubes from the I.V. run into her dress around the apron. She is making bread dough, there are rumpled bags of flour, a big bowl and several cups and measuring spoons among other clutter, AHUVA approaches mother who is watching the dough and doesn't notice her, AHUVA wears her shirt)

AHUVA: Hi, Eema!

MOTHER: Hi AHUVA! can you give me a little flour? No, no, a little more- not that much! Good, good, thank you! (MOTHER kneads the dough powerfully, then pulls her arm out weakly and shakes it loose as if to free it, she then begins again, AHUVA is crumpling a baking sheet into a flower, twisting and twisting stem and then putting it down next to the bowl)

MOTHER: A little more bread flour...

AHUVA: Like this?

MOTHER: No, a little more, that's enough, thank you, Ahuva, do you have any homework?

AHUVA: Is that a question? I always have home-work.

MOTHER: (laughs) I meant a little more than usual.

AHUVA: I guess not.

MOTHER: I was wondering if you could take them to the library for that project, they need three sources, it would be very nice if you could help them–

AHUVA: I don't know, I'm going to be working and I don't know if I want them tagging along...

MOTHER: Ahuva, you'll have to be more helpful now, your father can't do everything by himself, you'll have to help him take care of your sisters more. (AHUVA smiles apologetically at MOTHER) Can you give me a little flour? Thanks... that doesn't mean you don't have to do your homework or anything, just when you can help a little more, I know they can get annoying but they'll grow up... If you can't I will, don't worry about it.

AHUVA: Yeah, I guess I will, it's not much of a problem–

MOTHER: Okay, thank you Ahuva, just make sure you finish your homework, if you don't tell me. I don't want you to get behind or anything... I figured out the recipe for challa but I still want you to pay attention... a lot of it depends on the weather... the day of the year-everything.. you have to pay attention to the texture and then just play by ear.

AHUVA: O.K. (The fanny pack beeps and they both turn to look at it)

MOTHER: Oh-

AHUVA: Do you need help?

MOTHER: Yes, my hands are all covered with flour. (MOTHER looks down at hand, smiling)

AHUVA: Okay.

MOTHER: See that zipper? No, yes, that one take out the bag-that's all the nasty chemicals, they can torture you with chemo anywhere now. Yes, can you pull that out?

AHUVA: Sure.

MOTHER: Thank you. Okay put it back in.... good... o.k. now you can close it, thank you, Ahuva.

AHUVA: Eema, are you sure you should be making challah?

MOTHER: Why not?

AHUVA: Eema, you have that I.V. tube thing stuck in your chest, you have ovarian cancer, you aren't feeling too well, do I really need to explain?

MOTHER: (laughs) I know, Ahuva, it's easy to see death and surrender promptly, but it is better to fight, and triumph in a losing battle. (She kneads the dough thoughtfully) This is my fight, this is my triumph.

AHUVA: Eema-

MOTHER: No Ahuva, it doesn't matter how long I live if I don't do anything with my life. It only matters how long I live if it has something to do with how much I accomplish, and I'm going to make sure that it does. Ahuva, can you give me a little more

flour? Not so much, good, thank- you. Ahuva, people are always going to want your time, sometimes they'll want it for good things and sometimes they'll just want to waste it. You have to pay attention, you aren't always going to have time, life doesn't last forever. (MOTHER turns the dough in her hands) Time is a precious thing, you can't earn it, but you can waste it easily- or you can use it, and you can use it well. Ahuva, can you give me a little more bread flour? Thank you.

AHUVA: How can you tell when you put the right amount in?

MOTHER: Oh, it has to feel right, nothing wet and mushy, but there shouldn't be so much that it doesn't stay together-feel it now, you see how it's still a little too damp?

AHUVA: I guess.

MOTHER: It needs a little more flour. (AHUVA picks up the flour bag and pours in flour, MOTHER smiles at her) Thank you, you'd better go do your homework now, I'll finish by myself.

An excerpt from
ASPHYXIATION
by Margaret McCloskey

Characters:

Dana: Main character, about 18 years old. Senior in high school, wants to take a year off before college.

Miriam: Dana's mother, 45-50 years old, feels that Dana should go directly to college and doesn't understand her dream.

(lights up on DANA, at table in kitchen reading.)

MIRIAM: (entering stage right) God, it's hot out there. Can I have a pop? (MIRIAM sits in a chair and puts feet up on table. DANA slides a soda across the table to her.) Aww, it's warm. Some ice? (DANA reluctantly stands, gets cup with ice, returns to table and continues reading, obviously annoyed. After a pause) Where's the mail?

DANA: (monotone) On the counter.

(MIRIAM stands, gets mail, looks through it. Stops at fairly large manilla envelope)

MIRIAM: What's this? (pause) Is this your application to Marquette? The one that had to be in the mail this morning? (pause) Did you forget to mail it? Did you?

DANA: No. I just.... didn't mail it.

MIRIAM: Oh, I see. So now you don't want to go to Marquette?

DANA: I didn't say that.

MIRIAM: So you do want to go to Marquette?

DANA: I didn't say that, either.

MIRIAM: I don't understand, Dana. (sympathetically) What's going on? You've been acting different lately. Two years ago you were dying to go to college, and now you act like you don't care. I don't get it. Now you can't get into Marquette because your application had to be postmarked by today, and the mail

was already picked up. I don't even know of any other colleges that have application dates this late.

DANA: I don't either.

MIRIAM: So, what are you going to do? You must have had some idea when you decided not to mail that application. I hope it's good because I sure as hell—

DANA: (interrupting loudly) I'm not going to college.

MIRIAM: (obviously thinking about what DANA just said) No. There are other options. I didn't mean it to sound so bleak. You can still get into community college, junior college. Well, at least for the first semester. Then I'm sure you can transfer and by then you'll have figured out what you really want to do.

DANA: No, Mom. I mean I don't want to go to college.

MIRIAM is obviously in shock; DANA continues when MIRIAM stays silent) I don't mean never go to college. I just mean not right away. I'm thinking that after graduation I'll get a job and focus more on my writing, you know? (DANA looks for reaction from MIRIAM who is still silent) I want some time to think. Move out, live on my own for a while, get a better idea of what I want in life.

MIRIAM: Move out?

DANA: Yeah, and I don't mean very far. Just a cheap apartment where I can have some more freedom.

MIRIAM: Freedom.

DANA: You know, be messy, eat what I want, wear dirty clothes the majority of the time, throw loud parties, create my own schedule. But mostly for creative freedom, to inspire myself. Then after a year I can decide whether or not going to college is what I really want to do. Maybe then I'll have a clearer idea of who I am.

MIRIAM: How do you think you're going to support yourself? With your writing?

DANA: Partly. I mean I'm going to have to get a job, waiting tables or something. But that shouldn't be so bad. And with-

out school, I'll have all that time to work on my writing. I figure if I start calling publishers, I can get some stuff published fairly soon.

MIRIAM: (calmly) I see.

DANA: I know it's sorta sudden, but it really is what I want.

MIRIAM: Sudden? I would have said rash, headstrong, hasty, unexpected, stupid...

DANA: Saying stuff like that isn't going to help.

(MIRIAM finishes her soda and stands, pours a glass of brandy from a bottle underneath the sink)

MIRIAM: Well, what should I say? (MIRIAM downs the drink, pours another, but doesn't drink this one)

DANA: I don't know. (MIRIAM returns to the table with drink) Aren't you going to yell at me?

MIRIAM: Yell? No! Why should I yell? Just because you're considering throwing your life away and ruining your chances for a good education? Because after this it will be virtually impossible for you to amount to anything in the real world? Why should that cause me to yell?

DANA: (reacting to MIRIAM's sarcasm) I don't know, you tell me.

MIRIAM: (sighing, collects herself) Dana, I have no doubt that you think this is what you really want. What I'm wondering is whether or not this truly is the best thing for your future.

DANA: Mom—

MIRIAM: I know you're going to say "I've thought this all out, really!" But you don't know how oblivious you are to things that happen in the real world. You know nothing about life.

DANA: How can you say that? After 18 years of living in Chicago, don't you think I've seen my fair share? I know what happens out there, I know the dangers. I know that you and Dad have tried to protect me from the really bad stuff, but I've been around the block.

MIRIAM: It may seem that way, but there's so much you've never experienced. You'll end up working two jobs just to keep up with rent. You'll work all night, sleep for an hour, then work all day. Where do you think you're going to get the energy to write the great American novel or whatever it is you think you're going to do?

DANA: Or whatever? Gee, that's real supportive.

MIRIAM: I'm not trying to be supportive. I'm trying to show you exactly what life is.

DANA: (angrily) No. You're trying to show me the error of my ways. To convince me just exactly why you are perpetually right. To tell me that I absolutely have to live my life exactly the way you did. (Ticking off on her fingers) High school, college, grad school, good job, husband, kids, grand kids. Just like you.

MIRIAM: This doesn't sound like you at all.

DANA: Yeah, well, it is me.

MIRIAM: Where did you get this idea?

DANA: What do you mean?

MIRIAM: (suspiciously) I mean just exactly who gave you the idea to do this?

DANA: (slightly confused) I did.

MIRIAM: I know you. You would never think of something this irrational on your own.

DANA: (defensive) Oh? And who do you think gave me the idea?

MIRIAM: I don't know. You tell me.

DANA: There's nobody. I'm doing this. Just me.

MIRIAM: There's no boy...?

DANA: (offended) Do you really think I would let some boy influence me?

MIRIAM: No, I don't think you would consciously.

DANA: So?

MIRIAM: Well, you might not necessarily realize it was happening.

DANA: Don't you think that if there was a boy, which there isn't, you would have heard about him? Something about him? His name, his interests.... Wouldn't you have noticed him calling? Because I'd have to be talking to someone a hell of a lot to let them change me so much.

MIRIAM: I hope you would have said something to me.

DANA: Doesn't the fact that I didn't tell you something? (exasperated)... I swear, this is the truth.

MIRIAM: I just can't see how you thought of all of this on your own. (Silence, two to three seconds)

Dana continues to try to convince her mother
that her decision is sound.

MIRIAM: You're wasting a whole year of your life, assuming that you do return to school after this... sabbatical, which is highly unlikely.

DANA: Unlikely only in your head, because you don't know anyone who's done it. Why won't you let me have the opportunity to find out if I want to?

MIRIAM: I don't see how it will do you any good.

DANA: You have no idea what's going on inside my head. You've never experienced what I'm going through.

MIRIAM: How do you know that?

DANA: I know your life. You got the job your parents wanted you to have, married the "boy next door," and, as of now, have led a picture-perfect life. But you've never done anything. You've taken the safe road whenever possible. Your life is as sheltered as you want mine to be.

MIRIAM: Is that really the way you see me?

DANA: That's really the way you are. When did you ever want to do something your parents didn't want you to?

MIRIAM: I was young once, too, you know.

DANA: When you were my age you were deciding whether to go to Harvard or Yale.

MIRIAM: I had dreams once.

DANA: To become a nuclear physicist. (Pause; self-righteous) I don't know why I try. You've never been in the position I am, so therefore you can't understand.

MIRIAM: You talk as if I've never lived.

DANA: That's because you never really have. And now that I want to, you won't let me.

MIRIAM: I'm trying to protect you.

DANA: From what? You're clueless about the "real" world as I am. You're just scared. You're scared because I want to do something you never had the guts to do. You didn't even have the guts to think about it. Face it, I'm more mature than you were at my age.

MIRIAM: Oh, you are?

DANA: Yeah. And that freaks you out because I know where I'm going in life, and when you were 17 you were still doing what your parents told you to.

MIRIAM: (thoughtfully) Yeah, I was. They made sure of that. They kept a pretty strong hold on me and my sisters.

DANA: And now, you're doing it to me.

MIRIAM: You have no idea how easy I am on you compared to my father.

DANA: When did you ever give your father a reason to be hard on you?

MIRIAM: I wanted to move to New York.

DANA: (incredulous) You wanted to move to New York? Why?

MIRIAM: To become an actor.

DANA: (disbelieving) You wanted to be an actor? When were you interested in movies?

MIRIAM: Not movies, theater. Stage performance. I wanted to be Blanch Du Bois, Ophelia, Juliet. It was the most important thing in the world to me when I was 17.

DANA: (softly) I never knew that.

MIRIAM: (sighing) That's because nothing ever came of it. My parents, well, mostly my father, decided it was better that I go to college and finish my education. I joined the drama club, but dropped out sometime during freshman year. I guess it just wasn't meant to be.

DANA: How can you say that? You didn't even have a chance... think of what could have happened... Were you a good actress?

MIRIAM: I suppose. I mean, I have no way to judge now. I was decent. I doubt if I would have made it on Broadway, anyway.

DANA: (smiling) But you always wondered? There's that little voice inside you saying "If I only had the chance..." And you didn't go, all because of Grandpa?

MIRIAM: (sighing) No. I could have gone. But he was looking out for my best interests. Going to college was the smarter thing to do. I'm glad I did it. (MIRIAM stands and paces the room, trying to convince herself) It would have been a bad idea, anyway. So many young people looking for fame get cheated. So many people get their dreams trampled. Mostly everybody who goes looking for fame never find it.

DANA: But still, you can't help but wonder.

MIRIAM: (sitting down) Yes.

DANA: So you do know what it's like to be in my position?

An excerpt from
WWW. A FAIRY TALE.COM
by Shannon Kanika Patrick

(Curtain up. Lights reveal JAMES and JOVONDRA. JAMES is wearing baggy khaki pants and a white shirt, with brown suede boots. JOVONDRA is wearing baggy blue jeans with a white shirt and white gym shoes. Both are normal looking. They are standing at center stage.)

JOVONDRA: This is my best friend. Monique Watts.

(lights up on MONIQUE in her bedroom. She is admiring herself in a mirror, up stage left.)

JAMES: She's sweet, beautiful, cool, wild, really personable, and she's extremely popular. This is my best friend, Savion Reynolds.

(lights up on SAVION in his computer room standing in front of a mirror- upstage right)

JOVONDRA: I'll do the description, thank you. He's charming, fine, cool, crazy, quiet– sometimes, and he's out of this world. He's like Superman. (Savion imitates Superman). No he's like He-Man. (Savion tries to rip off his shirt, but can't). No he's– anyway, you get the picture. Now back to Monique. She comes from an All-American family.

(Lights up on JAMES, JOVONDRA, and MONIQUE. They make a little pose as if to take a picture)

MONIQUE: Mom, Dad. I love you guys.

JAMES/DAD: We love you too, pumpkin.

JOVONDRA/MOM: Yes, with all our heart.

MONIQUE: Daddy can I-

JAMES/DAD: Use the car (holds up keys)?

JOVONDRA/MOM: See, we were way ahead of you dear. Of course.

MONIQUE: Mommy, can I also-

JOVONDRA/MOM: Have a later curfew?

JAMES/DAD: Still way ahead of you Pumpkin. How's 12 AM sound?

MONIQUE: Wow. You're the best parents in the whole wide world.

JOVONDRA/MOM: Well, honey we have to be. After all we are an All-American family. (Poses again for family picture) Now go have fun. (Lights down on All-American Family. Lights up on JOVONDRA and JAMES)

JAMES: Savion comes from a single parent family. Don't get me wrong he is still spoiled to death. (Lights up on Savion and JOVONDRA. Posing as if to take a picture.)

SAVION: Mom.

JOVONDRA/MOM: Yes, Savion. You can take the car.

SAVION: And-

JOVONDRA/MOM: Yes, the curfew is 1AM.

SAVION: And-

JOVONDRA/MOM: No, I won't wait up for you son.

SAVION: Plus-

JOVONDRA/MOM: I'll make sure your little sister won't throw water out the window when you walk in.

SAVION: I love you mommy.

JOVONDRA/MOM: Love you too son. Have a good time.

SAVION: okay. (Lights down on SAVION. Up on JAMES and JOVONDRA)

JOVONDRA: Back to Monique. She's got this thing some call it an-

JAMES: Attitude. She's irritating sometimes. I mean she snaps over little things.

JOVONDRA: Sure, she may seem that way, but it's really just an act. She only appears to be mean and cruel. She's not even aware of how many people are scared of her. Really.

JAMES: Right, she's like a Mother Theresa, in a mini-skirt.

JOVONDRA: You pig. Is that all you can think about?

JAMES: Well, I certainly wouldn't want to see you in a mini-skirt.

JOVONDRA: (takes a deep breath) Speaking of mini-skirts, that seems to be Monique's favorite article of clothing.

JAMES: Yep, she has a closet full of them.

JOVONDRA: And how would you know? (Lights up on MONIQUE. She stands in front of a closet full of mini-skirts)

MONIQUE: Hum. Now which should I wear? (she picks identical skirts) It's such a hard decision. (Lights down on MONIQUE)

JAMES: Yeah right. Total exaggeration. I only wish she wore mini-skirts everyday and was chipper, but that ain't Monique.

JOVONDRA: Okay, let the truth be made known. When Monique has a bad day the whole world will know it. She will make sure of that. (lights up on MONIQUE and JAMES)

JAMES: Hey, Monique. You lookin' real good today. You go girl.

MONIQUE: Go shove it sissy-boy. Go back to yo' momma. It's time for your 2:00 feeding. (lights down on MONIQUE)

JOVONDRA: Savion never has a bad day. He's so perfect.

JAMES: Bull, the only reason why is because he brags about himself so much everyday that he actually believes it.

JOVONDRA: Do I detect jealousy in your voice?

JAMES: (gives her the hand) Ugh.

JOVONDRA: The bad parts of Monique.

JAMES: Yeah, she's smart, sneaky, and beautiful. Which is a bad combination. She uses all of them to get whatever she

wants.

JOVONDRA: Same with Savion.

JAMES: Savion wants to be a lawyer and go to Harvard or Princeton.

JOVONDRA: Well, Monique also wants to be a lawyer and she wants to go to Spellman College. She likes to argue and debate. So she figured she'll do what she's best at.

JAMES: Okay, let's speed this up.

JOVONDRA: Both Monique and Savion hate: Tag alongs

JAMES: They both hate bummy looking people.

JOVONDRA: Or staying in the house.

JOVONDRA: Or Public Transportation.

MONIQUE AND SAVION: (laugh) the bus. Please.

JOVONDRA: Then to top the list.

MONIQUE AND SAVION: Babies!!!

SAVION:Oh, God they stink.

MONIQUE: They drool.

SAVION: They spit up.

MONIQUE: They cry.

SAVION: They whine.

MONIQUE: They're destructive.

SAVION: They climb all over you.

MONIQUE: They get lost.

SAVION: I absolutely

MONIQUE: Positively

SAVION: Hate

BOTH: Babies!!! (lights down on MONIQUE and SAVION)

JAMES: You see what we mean.

JOVONDRA: They have so much in common.

JAMES: But the weirdest thing is the fact that they love the Internet's on-line service.

JOVONDRA: Yeah, Monique's on that computer all the time. (lights up on MONIQUE at computer)

JAMES: Yeah. So does Savion. He say he got a little girlfriend. (lights up on SAVION at computer)

JOVONDRA: Yeah so does Monique.

JAMES: (laughs) I somehow got the idea Savion and Monique were talking on the Internet.

JOVONDRA: And they didn't know it.

JAMES: Wait you got the same idea?

JOVONDRA: She doesn't say much about him, but she's always talking about how–

JAMES: Much they have in common?

JOVONDRA: Yeah. Wait Savion tells you that too?

JAMES: Yeah, although, he did tell me this funny story about how they were going to meet and um, these people—

JOVONDRA: Wore like the same thing they were supposed to be wearing and they ended up thinking those two were their dates–

JAMES: Because they met over the Internet too.

JOVONDRA: Wait a minute, Monique told me that.

JAMES: Well, Savion told me that story.

> *It may sound too conveniently coincidental, yet it is true.*
> *And they lived happily...you know the rest.*

An excerpt from

BLACK & WHITE
By Josh Prudowsky

(spotlight goes on chair where ROY is sitting)

ROY: Throughout my 17 years of life I have had many friends:
Short, tall, weak, strong, (laughs) Goofy looking, (puts hand
through hair) pretty boys, black, wh...., well actually I've never
had any real (pause) white friends. To tell you the truth I really
never had anybody white as anything more than an acquain-
tance. (pause) Going into high school I had a lot of stereo-
types of white people. (thinking out loud sarcastically) White
people only like rock & roll, heavy metal, and alternative music,
can't play basketball, dance all goofy, (starts dancing like Beavis
& Butthead) and talk like this. (makes a nerdy voice)
But let me tell you never in a million years did I think my best
friend, my boy, would be white.

(Spot down on ROY and then up on JASON)

JASON: My mom says I'm color blind, not literally but towards
other people. But that still didn't stop me from having different
stereotypes. I would have bet my last dollar that all black guys
from the South side were in gangs, could rap, and were good at
basketball. When I found out he wasn't in a gang, really could-
n't rap, and to tell you the truth he wasn't much of a basketball
player I was pretty shocked. I mean he thought I had no
rhythm (starts to dance) please! He also thought just because
I'm white I only listen to rock bands and talk like a nerd. Still
he seemed like someone I might want to get to know better.
After our first encounter we began to talk a little bit more and I
even began to hang with him, Kenny and David sometimes at
lunch time. (Shakes his head). Man, those polishes were good.
I don't know, it was at the point where we were more than
acquaintances, but not yet (pause) friends. He seemed cool and
all, but I didn't know how much I could depend on him, and I
think he felt the same way about me. Anyway, I still hadn't
proven I was any good at basketball but Roy was about to find
out.

(Lights dim as JASON goes upstage)

(A square wood piece is hanging upstage as if to symbolize a basketball court. Everything else is pantomime, no ball.)

ROY: (acting like he's in the NBA championship. Making his voice like the announcer) Roy gets the ball, fakes out M.J.. 3 seconds, 2, jumps over O'Neal, 1, scores. (Makes a buzzer noise; makes a crowd noise) The crowd goes wild, Roy has just a single handedly won the game. (Starts dancing and imitating cheer leaders) Go Roy, go Roy, go.... (Sees JASON entering the court)

JASON: (begins laughing) Go Roy.

ROY: (embarrassed). Shut up.

JASON: My practice ended early and there is no way I'm going home.

ROY: So you want to get balled up?

JASON: We'll have to see about that.

ROY: Up to 5 by 1's, check. (ROY throws the ball at JASON kind of hard. ROY takes one dribble and shoots the ball. He makes the shot – this will be done using a swish sound effect) You sure don't want to quit while I'm only ahead by one?

JASON: We'll see when the game's over and I've won. (During the check JASON throws the ball back at ROY. ROY brings the ball to the hole and gets blocked by JASON)

ROY: (sarcastically) Oooh! Nice one.

JASON: (Goes right past ROY as ROY trips and falls). My fault, didn't want to make you look too bad.

ROY: Let's see you do it again. (JASON is dribbling on top of the key) You know white men can't jump.

JASON: (matter of factly) I've seen the movie. (JASON drives to the hole and jumps way higher than ROY) (smiling) I'm sorry I didn't mean to jump that high.

ROY: (out of breath) I'll admit you got me. (JASON attempts to shoot but ROY blocks him and makes a lay up) It ain't over yet. (ROY is dribbling the ball as JASON looks strange as he is playing

defense. Starts cracking up on how JASON looks) Come on man. (JASON continues to look the same way. ROY can't stop laughing)

JASON: Hurry up, I want to get home before curfew. (JASON steals the ball fakes ROY out and makes the lay up.) Game point. (ROY attempts to steal the ball)

ROY: Call the cops! (ROY misses the steal and JASON scores the game winning point)

JASON: (sarcastically) Why? Nothing was stolen.

ROY: Yeah you can play, I'll give you that.

JASON: (bragging) That's what I told you from the start. (They go and sit on a bench)

ROY: I'm just tired that's all. Otherwise I would have killed you.

JASON: Whatever

(Lights darken as JASON leaves the stage and ROY goes upstage center. Spotlight goes on ROY)

ROY: I wasn't sure what to think of JASON. He was almost the opposite of everything I had come to think of white people. As the school year went on Jason and I were able to overcome most of the stereotypes we had about each other. Still there were differences but I think we both understood each other a lot more.

An excerpt from
NINA/MUJER
(LITTLE GIRL/ WOMAN)
by Lorraine E. Bahena

GABY: Oh, hey Que honda? I didn't see you there. I'm
Gabriela Guzman. But everyone calls me Gaby. This is my
stoop, my favorite thinking spot. And this (she puts her arms
up) is my barrio. It's da bomb over here. For one thing, I know
everyone and everyone knows me. I've lived in Chicago a total
of fifteen years and two weeks to be exact. In other words, my
whole life. My parents came here from Jalisco, Mexico in 1978,
before I was even born. I just turned fifteen as you might've
noticed. I love all the attention I've gotten from everyone.
Turning fifteen is probably the best thing that's ever happened
to me. I had a Cincenera and everything. Presents, money, a
dress and a memory I will never forget. Oh, and just in case
you don't know what a Cincenera is, it's a Mexican Catholic tra-
dition. In English it's call a cotillion. When a girl, like myself
turns fifteen that kind of means she's a woman or an adult.
Her parents arrange a mass and a party to celebrate her "wom-
anhood" (she puts her hands up in quotations). Some people
don't take this tradition seriously. But I do. I feel like an adult
now. I'll be able to stay out late and be responsible for myself.
No more nina this nina that or "adult supervision" (she puts her
hands up in quotations) all hours of the day. I've been waiting
for this for a long time and it's finally here.... See the thing is,
I'm the youngest of three kids. So my turning fifteen was kind
of hard on my parents. They've always been so protective of
me. At the mass my mom cried as if it was my funeral, I swear.
Even my dad cried, which was funny because as he says: (mak-
ing her voice deeper) Men don't cry. (She laughs) My sister
wasn't able to make it because of school. She goes to
University of Wisconsin. So she just called to congratulate me
and say: "Now you have to be senorita.".... Everyone went to my
party! Nena, Puppet, Eddie, Claudia, Tia Sonia, Tio Raul, Joey,
the Garcia's, Lala, Shy girl, Chris, Araceli, Leticia, Omar,
Sanchez, Pookey, Joker, Demon, Ivan, Leesie, Loca and a whole
bunch of others. My brother only stayed at the party a little
while and then pulled up. But he still gave me a kiss and told
me to stay cool and not become a cualquera. That means not
become a slut. He's real cool, my brother. But he's a gang

banger. He doesn't live with us anymore cause my dad kicked him out for bringing a gun to the house. I remember it was like two years ago. Alex and my dad got into an argument, then Alex got mad and pulled up to his boy's house and never came back.... I never really see him anymore. When I do, it's like seeing a stranger. I don't even know him. I had just turned thirteen when he left. He was fifteen, my age. I miss him (she puts her head down, then brings it back up).... But oh well, that's life... I guess. Anyways I —

MRS.GUZMAN: (Yelling from inside the house) Gaby! Metete. Come in and pick up these papers you left on the floor.

GABY: Coming! God, can't even have quiet time to myself without someone interrupting me. (To audience) Not meaning you. (GABY gets up and walks through door into living room. Lights go out on stoop and up on living room. MR. and MRS.GUZMAN are sitting on the couch watching TV. GABY squats by TV and gathers papers.) Oh, I forgot about my report. Sorry.

MR.GUZMAN: You shouldn't leave it thrown around where people could step on it. (GABY gets up and puts papers on top of lamp table. She sits down joining her parents on the couch.)

GABY: It's cause I was working on it but then I went outside, for fresh air.

MRS.GUZMAN: You didn't even tell me you were going outside. I was in the kitchen calling you like an idiot thinking you were in here.

GABY: Well sorry. It's not like I went anywhere.

MR.GUZMAN: What were you doing out there?

GABY: Nothing. Just chilling. Oh, and Mama, I saw Mrs. Garcia from church passing. She told me to tell you about Cheli's baby shower next week.

MR.GUZMAN: (Looking away from TV) Cheli's pregnant?

GABY: Yeah, Pappy. You didn't know?

MR.GUZMAN: I'm not a chismoso, I work all day. I don't have time to talk about others affairs. Who tells me anyhow? (He turns back to TV.)

MRS.GUZMAN: Gaby, do you talk to Cheli?

GABY: Yeah, sometimes when I see her. But we're not tight or anything like that though.

MR.GUZMAN: Tight? What kind of word is that? Tu y tus palapbras. If you can't speak properly, don't speak at all.

GABY: It's just another word for close Pappy. Chill. Regular English is so boring. (MR.GUZMAN shakes his head and picks up remote and turns TV off. He picks up newspaper and starts reading it. GABY looks at her mom questioningly. MRS.GUZMAN shakes her head)

MRS.GUZMAN: How old is Cheli? She looks a little young.

GABY: She's sixteen, I think.... Yeah, yeah she's sixteen.

MRS.GUZMAN: Sixteen! I thought maybe eighteen, nineteen. But sixteen? And she's pregnant?

GABY: You're surprised? Lots of girls get pregnant at a young age. It's just natural today.

MR.GUZMAN: (Puts his newspaper down) It's not natural. It's wrong. If I were to ever find out you were fooling around with little mocosos.... You'd wish otherwise.

GABY: Pappy! I wouldn't go around having sex, that's disgusting!

MRS.GUZMAN: (Sternly) I don't want to hear that word coming out of your mouth. Me oyes?

GABY: What? sex?

MR.GUZMAN: Yes. You're too young to even know about that.

GABY: Oh, come on. They teach us about it in school.

MRS.GUZMAN: They teach that in your school?! (MR. and MRS.GUZMAN look at each other with concern)

MR.GUZMAN: Then they wonder why today's youth are going bad.

GABY: They teach us about it so that we could know the facts and dangers. It's not like they let us watch pornos and look at

playboy magazines all day.

MRS.GUZMAN: Cochina! Stop talking like that. They should just tell you it's wrong, don't do it, and that's that.

MR.GUZMAN : And you're right. You certainly won't go around having novios like a little cualquera kissing and making a fool of yourself.

GABY: What! Wait a minute! (She backs away from her parents) I wasn't saying it was disgusting to have a boyfriend. I said it was disgusting to sleep around.

MRS.GUZMAN: Gabriela, it's the same thing. Why do you think girls like you get pregnant?

MR.GUZMAN: Because their careless parents let them go out with perverts and stay out late.

GABY: Who says all girls go out with perverts?

MRS.GUZMAN: You never know. Some girls end up dropping out, becoming druggies, drunks and living like dogs in the streets the rest of their lives.

GABY: Not all girls are the same! I know the difference between right and wrong. Maybe if parents would TRUST their kids, having a boyfriend wouldn't be so "dangerous"...

MR.GUZMAN: Gaby when your mama and I were your age, novios were only allowed chaperoned dates.

MRS.GUZMAN: That means they couldn't even be alone to see each other.

GABY: Hey, at least they were allowed to be novios! Besides, this isn't Mexico cerido anymore. It's the United States, people don't do that in this country.

MR.GUZMAN: It might not be Mexico, but we're still a Mexican family. We brought our language, culture, and traditions with us when we came here.

MRS.GUZMAN: You shouldn't disrespect your country like that!

GABY: It's not my country. It's your country! I was born here

and I follow this country's traditions.

MR.GUZMAN: So long as you're living under my roof, you're following my traditions.

GABY: Do you really think people still practice those old traditions? You don't see girls going out with their boyfriends and their mothers next to them holding their hand!

MRS.GUZMAN: Gabriela! Stop! ... You talk about old traditions; well what about Cinceneras? That's an old tradition.

GABY: Yeah, probably the only one that makes sense. You turn fifteen and become a woman, you can marry conceive and do what you want. It might not be the same anymore, but it still sounds good to me.

MR.GUZMAN: You're right, it's not the same anymore, and do you know why? Because people found that it was wrong to make girls so young grow up so fast.

GABY: Yeah, maybe Pappy, but you should still let me make my own decisions. Let me be independent, trust me!

MRS.GUZMAN: We do trust you. We trust that you'll obey our rules.

The conversation ends and GABY
goes back outside to her stoop.

MRS.GUZMAN: Now that Gaby is fifteen, things will change. She'll understand more of what we want.

MR.GUZMAN: She needs to see, she's not all grown-up yet. She has to take it slow. (Parents freeze)

GABY: They don't understand how I feel. They don't even bother considering my opinion. (GABY freezes)

MR. GUZMAN: We understand she wants to be grown up.

MRS.GUZMAN: We hear her point of view. But we always know best. (Parents freeze)

GABY: I wish they would just listen to me for a change! (GABY freezes)

An excerpt from

LET ME EAT CAKE
by Laura Nunez

(Door opens and closes, EDINA enters stage right. She's wearing jeans, a Pop-Tart's T-shirt and gym shoes.)

EDINA: Hey doll.

LOUISE: (pauses movie) Hey Ed.

EDINA: What are you doing?

LOUISE: Just watching a movie

EDINA: What movie?

LOUISE: *Mirror Has Two Faces.*

EDINA: How long have you been watching?

LOUISE: Just a few seconds, why, you wanna watch?

EDINA: No way. In fact, you're coming with me.

LOUISE: Where?

EDINA: My Sister's House.

LOUISE: But, you don't have a sister.

EDINA: I know.

LOUISE: So, why are you going?

EDINA: We're going because it's a club.

LOUISE: (turns movie back on) Have fun.

EDINA: (takes away the remote) You're coming too.

LOUISE: Very funny, you know I don't go out.

EDINA: Well, you're coming this time.

LOUISE: We've been over this a thousand times. I'm not going to go clubbing, or barhopping or anything else tonight.

EDINA: Come on, let's see a movie, have dinner, see a play.

LOUISE: Hey, we got cable, take out, and tons of movies right here. Why go out and spend money to do something I can do right here for free?

EDINA: So we can meet men who don't feel the same way! Besides you've become a couch potato. You have everything right in arms reach so that you don't have to leave. Unfortunately, you don't have a guy there too. Face it, you're in a rut.

LOUISE: I'm not in a rut. I'm in a niche. There's a big difference.

EDINA: Rut, niche, whatever. You're coming with me.

LOUISE: Look, there is no way I'm leaving this chair!

EDINA: Wanna bet?

LOUISE: Make me! (ED goes up to LOUISE and shoves her off the chair. LOUISE lands on the floor) Okay... but I'm not leaving this apartment! (ED goes to the closet and takes out a dress, then throws it to LOUISE, who is now standing) Just stop it, I'm not going. (ED grabs a pair of matching pumps and hands them to LOUISE) Listen to me! I'M NOT GOING!!!

EDINA: Just shut up and put the dress on.

LOUISE: No, I'm not putting that dress on.

EDINA: Whatever, look, you better hurry up cuz it's almost 9:30.

EDINA: I'm not gonna leave you here to mope around and feel sorry for yourself. It's sick.

LOUISE: No, it's not!

EDINA: Celebrating your ex-boyfriends birthday is sick! It's morbid! The guy was a jerk and he's still making you suffer. Get over it.

LOUISE: I can't.

EDINA: It's been three years you idiot. Get a grip. There are so many great guys out there, but no, you'd rather dwell on a guy that isn't worth the paper his number was written on.

LOUISE: Don't talk like that about him.

EDINA: Eric was a jerk, we both know it. It's time you let go and met someone else someone worth the time of day. It's not like you don't have an opportunity. You're young, beautiful, and always getting set up with great guys.

LOUISE: That's the point. Everyone's constantly setting me up on blind dates. My mother, my sister, you, the lady across the hall! I'm so sick of it. It's like they think my time is running out. I'm 25 for Christ's sake! I'm not an old maid, not a lifeless spinster–

EDINA: But you're on your way.

LOUISE: How?

EDINA: How? How! By dwelling on an old boyfriend! By refusing to move on. By turning down every guy you're set up with. Do you have any idea how lucky you are to be going out all the time?

LOUISE:(sarcastically) Oh, yeah, I'm sooo lucky! Look at me, I'm having the time of my life! Do you know the losers I've gone out with?

They discuss Louise's dating scenarios.

———————————

EDINA: Okay, so you've had TWO lousy dates. That doesn't mean you should give up on men in general!

LOUISE: If only it were two guys, but it's not! It's every single guy I meet.

EDINA: So, you've had a string of bad dates. So what?

LOUISE: So what! So you should stoop setting me up on dates that's what!

EDINA: It's just cuz we worry you're gonna go nuts and open an account at a sperm bank or something.

LOUISE: I know you guys mean well, but please stop. Since when is my love life so important? Was there an all-points bulletin saying, Attention everyone, Louise Cerullo needs a man? Is there a sign on my forehead saying Help, I'm lonely?

EDINA: You made your point.

LOUISE: You swear you won't set me up on any more dates?

EDINA: I'll still set you up, but I'll intensify the screening process.

LOUISE: Why? Because my happiness means more to you than having extra closet space?

EDINA: No. I just want you to shut up.

(PAUSE. They look at each other, smile, then laugh.)

LOUISE: Do you have to go out tonight?

EDINA: No, WE have to go out tonight.

LOUISE: I mean, can't we stay in and watch a movie? I have popcorn.

EDINA: Well, I guess. But I'm hungry, and popcorn won't do. Let's check the menus. (EDINA goes to a drawer and pulls out many take-out menus.) Pizza, Chinese, Mexican, Greek, Italian; I can't decide.

LOUISE: Hmmm. Greek, too far away.

EDINA: Mexican, too spicey.

LOUISE: Italian–

EDINA: Too expensive.

LOUISE: That leaves pizza.

EDINA: Too cute delivery guy.

LOUISE: Pizza it is!

An excerpt from

HIGHER EDUCATION
by Emily Schafer

*This is the most important day in Katie's life – her
wedding day. Her Mother wants to share her daughter's
happiness, but she doesn't approve of this new lifestyle.
Cheryl, Katie's younger sister, offers support and at times
her own insightful perspective on her sister's life.*

(Lights up on a low-budget church-type setting, consisting of a
simple podium at the front and fold-out chairs in the congrega-
tion. FATHER JOHN, in a suit, stands at the front before
KATIE in a simple white dress and MATTHEW in a suit.
CHERYL and MOM sit in the congregation in casual to dressy
clothes. If other actors are available, they too will fill up the
congregation.

FATHER JOHN: Welcome everyone. We are here today to wit-
ness the marriage of Kathleen Strempek and Matthew Buckley.
I would especially like to extend a warm welcome to our special
guests, the families of Katie and Matt. I know everyone here is
very proud and happy for our couple-to-be, so without any ado,
let's begin... (Spotlight on CHERYL. All else freezes.)

CHERYL (to audience): So this was it. My sister was tying the
knot. I wondered how she felt, standing up there. I wondered
what Mom was feeling, seeing, her daughter about to leave us
for–him. She sort of looked like a stranger, in that white dress,
in this place.

CHERYL (to audience): Katie did some pretty weird things,
things I would never have the guts to do. I remember when she
told us she was dropping out of college, the same college she
was so excited about going away to a year before. That girl was
always changing her mind. Mom was mostly confused over that
one...(Spotlight fades on CHERYL and goes up on KATIE.)

KATIE: I did some pretty weird things. Now I see the error of
my ways. Life was so confusing for me. When I first went away
to college, I didn't know who to hang around with. I didn't
know where I fit in. I mean, when I was in high school I didn't
believe anything anyone told me, especially adults. I got good

225

grades because I knew I could, but then I tried to rebel to show that I wouldn't just blindly swallow everything I was taught. When I got to college, the world got bigger. I knew I had to find my place, but the trouble was I didn't know where to look. I felt lost, so far away from everything familiar and surrounded by strangers– it was overwhelming. Everyone there seemed so phony, like nothing mattered to them except partying and getting drunk. I didn't want to become like that.

*Katie's life did change. It changed a bit
more drastically than anyone expected.*

(Lights down. When lights come on, KATIE is standing near desk, acting as if she is looking at herself in the mirror in a new dress. It's the wedding dress. MOM enters.)

MOM: What are you doing?

KATIE: Um, trying on a dress. I just bought it.

MOM: Good, you could use some new clothes. It's a very nice, simple. But white? White is a dry cleaning disaster! And plus it's inappropriate for a lot of occasions. What did you buy it for?

KATIE: It's appropriate for the occasion.

MOM: What occasion? (thinks a moment) No, don't tell me. Please don't tell me it's what I think it is.

KATIE: I'm getting married. It's the right time for me to be married. I can feel it. Invitations will be sent out soon. Father John has everything organized for us already.

MOM: I don't even know who your husband's going to be.

KATIE: Don't worry. We're perfect for each other. Matthew. Matthew Buckley. You remember him, right? He came over here a few times to pick me up to go to Bible meetings. He stayed for dinner once.

MOM: Oh, him. But I thought you two were just... how do his parents feel about this?

KATIE: I'm sure they're happy about it, just like everyone else.

MOM: I would like to talk to them. So you're really going to do this. You're fresh out of college, Katie. Maybe you need some time out there in the world on your own.

KATIE: You got married right after high school.

MOM: I know that. But if I was your age now, I wouldn't be in any rush to get married. I wish you wouldn't make this mistake. Katie, do you really love him?

KATIE: God found him for me.

MOM: No, Father John found him for you. Now I don't even know Matthew, but in all the three years you've been going to this... church... I've been able to form an opinion of Father John, and just because he tells you something, doesn't mean it's true.

KATIE: You don't even know him.

MOM: But he's more involved in you life than I am, or even you are. You realize this has an enormous bearing on the rest of your life, don't you?

KATIE: I have faith that this is right for me.

MOM: I wish you would think about your faith.

KATIE: What? Just because it's different from yours it's wrong? (KATIE walks away in anger. Lights down. Lights up on church scene. FR. JOHN is standing before KATIE and MATTHEW, who are standing and facing each other. They look nervous. MOM and CHERYL look on from congregation.)

FR. JOHN: Do you, Matthew Buckley, take Katie Strempek to be your wife – with whom you will carry out God's will as long as you shall live?

MATTHEW: I do.

FR. JOHN: And do you, Katie Strempek, take Matthew Buckley to be your husband? Do you vow to serve him under God's will for as long as you shall live?

KATIE: I do.

FR. JOHN: Lord, look over Katie and Matthew, bless them with

many children and long lives. Guide them in your love. Amen. (KATIE and MATTHEW sit.) I am very happy today for my children Katie and Matthew. My son Matthew is a very bright young man with a promising future in God's love. Today God has blessed him with my daughter, Katie, a woman who will be sure to stand by him as he does God's will...

MOM: (fuming, whispering to CHERYL) I don't know why he's calling them his children, they're not his children.

FR. JOHN: ...Let us now celebrate this joyous occasion and gather downstairs for the reception. (CHERYL and MOM walk up to the front, toward KATIE and MATTHEW. MOM is lagging behind. If other actors are present, they too make their way up to the front. FR. JOHN notices MOM and comes toward her. He is beaming.)

FR. JOHN: You must be Mrs. Strempek. How nice to see you here. I'm glad to finally meet you. (FR. JOHN extends his hand to MOM in greeting. CHERYL looks on.)

MOM: (rejecting handshake) I only have one thing to say to you. You call yourself a father and you call Katie your daughter; But I think your an enormous fake and Katie, Katie is NOT YOUR daughter. She's mine, and I don't appreciate you saying otherwise.

FR. JOHN: Even those who are lost will one day be found.

MOM: I don't want to talk to you or even look at you anymore.

FR. JOHN: Some even deny the face of God. Everyone will receive their justice.

MOM: Just let me get by. (MOM storms past him, over to CHERYL.) I have to get out of here. If you want to stay, fine. I'm sure Matthew's parents wouldn't mind giving you a ride home. But please promise me you won't talk to that man. I have to go, now. (MOM exits. CHERYL stays a moment, confused. Then she follows MOM and exits. FR. JOHN sees this but does not stop beaming. He walks over to KATIE and MATTHEW and places his hands on their shoulders. Happy violin music begins to play and the merriment continues. Curtain.)

An excerpt from

NOT JUST A RIVER IN EGYPT
by Brian Patrick Norton

*The school cafeteria is one of the most unlikely places to be
confronted by God. But Bradley's humorous encounter
brings a whole new meaning to the words food fight.*

GIRL:(gesturing out over the audience) The foodfight. Isn't that
what you asked me about when you ever so rudely invited your-
self to sit down next to me?

BRAD: I didn't think you heard me.

GIRL: Yes, Brad, I know. I'm sure you think a lot of things.
Like you thought that you could pick me up with that cheesy
line.

BRAD: (on the spot) Yeah, well... ya know, I... (pause) Wait a
minute. How'd you know my name?

GIRL: (GIRL's smile turns sly) Oh, I don't know.... I guess you
just look like a Brad. You've just got that kind of face.

BRAD: Give me a break. Come on tell me. How did you know
my name?

GIRL: (smiling) Alright, do you wanna know a secret?

BRAD: Sure.

GIRL: Okay. But you've got to promise not to tell anyone.

BRAD: I promise.

GIRL: No, I mean you have to really promise me.

BRAD: Yes, alright? I promise not to tell anyone your stupid lit-
tle secret. Now will you please just tell me already, while we're
still young?

GIRL: Okay. (GIRL moves over to speak into BRAD'S ear, slow-
ly) I... am... God. (short pause. BRAD starts laughing and GIRL
joins in)

BRAD: (chuckling) Well, now that's interesting. Very interesting.
So, God, do you have a name or shall I just call you God?

GIRL: (matter-of-factly) I've gone by many names in my time;
Yahweh, Jesus, Allah, Jehovah–

BRAD: Thanks, that's really cute.

GIRL: I know, isn't it? Most people think that being the creator
and ruler of the universe is pretty cute. (GIRL and BRAD are
bombarded by food items thrown from out in the audience.)
Oh, for crying out loud! What the... I just can't stand that kind
of crap. It's so incredibly stupid.

BRAD: What is?

GIRL: The foodfight silly. (GIRL looks out over the audience)
It really is such a waste. I mean, what does anyone gain from
all of this? It's just so stupid. I don't see why people don't
understand that there are consequences to these things they
do. Nothing good can come from this foodfight, but people still
do it. I guess people don't think before they act.

BRAD: (unintentionally transparent) Oh, yeah. I totally agree. I
mean, I don't understand why the teachers or the school
administrators don't break it up. It's hard to believe that people
are so ignorant. I just don't get people sometimes.

GIRL: (smiling) So, why do you want to go out there?

BRAD: I don't.

GIRL: (shakes head teasing) Tsk, Tsk, shame on you, Brad.
Can't you go three minutes without lying to a girl?

BRAD: I'm not lying. I don't want to go out there. Foodfights
are for morons. They are just a juvenile way for people to rebel.
Now, I realize that most people feel the overwhelming urge to
rebel, but I am not most people. I don't feel that I have to
cause trouble wherever I can. Its so childish and immature, I'm
sorry, but I just don't buy into that.

GIRL: No, it's really obvious. I can see this menacing look in
your eyes, no matter how hard you try to conceal it. You just
can't wait to get out there and rebel, rebel, rebel, can you?

BRAD: (lying) I have no idea what you're talking about.

GIRL: Yeah, you do. C'mon why don't you admit it? Spill your guts to me. What, are you embarrassed or something?

BRAD: Shut up. How would you know if I wanted to go out there, anyway? (short pause. GIRL's smile gets wider.)

GIRL: 'Cause I'm God.

BRAD: (smiles) You really like saying that don't' you? It's weird, it's like you get some kind of a high off it.

———————————

BRAD: Listen, I said before that I didn't want to go out there. That means that I don't want to go out there. I don't want to be in that foodfight. I'd much rather stay here with you.

GIRL: (hamming) Ohhh!.... That's so sweet. But really, fess up. Denial's not just a river in Egypt.

BRAD: Oh please. Will you come off it? I don't want to go out there, and that's all there is to it. So don't you start lying that denial bullcrap on me. I'm not denying anything. Why would I? I've got nothing to hide. Besides, even if I did, why would I lie to you? I've only just met you and its not as if I'm trying to impress you or anything.

GIRL: You're not trying to impress me?

BRAD: (lying) No, of course not. What would give you that impression?

GIRL: Oh, nothing. Nothing at all. Just maybe that slick pick up line you gave me earlier, but hell, you probably give that to your guy friends all of the time. I bet you they eat that suave stuff right up, don't they? I bet you you always get them coming up to you and saying stuff like: (GIRL mocks gruff, manly voice) "Yo, Brad. You're looking really cute in them jeans. How's about I come over there, sit on your lap and and hand feed you cherries and grapes.

BRAD: You're getting off the whole subject completely, We're not talking about any of this crap that you keep bringing up. We're talking about the foodfight. The fact is that it's stupid.

All foodfights are stupid. I don't want to go out and I don't understand why anyone else would.

GIRL: Yes, you do. In fact, you are.

BRAD: Are what?

GIRL: Are going to go out there.

BRAD: Will you please just stop. It's getting really old, really quick.

GIRL: Hey I'm just saying what we both know is true. And you can deny it all you want, but the fact of the matter remains. I'm sure all those people out there throwing their fruit cups at everyone have plenty of excuses, but at least they're not over here trying to deny their whole connection with the whole thing. They're out there and in a little while you'll be out there too. The least you can do is be a man and just admit it.

BRAD: It's not gonna happen.

GIRL: Oh really. Well, right now you're trying to sit here and push back every thought of going into that foodfight, beause you don't want me to know that you're just as mindless as the rest of the people in this room. But in a couple of minutes, that will slip your mind and you'll start yelling at everyone throwing food.

BRAD: How do you know?

GIRL: Because I'm-

BRAD: (interrupting) Because you're God, right?

GIRL (smiling wide) Why Brad! You catch on quick now don't you? You're shaping up to be a regular Einstein, you know that?

BRAD: (playing along) Well, its nice to have the approval of God.

GIRL: It is, isn't it?

> God continues to give Brad a piece of her mind,
> and a whole lot more than he bargained for.

An excerpt from

CHAPTER 6

by JEFF GOLDMAN

CLAIRE (wearing pajamas): (journal): I think I was about eight years old. Steve was 16. Steve is my older brother. I used to think he didn't like me much. Whenever he would help me with my homework, he would always get so mad. He would yell at me. I was very scared of him. I had a learning disability. I was born like that. My brother would help me with my homework, since Mom never wanted to. Whenever I asked Mom to help me, she would just make up these excuses. I thought she didn't care enough about me. It hurt a lot. I felt so stupid and hopeless.

MOM: (putting down newspaper) Are you done helping Claire with her spelling words yet?

STEVE: No! I don't wanna help her anymore! She's gotten almost every word wrong.

MOM: Well, Steve, you just gotta stay with her until she gets it. She needs help with her homework, especially with her spelling words. You gotta help her, because you're her older brother, and um, you know her teacher better. You had her when you were her age.

STEVE: I did stick with her. I went over the words with her eight times. And besides, why do I have to help her? It's not my fault she's dumb!

MOM: First off, she's not dumb! She's learning disabled. You have to help her! You know what kind of things the teacher expects from her! I can't help her. I'm busy! You just have to stay with her until I can get her some professional help.

STEVE: (sighing) Look, ma, I know she's my sister and I have to help her, but it's so frustrating! You never help her! You're her mother, I'm not. I have better things to do than help a second grader with homework. It's easy, kiddie stuff. She should know how to do it. (crosses arms across chest).

MOM: (putting a hand on STEVE'S shoulder): For her, it's not easy. It's not easy for me, either. My job demands long hours. I'm a nurse. I'm always on my feet, running around. You don't know what it's like to be an adult, having all these responsibilities.

STEVE: You may have a job, but listen, lady, I have a life!

MOM: (pointing her finger at STEVE) Don't you dare talk to me like that, young man! You listen to me when I tell you to help your sister, OK?

CLAIRE: I overheard my mom and Steve talking. Or yelling. When I heard Steve call me dumb, I thought he hated me 'cause I couldn't spell right. So that night, I tried real hard spelling those words, but I just couldn't get them right. I felt bad because Steve was older and I felt like I was holding him back. He had other things to do besides helping me. Every time he would sit down and help me, he would look so bored. He thought I was a big pain in the ass. I hated feeling so useless. I wanted Steve to like me at least. I wished we were like other brothers and sisters. I had friends whose older brother or sister took them to the movies and shopping and stuff like that. Steve never did that with me. I wish he had. (lights down on room. Lights up in classroom. Bell rings and kids sit down. Teacher enters stage right, wearing a skirt, blazer, and blouse).

MRS. MULLBERRY: OK, class, pull out your history books. Open to chapter six. Read silently. Claire, I want to see you working, especially. I notice you haven't been reading the assignments. (TAMMY slips CLAIRE a note). Claire, I'm aware of your L.D. problem. I think you are exaggerating your problem, though. You just sit there doing class time and passing notes back and forth with Tammy. Now if you can read Tammy's little notes, I'm sure you can read your history book. So now you have to get your stuff and move away from Tammy. (CLAIRE gets her stuff and sits in front of the teacher. CLAIRE takes her book out. (Lights down to reflect time passing. The bell rings). Lunch, everybody! Claire, come here again please.

CLAIRE: (sighing and walking to MRS. MULLBERRY's desk): Yes?

MRS. MULLBERRY: Claire, this is your spelling test that you took this morning. You've gotten almost every word wrong. How can you get a big fat F when you had an extra two days to work? How can you get such a low score?

CLAIRE: I studied. My older brother helped me.

MRS. MULLBERRY: Yeah, well, your spelling test doesn't reflect that you studied. If you ask me, I think that your L.D. problem isn't that bad. I just think you're lazy. You don't want to do your work. It's that simple, you're lazy.

CLAIRE: But I studied the words over and over again!

MRS.MULLBERRY: Well, you say you studied your best but you got a F. Admit it, Claire, you you didn't study.

CLAIRE: But I did! Steve helped me!

MRS.MULLBERRY: All I want is for you to try a lot harder, Claire. When I had your brother Steve he was a perfect student. I expected the same for you. (lights down on classroom. Lights up in the kitchen. MOM is at the counter, making lemonade).

MOM: Hi, Claire! How was school today?

CLAIRE: (quietly) Hi, ma. (shrugs shoulders) School was fine.

MOM: Claire, would you help me put the dishes away?

CLAIRE: Yeah, sure... Mom, can I ask you a question? (they start piling dishes in cabinets)

MOM: Sure. Is there something wrong, dear?

CLAIRE: Yes. Um, mom... does Steve hate me? I overheard Steve saying I was dumb.

MOM: Sometimes Steve gets a little frustrated and says things he doesn't mean. That's all.

CLAIRE: I just wish you would help me, mom. (STEVE enters from stage left. He is wearing jeans and a basketballl jersey. A book bag is slung over his shoulder).

STEVE: Hi, ma. Hi, Claire.

CLAIRE and MOM: Hi, Steve.

MOM: Um, Steve. You need to help your sister with her homework.

STEVE: (throwing bookbag on floor) Aw, ma!! I was gonna shoot some baskets with the guys this evening. You're not doing anything! Why don't you help her?

MOM: I'm gonna start dinner in a few minutes. Please, Steve.

STEVE:(shouting) Fine! Fine! Ruin my life some more, why don't you? (exits stage left).

MOM: See, Claire, he just gets overly angry sometimes. Don't worry, he'll help you.

CLAIRE: I know... mom, I have a problem. Mom, Mrs. Mullberry thinks I'm lazy. She thinks I don't want to work in class.

CLAIRE: (journal) I still thought Steve hated me. My mom thought I was making up what I said about Mrs.Mullberry. I hate the thought of my brother hating me. I love him, he's my big brother, I just wish he would return my love. Why did he have to be so cruel? I never did anything for him to be so mean. I could never understand why he hated me so much... (lights down, lights up in classroom. CLAIRE and TAMMY are sitting in their desks, wearing school uniforms).

TAMMY: Good morning, Claire.

CLAIRE: Hi, Tammy... um, I have something to tell you. Um, I...I didn't read your note because... well, um, it wasn't 'cause of your handwriting. I...I can't read.

TAMMY: (looking shocked) Oh. But why can't you read when everyone else can?

CLAIRE: I don't know. I guess I was just born like that.

TAMMY: Well, can you at least read small words like dog and cat?

CLAIRE: Um, well, no not really.

TAMMY: Can you...

CLAIRE: Look, Tammy, can you quit asking me all these questions? It makes me feel weird! (bell rings and teacher enters stage right).

MRS. MULLBERRY: Good morning, class. Lets pull out our history books now. Open to chapter six and read aloud what we read yesterday. Who would like to read first? (TAMMY raises her hand. MRS. MULLBERRY scans the classroom) Hmmmm... how about you, Claire? (TAMMY starts reading) Excuse me, Tammy. I asked Claire to read first.

CLAIRE: Um, Mrs.Mullberry? I...I can't, um, read.

MRS. MULLBERRY: What do you mean you can't read? How can you go through all these years in school and then say you can't read? You're lazy, Claire. I won't tolerate laziness in my class anymore, Claire, quit your joking and read (voice rising). (lights down.)

CLAIRE: (journal) I was so embarrassed when she did that to me in front of the whole classroom. I told her I couldn't read, then she made me do that stupid worksheet. I couldn't read it. I tried but I couldn't.

(lights up on kitchen).

MOM: Claire, help me set the table for dinner.

CLAIRE: OK.

MOM: What's the matter, Claire? You look upset.

CLAIRE: Remember when I told you about Mrs. Mullberry?

MOM: Yes?

CLAIRE: Well, today, when we were reading in our history books she made me read aloud. When I told her I couldn't read, she made me sit and do a worksheet. She yelled at me for

not doing the worksheet. Then when I told her I couldn't do it, she called me lazy and told me she was going to call you tonight. (phone rings. MOM picks it up.)

Mrs. Mullberry and Mrs. Hinstine
arrange to meet the next day at noon.

MOM: (entering classroom) Hello, Mrs. Mullberry.

MRS.MULLBERRY: (extending hand) Hello, Mrs. Hinstine. Nice to meet you. Have a seat. (MRS. HINSTINE sits on desk chair in front of MRS. MULLBERRY'S desk). About Claire, it has come to my attention that Claire has not been doing any work in my class. She sits there when it's quiet reading time and just stares at the page without reading. When we read aloud, she doesn't read or participate at all. The other day I called her to read but she told me she couldn't read. That is very hard to believe. I am aware of her learning disability, but if it's that bad, then she cannot continue to fifth grade. If this continues I will fail her, and it looks like that's going to happen. She will have to attend summer school. She will have to repeat the fourth grade.

MOM: Mrs. Mullberry, Claire does try hard. Her brother helps her all the time with her spelling words.

MRS.MULLBERRY: Mrs.Hinstine, she's your daughter. You have to help her. If she continues not doing work in my class, I will fail her. I have no choice but to do that. (bell rings) You'll have to excuse me. I have to teach my class now.

MOM: (standing up) While teaching your class, teach my daughter, ok? (exits down stage left. lights up, revealing new day).

MRS.MULLBERRY: Good morning, class, pull out your history books. Open to chapter eight. Begin reading silently. Claire, pull up a chair and bring your book to my desk. (lights down on class, up on CLAIRE's room).

CLAIRE: (journal) Mom also started helping me with my homework. She got me a tutor. Steve has more patience, too.

An excerpt from

DESTINY

by Najah Charlton

Destiny's realization that her little brother is growig up brings her face to face with her own maturity. She's painfully reminded that decisions of the past can impact ones life and the lives of those you love forever.

(DESTINY goes and gets the photo album off of the bookshelf and flips through the pictures. MICHAEL takes the album)

MICHAEL: Gosh, we haven't looked through this thing in a while.

DESTINY: I know, Mom would take it out and take us step by step through every grueling picture.

MICHAEL: (imitating the mother) And this is the brother of your grandmother's sister's aunt's cousin who married Bob, you remember Bob don't you? Well, I think there's a picture of him in here some where. Let me look.

DESTINY: (laughing) That's Mom for you!

MICHAEL: So is yelling her head off. Hey, wuz this you? (MICHAEL points at the picture)

DESTINY: Yeah, wasn't I beautiful?!?

MICHAEL: Sure, what ever you say! EW, you're holding me naked!!!

DESTINY: You were so cute!!!!

MICHAEL: Sure, whatever. Anyway, what do you mean I was cute?!?

DESTINY: You still are. (DESTINY pinches MICHAEL'S cheek)

MICHAEL: (blushing) Cut it out!

MICHEAL: (still looking at the pictures) Hey, why aren't there any pictures of my dad in here?

DESTINY: Your dad didn't really like to take pictures

MICHEAL: You know, I was telling my friend about our family, about how me and you are so –

DESTINY: You and I

MICHEAL: You and I are so close and about how Mom can be so overprotective sometimes. And you know what? She asked me where my dad was and why we were so far apart... in age I mean. I told her how Mom married John and figured you'd be her only child, but then they got divorced and she married my dad, Robert, who died when I was one.

DESTINY: So what's the problem then?

MICHEAL: The problem is why Mom can never stay with guys.

DESTINY: Things don't always work out as they are planned, but they always work out. I mean if Mom had stayed with John, she wouldn't have had you.

MICHEAL: Yeah, I guess so. (DESTINY puts her arm around MICHEAL)

DESTINY: So what'd you do over Sean's house anyway?

MICHEAL: (suspiciously) Nothing. (DESTINY takes her arm from around MICHEAL'S neck)

DESTINY: Spit it out!

MICHEAL: We looked at these magazines of his dad's with--

DESTINY: That's enough

MICHEAL: I told you not to get grossed out, besides you promised!

DESTINY: I know I did, but how am I not supposed to get grossed out... it's disgusting!

MICHEAL: I think it's great.

DESTINY: (getting upset) I'm sure you do, but it's not.

MICHEAL: How come? Sean's dad looks at them!

DESTINY: (angry) Well, that's a completely different discussion. Those magazines–

MICHEAL: What–?

DESTINY: –portrays women as sex objects. I mean there's more to a person than how they look.

MICHEAL: (joking) It can help you learn about the human body.

DESTINY: (not seeing the humor) Oh, yeah. I'm sure that's why people look at those magazines – to educate themselves. Oh, please! And I'm almost positive that's not the reason you were looking at them!

MICHEAL: So maybe that wasn't my reason, but who really cares anyway?

DESTINY: (angry) I do. Micheal, women have personalities that aren't displayed in those kind of magazines. It gives people messed up ideas about women.

MICHEAL: Well then, if older guys know all this...why do they look at them?

DESTINY: (hostile) They have their reasons, as stupid as piggish as they might be, they have their reasons.

MICHEAL: Well, I already know about girls.

DESTINY: You're ten years old. What do you know about girls?

MICHEAL: (very matter of factly) I've kissed a girl!

DESTINY: (angry) You what?

MICHEAL: Well, that's where the rest of the story comes in.

DESTINY: What rest?

MICHEAL: Just listen, it gets better. Before we went over Sean's house we went to this girl Julie's house and me and her, I mean, her friend Sarah and I well, um... we kissed!

DESTINY: (angry) What were you thinking going over some strange girl's house?

MICHEAL: (defensively) She wasn't strange. I met her at church with Mom.

DESTINY: Oh, no, Micheal, you can't be doing stuff like this.

MICHEAL: We went over Sean's house eventually.

DESTINY: (annoyed) YOU know what I mean! It's one thing to kiss a girl, but then go look at those trashy magazines. What are you getting yourself into?

MICHEAL: It's not a big deal.

DESTINY: You just don't realize exactly how big of a deal it really is.

MICHEAL: I'm sure you did the same thing when you were my age.

DESTINY: (protectively) That's not the point.

MICHEAL: Sure it is. You've probably snuck around and stuff.

DESTINY: (angry) We're not talking about me!

MICHEAL: Well, why not? You know you probably kissed guys when you were my age, so why are you making such a big deal out of this?

DESTINY: Do you know how many kids start out young and get pregnant and—

MICHEAL: (getting angry) It's not that serious. I mean, it's not like we're getting married or anything, so somehow I don't think that's gonna happen.

DESTINY: It's the whole principal of the thing, don't act like you don't know what I'm talking about.

MICHEAL: (annoyed) You're not making any sense!

DESTINY: See if this makes sense. You're not doing anything like this ever again. (angrily) Do you understand that?

MICHEAL: (upset) I don't have to listen to you!

DESTINY: Don't talk to me that way!

MICHEAL: Why don't you take a pill?

DESTINY: (to herself) Maybe I should have.

MICHEAL: What?

DESTINY: Nothing. Anyway, do you even care about this girl?

MICHEAL: (angry) It's none of your business. Besides, kids do stupid things. Don't you remember what it's like to be young?

DESTINY: All to well, but you're not me!

MICHEAL: Get off my back will you?

DESTINY: (angry) No, I won't get off your back, you need to hear what I'm saying to you.

MICHEAL: (defiantly) I don't have to!

DESTINY: Don't you dare tune me out!

MICHEAL: (furious) When did you decide to become my mother? (DESTINY smacks MICHEAL)

DESTINY: (blowing her top) About ten years ago! (Pause. DESTINY realizes what she said and did. MICHEAL is stunned from the smack.)

DESTINY: Oh my God, MICHEAL, I'm sorry! (DESTINY moves in MICHEAL'S direction. MICHEAL backs away, his hand on his face.)

MICHEAL: I don't understand why you're acting this way! (DESTINY hugs MICHEAL, but MICHEAL pulls away)

DESTINY: I should have told you sooner.

An excerpt from

UNSUBSTANTIATED PROPAGANDA
STYLE UNTRUTH
by Suzette Opara

(lights up on Donna sitting stage left in a chair on a porch, top part. There is an ashtray next to the chair. Donna is talking to her psychiatrist, who is offstage)

SHRINK: So Donna, how've you been doing?

DONNA: (calmly) Alright, I guess. Better than the last session, I'm a little more comfortable now. (pulls out package of cigarettes from her pocket, along with a lighter)

SHRINK: So how is your summer going?

DONNA: It's nice. (lights cigarette) But if it's one thing I hate about the summertime it's those damn mosquitos! I remember when my daughter, Nautyca was little. She used to run outside and play with her little brother, Mauriece, They'd both come back in crying and scratching. Those mosquitos used to tear them up! My husband and I, (turns serious) well, ex-husband, Malone, used to laugh til we cried. (starts smiling)

SHRINK: Tell me something about Malone.

DONNA: Malone was my high school sweetheart. We were together all four years at Rydell High. Right after Senior Prom he took me to this beautiful beach resort in San Juan and nine months later I had Nautyca.

SHRINK: How were things after you had her?

DONNA: Everything was great. We were so happy. Malone had a good job working as an assistant manager at Carson Pirie Scott downtown. (Sarcastically) I was a wonderful house-mom.

SHRINK: When did you have Mauriece?

DONNA: Three years later. That's when everything started getting shaky. Mauriece cried all the time. It seemed like everything was harder with him.

SHRINK: Did you treat them differently?

DONNA: No. I always made sure that anything Nau Nau got, he got. If Nau Nau got a Barbie, Riece got a truck.

SHRINK: Did you and Malone go out much after Mauriece was born?

DONNA: Except for the store and work, no. Malone and I was always tired. I missed going out with my girls to the discos and the stepper sets at the Cotton Club. (Gives a dreamy sort of smile)

SHRINK: Were the two of you having any kind of financial struggle after a while?

DONNA: Money just wasn't going in like it used to. We applied for Public Aid and got accepted. Me and Malone were always arguing over every little thing.

SHRINK: So what happened after that?

DONNA: One day he went to work, (pause, takes a puff of her cigarette) and never came back. In the back of my mind, I knew it was bound to happen one day, but I guess I was blinded by love. I didn't know what I was going to do. I depended on him for everything I just went into this state of depression.

(lights up on entire stage indicating a scene change.
Enter NAUTYCA stage right carrying a big purse on shoulder and 2 hand luggage bags)

DONNA: It was just kinda like...

(NAUTYCA interrupts)

NAUTYCA: (happily) Hey mama!

DONNA: (stands to hug NAUTYCA) Is that my Nau Nau?

(DONNA and NAUTYCA hug and laugh)

NAUTYCA: In the flesh! (They both sit)

NAUTYCA: So how's everything going? You look great!

DONNA: You do too. I've just been trying to eat right going to

the therapist regularly and just living everyday to the fullest. You look a little thick there girl! They been feeding you that country cornbread down there, huh?

NAUTYCA: Ma! (shyly and embarrassed) You know that's just freshman fifteen.

DONNA: Freshman fifteen. Prayer, gravity, whatever. I'm just glad all that fat to that big ole' head of yours! (They both laugh) So, how is school?

NAUTYCA: Fine, my classes were kinda hard at first, but I got used to them.

> As they talk, Nautyca shows her Mother a picture album
> that includes a photo of her brother Mauriece and his
> daughter Aramis. Donna has never seen her grand-
> daughter– then the conversation turns to talk of Mauriece.

NAUTYCA: He's supposed to be meeting me here any minute now. (NAUTYCA looks at watch.)

DONNA: (looks surprised) Over here?

NAUTYCA: Yeah. I called him over his baby mama house from the train station. (they both sit and look out and around at people on the street. Enter MAURIECE stage left. Her face widens with happiness. NAUTYCA sings) Mauriece!!

MAURIECE: (sings back) Nau- Ty- Ca!! (NAUTYCA gets up to hug MAURIECE. MAURIECE pays no attention to DONNA. He sits down first, but not next to DONNA.) (excitedly) OOH!! Look at you girl! Looking all good. Boy, I'm glad you went down South, cause you finally got that booty you was praying for!

NAUTYCA: (smiling) Yeah, and still yo' peanut head, fool!

DONNA: (sarcastically, almost to herself, but loud enough for everyone to hear) Oh, hey mom, long time no see. How you doing? Oh, I'm just fine and dandy, it's so nice of you to ask.

MAURIECE: (rolls his eyes) Yeah, whatever man. An-ee-waay!!! How's college life? (DONNA takes out cigarette and lights it. She looks up periodically almost as if she wants to interrupt during their conversation)

NAUTYCA: It's straight, it was kinda hard at first, but now I think I got the hang of it. Do your homework, read, study, and you pass.

MAURIECE: Yeah, I need to be trying to get myself ready for all that.

> *The sibling's discussion leads to talk about Mauriece's plans for school and the upcoming Prom. Then Mauriece helps to take his sister's bags into the house.*

(They go inside. Lights dow on stage. Spotlight on DONNA talking to Psychiatrist. He is not visible.)

DONNA: (kind of upset, with an attitude) That boy had his nerve! I raised that boy the best I could until I got into my (pause) habit.

SHRINK: But Donna could you blame him?

DONNA: (giving into it.) Well, I guess I can't blame him. He could at least gimme a picture of my grandbaby. (picks up album, looks at picture sentimentally.) She's so pretty. (smile slowly fades) I never even got a chance to hold her. I guess I'm paying for my mistakes, but I would think that he would have gotten over it by now. Nautyca has gone on and moved along with her life. When he came back out, it was a do or die situation.

(Lights fade up on entire stage, indicating scene change. Mauriece interrupts by opening the door. Still yelling to Nautyca.)

(MAURIECE walks almost to the bottom of the stairs. Not trying to look at DONNA, trying to avoid eye contact.)

DONNA: (hesitantly, but quickly before he walks down the last step.) Hey Mauriece.

MAURIECE: Ssup.

DONNA: (calm. pause.) So how've you been?

MAURIECE: I'm straight.

DONNA: How's my grandbaby?

MAURIECE: My (emphasis on daughter) daughter is doing just fine.

DONNA: (pause) Look Mauriece let's not go through this right now, okay.

MAURIECE: Let's not go through what?

DONNA: Don't play games with me Mauriece (pause, looking at him desperately) Riece, I want to see Aramis.

MAURIECE: (with attitude) For what?

DONNA: That's my grandchild!

MAURIECE: And that's my shorty!

DONNA: (gets up, almost in tears) Mauriece, why are you doing this? Can't you see I've changed? What I did in the past was dumb and yes, I've made some mistakes. And I'm sorry!

(NAUTYCA opens door after hearing all the noise, but does not speak.)

DONNA: And if I could change the past, I would, but I can't. So why– (Mauriece interrupts. He finally looks at her.)

MAURIECE: (yelling) So why, what?! So why can't I bring her over here? Look at yo'self! All you do is smoke all day! I can't trust you with her! You even ran my dad away!! (almost face to face) For all I care you ain't nothing but a hype and I wish you was dead! (Mauriece makes total eye contact with Donna)

DONNA: Do you know why y our dad ran away? (pause. Then yelling) Do you? (Mauriece looks down) Do you know why I was a (stressing every syllable) drug addict, Mauriece? Because your father gave them to me, that's why!

(Mauriece and Nautyca look at each other in shock. Donna looks down and begins to light another cigarette. Nautyca walks out of the house onto the porch shocked. She sits down next to Donna. Mauriece, embarrassed sits down on the bottom step, Donna picks up picture album and begins to flip through it.)

NAUTYCA: Ma, (pause) Why didn't you tell us before?

DONNA: You never asked. I guess I was ashamed. I didn't want yall to hate him. Instead, Mauriece ended up hating me. I got really depressed because I had gained alot of weight after I had you Mauriece. Your dad told me that taking the drugs would help me loose weight and feel better. I'm sorry I never meant to hurt you Mauriece. I guess I was just being selfish.

(spotlight on Donna talking to shrink, lights down on entire stage)

SHRINK: So how do you feel Donna?

DONNA: I feel great.

(lights down)

An excerpt from

AN OPEN DOOR

Jacob Ze`ev Barnet Goldsmith

*Trust, an important and fragile bond, is often taken for grant-
ed in families.* An Open Door *explains that bond and what
happens when it has been broken. The road to repair has to
be taken one step at a time.*

MARIA: We're going to see that new Oliver Stone film tomorrow.
You're welcome to join us.

MIKE: No thanks. I saw it, remember? I told you it was awful.

JAMES: I don't remember that.

MIKE: (Exasperated) Well I did tell you.

MARIA: Okay, okay. You saw it.

MIKE: (Under his breath) Jesus!

MARIA:(Exasperated) Well excuse me if I want to see it myself.
(The phone rings and JAMES and MIKE both get up to answer
it. JAMES walks fast and answers the phone MIKE sits back
down.)

JAMES: Hello? (his voice drops to a disgusted tone) It's for you
Mike. Jimmy.

MIKE: I'll take it in my bedroom. (He runs out before either
parent can respond.)

JAMES: Don't talk long, I've got to make a business call.

(Lights up on MIKE'S bedroom as he runs in. He shuts the door
and dives onto the bed, grabbing the phone from the bedside
table. He sits on the edge of the bed.)

MIKE: (on phone) Wazzup!!! (waits till he hears his father hang
up the phone, then falls backwards onto the bed with a sigh.)
Ah! I can't deal with this.

JIMMY (from off stage, voice is rough and relaxed)- Yeah your
dad sounded thrilled.

MIKE: Oh no, he wasn't in a bad mood. He just hates you. I'm the one who's had the crappy day. (MIKE begins mouthing a conversation as the focus returns to the kitchen, where JAMES and MARIA clear the table. JAMES resets the picture on the fridge.)

JAMES: I just don't need this after the day I've been having.

MARIA:What?

JAMES: Don't act like you don t see it. I've got a work call to make, he knows it, and now he's lying on his bed talking to some drugged out imbecile, or he's called his girlfriend. What's her name.

MARIA: Erica.

JAMES: Nice girl. I hope she dosen't get mixed up in his crap. (Focus returns to the bedroom)

MIKE: Impossible. (Laughs) They'll go through physical withdrawal from each other. They went at it like rabbits man! (JIMMY laughs.) Speaking of that. I'm bringing Erica with me tonight.

JIMMY: And you're gonna introduce her to Cindy? I'm sure they'll love each other.

MIKE: Oh Jesus, I forgot she was gonna be there.

JIMMY: That's why you need me.

MIKE: That is why I need you.

JIMMY: So? whatcha gonna do. Bring Erica and hope for a three way?

MIKE: You disgust even me, Jimmy. I'll... (thinks) Tell Erica I'm sick. (Focus returns to kitchen)

MARIA: Of course he isn't.

JAMES: He could be. They've been dating for a month and a half.

MARIA: He would have told us if he was sexually active. (Focus is split between kitchen and bedroom.)

JIMMY: I'm all out. Bring a few condoms, will ya.

MIKE: Not like you'll need em.

JAMES (In kitchen. To MARIA, who is exiting)- I'm going to call in now. He should be off. (JAMES picks up receiver and puts it to his ear. He is about to dial when he hears Jimmy and MIKE conversing)

JIMMY: Just make sure you bring it. Okay.

MIKE: I don't leave home without it. (Laughs. JAMES hangs up the phone in disbelief. Runs out after MARIA.)

JIMMY: Seriously...

MIKE: Hold on. Did you hear that click?

JIMMY: (reassuring) No one was on.

MIKE: Yeah. He was. That S.O.B. was listening in on me. After all he preaches about privacy.

JAMES: After all he preaches (JAMES walks on stage with MARIA) about his new life.

MIKE: I have no control over my life. They control everything.

MARIA: My God, this is our house. We should have control over things. Not him! (She stops for a second to rationalize the situation.) That phone call could have meant anything... But what if it didn't. I Don't want to feel out of control. (MARIA looks to JAMES trying to figure out what to do. JAMES starts to respond but is cut off by MARIA)

JAMES: We've raised him to be open.

MARIA: And since we put him into rehab we've been great.

JAMES: What? Great?

MARIA: Yes!...

JAMES: I don't find this great. You and Dr. O'Connor shouldn't have allowed Mike this kind of freedom.

MARIA: So this is my fault!?

JAMES: I don't mean that. I mean...

MARIA: Well damn it, that's what you said.

JAMES: I just think it was your.. um (Trying to think up the appropriate word) task.. to...

MARIA: Task? Dosen't a year of therapy mean anything to you. It sure seems like it meant something to him.

JAMES: So you're saying it's my fault.

MARIA: No! I'm saying you should work with us. With him. And not shut him out.

JAMES: It's not shutting him out. We're his parents (JAMES is feeling very helpless). We are his parents.

MARIA (Looks up at JAMES)- Is this really happening....again? (JAMES nods "Yes". Lights down on the kitchen.)

JIMMY: You haven't done anything wrong bro! So whaz the problem?

MIKE: You're right. Man, they guilt trip me so much. I feel bad enough for what I did.

JIMMY: You shouldn't...

MIKE (Interrupting)- I do! But that doesn't matter much. Its the things I haven't done. Stuff they suspect. That's what I hate. I don't wanna feel bad for that stuff.

JIMMY: So?

MIKE: So what?

JIMMY: So ya common' out tonight.

MIKE: Hell yeah man. (Trying to sound confident)

Jessie'll pick me up in like 5.

JIMMY: Straight. See Ya...

Gallery 37 Literary Program Apprentice Artists and Teaching Artists

Poetry Program
Guild Complex
Downtown 1997
Maria McCray, *Lead Artist*
Quraysh Ali, *Lead Artist*
Emily Hooper, *Lead Artist*
Glenda Baker, *Lead Artist*
Jen Morea, *Teaching Assistant*
Senior Apprentice Artists
Ayanna Maia Saulsberry
Apprentice Artists
Muneerah Hanan Askia
Eliza Browne
Jessica Carrillo
Olga Leticia Chavez
Jennifer Rebecca Clary
Scenecia Curtis
Jeffrey Malcolm Daitsman
Onome Oma Djere
Molly McGing Dunn
Maria Christina Gonzalez
Shon P. Harris
Rufus J. Jackson
Kathy Star Jacobson
Ann Margaret Janikowski
Charlotte Y. King
Eric Paul Komosa
Alan Lawrence
Trina Renee Mack
Robertha C. Medina
Alia Rajput
Sean Slive
Nnennaya La'trice Smith
Amy Kristen Stauffer
Marijke Maurine Stoll
Jamaal C. Webster
Amber Lee Wilson
Onzsalique Wright

Prose Program
Guild Complex
Downtown 1997
Tsehaye Hebert, *Lead Artist*
Mike McCauley, *Lead Artist*
Jennifer Sutton, *Teaching Assistant*
Mario Smith, *Teaching Assistant*
Senior Apprentice Artists
Gina Marie Holechko
Kevin James Irmiter
Apprentice Artists
Sheryl Lynn Bacon
Amey Jaqueline Barba
Jonathan Wise Baskin
Jaycee Bryant
Edith Elizabeth Bucio
Bryson K. Clark
Carolina Coello
Keinika Alina Cooper
Matthew Ezekiel Dunn
Jonathan William Edward Farr
Paul James Fitzgerald
LaToya Trese French
Miriam Gluck
Michael Poland Hamburg
Virginia Katherine Hunt
Sarah Marie Kozlowski
Benjamin Joseph Lieber
Brenda Maldonado
Tara Anne McDonald
Dawn Marie Munger
Edward John Peterson
Sarah Claire Pickett
Elizabeth Jean Shaw
Monica Itesha Thomas
Sandra Trevino
Lenora Diann Warren

Playwriting Program
Pegasus Players
Downtown 1997
Eugene Baldwin, *Lead Artist*
Lauren Targ, *Teaching Assistant*
Ray Thompson, *Teaching Assistant*
Senior Apprentice Artists
Emily Grace Schafer
Kirk Daniel Evans
Claudia Alonzo
Lorraine Eve Bahena
Najah Hanan Charlton
Naimah Sabreen Cyprian
Albert Lee Downing
Margaret McMurry Elrod
Jeff A. Goldman
Jacob Ze'ev Goldsmith
Chasiah Teipporah Haberman
Tiffany Joy Henderson
Stephanie Laurel Hernandez
Mary C. Kushiner
Rory John Leahy
Margaret Mary McCloskey
Tiffany Anne McDonald
Brian Patrick Norton
Laura Nunez
Suzette Chinwe Opara
Shannon Kanika Patrick
Josh Micheal Prudowsky
Lindsay Dee Quinlan
Jessica Violet Rose
Zaneta Lynn Wrightsell

Creative Writing Program
Guild Complex
Juarez High School
Schools Program 1997
Ms. Anna Garcia-Berlanga, *Principal*
Natividad Laredo, *Teacher Liaison*
Lisa Alvarado, *Lead Artist*
Eduardo Arocho, *Teaching Assistant*
Apprentice Artists
Adriana Avina
Alejandro Cruz
Columbo Galindo
Nancy Lopez
Carlos Rubio
Irma Salazar
Veronica Tinoco

Creative Writing
Guild Complex
Whitney Young High School
Schools Program 1997
Ms. Joyce Kenner, *Principal*
Anita Andrews, *Teacher Liaison*
Tsehaye Hebert, *Lead Artist*
Jen Morea, *Teaching Assistant*
Amy Ventura, *Teaching Assistant*
Apprentice Artists
Donald Andrews
Heather Banas
Akiba Barberousse
Anthony Eddings
Zaavana Fowler
Maurice Johnson
Eric Komosa
Kirkland Mack
Carmelia Mcdaniel
Tyion Motley
Yemisi Odedina
Loretta Okoye
Bobby Patrick
Takenya Pillman
Yolanda Porter
Leonard Posey
Patrice Robinson
Noel Thomas
Danielle Townsend
Ebonique Walton
Jennifer Webber
Niesha Wheat
Michelle Zeigler

Creative Writing Program
Gallery 60
Boulevard Arts Center
Neighborhood Program 1997
Jesse Goodwin, *Lead Artist*
Apprentice Artists
Raushanah Azim
Antonio Baskin
Jesse Daniels
Shannon Dellahousaye
Falyn Harper
Mark Hodges
Wakeesha Jackson
Marcella Knox
Tamika Little
Jacob Lyons
Lasonia Reed
Davonna Smith
Sheilina Stingley
Antoinette Wiley

**Writing/Performance Program
Gallery Truman
Beacon Street Gallery at
O'Rourke Center
Neighborhood Program 1997**
Susan F. Field, *Lead Artist*
Patricia Murphy, *Lead Artist*
Rolanda Bringham, *Lead Artist*
Abi Gonzales, *Teaching Assistant*
Margy Stover, *Teaching Assistant*
Senior Apprentice Artists
Joe Nelson
Apprentice Artists
Bonavy Chey
Teman Coger
Tuan Dang
Roxanna Hernandez
Enis Husanovic
James Freeman-Hargis
Laura Johnson
Vutha Keo
Daniel Lieber
Brenda Mendizabel
Hawa Mohamed
Dai Nguyen
Semha Orgorinac
Viviana Ortiz
Phorn Phuong
Sandad Som
Kathy Tsang
Cassandra Valentino

Third World Press
Third World Press is one of the oldest, independent African American
publishers of creative thought and literature in the country. Founded in
1967 by Haki R. Madhubuti along with Johari Amini (Jewel Latimore)
and Carolyn Rodgers, TWP is dedicated to publishing culturally pro-
gressive and politically insightful works of fiction, nonfiction and poetry.
TWP publishes works by literary figures such as Illinois Poet Laureate
and Pulitzer prize-winner Gwendolyn Brooks, Amiri Baraka, Sonia
Sanchez, Haki R. Madhubuti, John Henrik Clarke, Derrick Bell, Frances
Cress Welsing, Sterling Plumpp, Chancellor Williams, and many others.
For thirty-one years, TWP has served as an important part of Chicago's
South Side business community.

Haki R. Madhubuti
As poet, publisher, and educator, Haki R. Madhubuti is a pivotal figure
in the development of a strong Black literary tradition that emerged
from the era of the sixties. Madhubuti, a widely anthologized poet and
essayist, is the author of twenty-one books including the best selling
Black Men: Obsolete, Single, Dangerous? His latest books are *Claiming Earth:
Race, Rage, Rape, Redemption: Blacks Seeking a Culture of Enlightened
Empowerment, GroundWork: New and Selected Poems, 1966-1996* and
HeartLove: Wedding and Love Poems. He is a professor of English and the
founder and director emeritus of the Gwendolyn Brooks Center for
Black Literature and Creative Writing at Chicago State University.
Haki R. Madhubuti serves as the publisher at Third World Press.

Gwendolyn Mitchell
Gwendolyn Mitchell, poet, editor, and community arts administrator
recently relocated to Chicago from Pittsburgh, Pennsylvania. She is the
recipient of a 1994 Pennsylvania Council of the Arts Fellowship in
Poetry and is the author of *Veins and Rivers,* a book of poems. Her
works have appeared in a number of journals and anthologies including
American Review, Prairie Schooner, and *Say that the River Turns: The Impact of
Gwendolyn Brooks.* Ms. Mitchell served as one of the co-chairs for
Chicago's 1998 Power Poets Twenty-four Hour Poetry-Thon. She cur-
rently works as an editor for Third World Press.

Picture Credits

All artwork contained within this book was completed
by apprentice artists employed by Gallery 37

Cover: Leonides Polanco, age 18
Contents page: Joey Corrado, age 16

Section 1
page 1: Melissa Martens, age 14
page 4: Margaret Poniatowska, age 16
page 8: Judy McGrath, age 18
page 12: Madonna Delizo, age 18
page 16: Cathy Mooses, age 14
page 20: Melissa Marquez, age 17
page 25: Madonna Delizo, age 18

Section 2
page 27: Katrina Warren, age 14
page 31: Casey Hale, age 17
page 36: April Harvey, age 20
page 42: Carolina Diaz, age 17
page 48: Monique DuPree, age 16

Section 3
page 57: Diep Nguyen, age 17
page 61: Jay Gaudiano, age 17
page 69: Jadie Robinson, age 18

Section 4
page 73: Jonathan Sangster, age 16
page 82: Brian Sami, age 16
page 87: James Wright, age 15
page 89: Lindsay Kessner, age 17
page 94: Javier Govea, age 15
page 101: Maria Ibarra, age 16
page 108: Alexandria Miller, age 17
page 110: Carolina Diaz, age 17

Section 5
page 131: Deborah Murphy, age 18

Section 6
page 193: Jennifer Martell, age 18

Back Cover: Rebecca Crouch, age 15